Samuel Cooper
1609–1672

by the same author

*

DICTIONARY OF BRITISH MINIATURE PAINTERS
BRITISH PORTRAIT MINIATURES
(*Methuen & Spring Books*)
JOHN SMART
(*Cory, Adams & Mackay*)

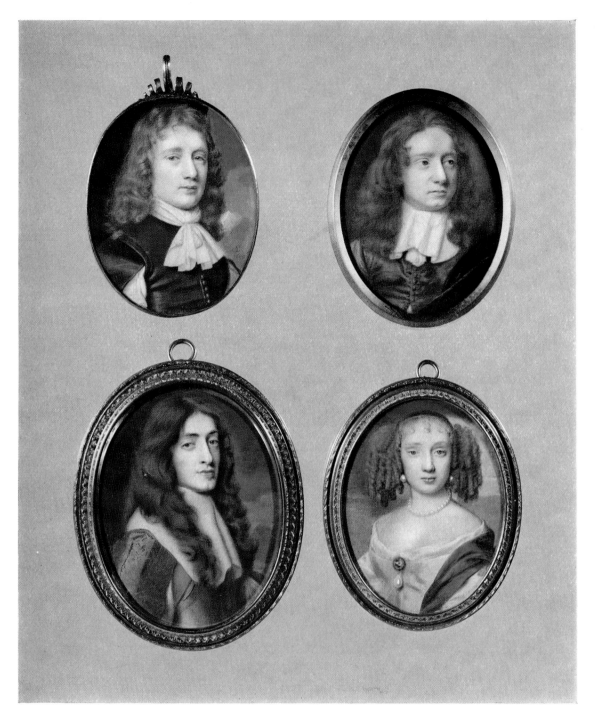

1. Possibly Sir R. Henley.
72 × 59 mm.

2. Self portrait of the artist, 1609–1672.
70 × 56 mm.

3. James II, as Duke of York, 1633–1701.
83 × 65 mm.

4. Henrietta, Duchess of Orleans, 1644–1670.
72 × 56 mm.

Daphne Foskett

SAMUEL COOPER

1609–1672

FABER AND FABER

3 Queen Square · London

First published in 1974
by Faber and Faber Limited
3 Queen Square London WC1
Printed in Great Britain
by W & J Mackay Limited
Chatham, Kent

ISBN 0 571 10346 4

Samuel Cooper: an Appreciation

by ROY STRONG

Samuel Cooper, 'the prince of limners', 'the Vandyck in little', he 'first who gave the strength and freedom of oil to miniatures' and he who could 'equal if not exceed the very best in Europe'. With such eulogies the great seventeenth-century miniaturist was hymned in his own lifetime and in the century after. Such an artist deserves a place in our national mythology and yet he remains a diminished figure, a name which never springs to mind alongside that of Holbein and Hilliard, Hogarth and Gainsborough or Reynolds and Romney. Yet Cooper is one of our great artists, consistently more evocative and more perceptive than the slick interpreters of his age, wooden Robert Walker or langorous Peter Lely. He painted in Covent Garden for three decades the great and the ordinary who peopled the streets of Caroline, Cromwellian and Restoration London. Why has he sunk in popular esteem? Partly because he remains a shadowy figure, although we know he was 'good company' and 'all wit and courtesy', but partly also because in our own period taste for the muted baroque of the post Van Dyck era has been at its nadir for decades. We have no feeling for the gentlemen who peer out from beneath those enormous bushy wigs and even less for the droopy ladies with those cascading corkscrew curls. Instead we are excited by the bright harsher values of the Tudor age or the puzzles and paradoxes of Victorian England. These are the hazards of fashion and Cooper must await to recapture public imagination. I personally cannot think of any British artist who is so neglected as one of our 'greats', a creator of 'images' which powerfully linger in the mind. He is an intensely masculine artist and he interprets his sitters with a blustering vigour. He gives us the reality of them with little idealisation and, due to their size, no props to remedy their defects. In every case we feel the thrust and recession of their features, the allure or rejection of their eyes, the

response of their lips, sometimes tight and withdrawn, sometimes stupid and louche, sometimes composed but on the point of intelligent utterance. We feel too, within the tiny miniature's surface, the movement of the head, a tell tale for character, whether it is held composed and aloof or leans forward in communication, or whether it shyly turns towards us or draws us with beguilement into the tiny picture's surface. And one respects Cooper even more for the circle that knew and admired him: Thomas Hobbes, Samuel Butler, Samuel Pepys and John Evelyn. He would surely have been a fascinating man to meet, and like all successful portrait painters of an extraordinary charm. This is recorded both by contemporaries and evidenced from the honesty of characterisation he was able to draw from his sitters. Cooper was never a man for concealment and artifice. His success in the highly artificial age in which he lived is testimony to a talent which was so amazing that it could rise above and ignore the idiosyncracies of transient contemporary fashionable attitudes. In this lay his true genius as one of our greatest portrait painters.

Contents

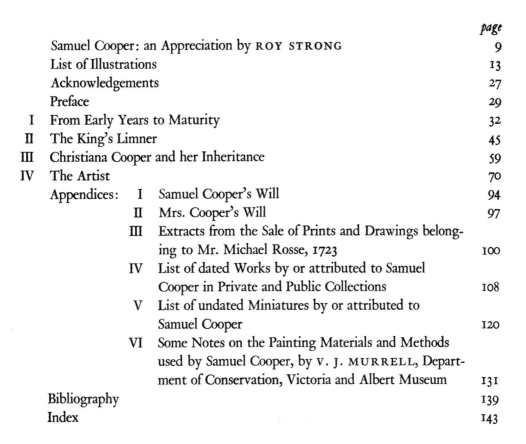

Illustrations

COLOUR PLATES

1. Possibly Sir R. Henley. *frontispiece*
 Vellum, oval, 72 × 59 mm. Signed with monogram and dated: *SC/1659.*
 The sitter was formerly called Edward Montagu, 1st Earl of Sandwich. The minia-
 ture is a particularly fine example of the artist's work.
 By courtesy of the Victoria and Albert Museum (Salting Bequest)

2. Self portrait of the artist, 1609–1672. *frontispiece*
 Vellum, oval, 70 × 56 mm. Signed with monogram and dated: *SC/1657.*
 This supposed portrait of Cooper shows him at an earlier age than the chalk
 drawing (monochrome illustration No. 59).
 By courtesy of the Victoria and Albert Museum (Dyce Bequest)

3. James II, as Duke of York, 1633–1701. *frontispiece*
 Vellum, oval, 83 × 65 mm. Signed with monogram and dated: *SC/1661.*
 This superb miniature, of which there are copies, was purchased at the sale of the
 Sotheby Heirlooms, Lot 44, Sotheby's, 11.10.1955. It was bought by James Sotheby
 on 6 March 1711. His account book records the purchase as follows: 'Pd for K.J.2ds
 Picture when Duke of York Aetat 28. A half length painted by Sam. Cooper in
 water colours & set in a gilt-metal frame; bought at Mr. Graham's Auction for
 me by Mr. James Seamer, Twenty guineas. £21.10.0.'
 By courtesy of the Victoria and Albert Museum

4. Henrietta, Duchess of Orleans, 1644–1670. *frontispiece*
 Vellum, oval, 72 × 56 mm. Signed with monogram: *SC.*

The Duchess, who was a great favourite of her brother Charles II, was described as: '. . . the centre of a thousand fetes and Madam of France'. She was said to have been poisoned with the connivance of her jealous husband.

By courtesy of the Victoria and Albert Museum (Salting Bequest)

5. Unknown lady, formerly called Princess Mary, 1631–1660. *facing page* 32
 Vellum, oval, 70 × 52 mm. Signed with monogram: *SC*.
 By courtesy of the Duke of Buccleuch and Queensberry, K.T.

6. Unknown lady. *facing page* 32
 Vellum, oval, 57 × 51 mm. Signed with monogram and dated: *SC/1655*.
 By courtesy of the Duke of Buccleuch and Queensberry, K.T.

7. Margaret Brooke, Lady Denham, *c.* 1647–1666. *facing page* 32
 Vellum, oval, 84 × 70 mm. Signed with monogram: *SC*.
 The sitter was at one time said to be Lady Heydon, but her date of death (1642) makes this impossible, and the coiffure is *c.* 1660–65. Margaret Brooke was the wife of Sir John Denham, 1615–1669, author of *Cooper's Hill*.
 By courtesy of the Duke of Buccleuch and Queensberry, K.T.

8. Unknown lady. *facing page* 32
 Vellum, oval, 70 × 57 mm. Signed and dated: *SC/1647*.
 The sitter was once erroneously identified as Elizabeth Vernon, Countess of Southampton.
 By courtesy of the Duke of Buccleuch and Queensberry, K.T.

9. Charles II, 1630–1685. *facing page* 48
 Vellum, rectangular, 190 × 162 mm. Signed with monogram and dated: *SC/1665*.
 This miniature was given by Charles II to Louise de Keroualle, Duchess of Portsmouth, mother of Charles Lennox, Duke of Richmond. An oval version of this miniature by Cooper, painted in the same year, is in the Mauritshuis, The Hague.
 By courtesy of the Trustees of the Goodwood Collection

10. James Scott, Duke of Monmouth and Buccleuch, K.G., 1649–1685. *facing page* 70
 Vellum, oval, 76 × 64 mm. Signed with monogram and dated: *SC/1667*.
 The sitter was at one time identified as Philip Stanhope, Earl of Chesterfield.
 By courtesy of the Duke of Buccleuch and Queensberry, K.T.

[14]

ILLUSTRATIONS

11. Mrs. John Claypole or Claypoole, née Elizabeth Cromwell, 1629–1658.

 facing page 70

 Vellum, oval, 70 × 57 mm. Signed with monogram and dated: *SC/1653*.
 Second daughter of Oliver Cromwell; married, 1646, John Claypole, parliamen-
 tarian. The sitter was at one time identified as her sister, Frances, Lady Russell,
 but the miniature is now thought to be Elizabeth.
 By courtesy of the Duke of Buccleuch and Queensberry, K.T.

12. (*called*) Barbara Villiers, Duchess of Cleveland, 1641–1709. *facing page 70*
 Vellum, oval, 86 × 70 mm. Signed with monogram: *SC*.
 By courtesy of the Duke of Buccleuch and Queensberry, K.T.

13. Frances Teresa Stuart, Duchess of Richmond, 1647–1702, in male dress.

 facing page 70

 Vellum, oval, 89 × 76 mm. Signed with monogram and dated: *SC/1666*.
 The background to the portrait has been left unfinished, and it differs from that in
 the collection of H.M. the Queen in several respects, including the fact that in this
 miniature the sitter is wearing a hat.
 By courtesy of the Mauritshuis, The Hague

MONOCHROME PLATES

(Plates 1–30 between pages 40–41)

1. Sir John Hamilton, 1605–1647. Third son of Thomas 1st Earl of Haddington.
 Vellum, oval, 57 × 46 mm. Attributed to Cooper on the basis of the style noted in
 some of his early works.
 By courtesy of the Earl of Haddington, K.T.

2. John, 6th Earl of Rothes, 1600–1641.
 Vellum, oval, 52 × 38 mm. Attributed to Cooper on the basis of the style noted in
 some of his early works.
 By courtesy of the Earl of Haddington, K.T.

[15]

3. Algernon Percy, 10th Earl of Northumberland, 1602–1668.
 Vellum, oval, 60 × 48 mm. Signed: *S.C.* After Van Dyck.
 By courtesy of the Victoria and Albert Museum

4. Henry Rich, 1st Earl of Holland, 1590–1649. Son of Robert, 1st Earl of Warwick.
 Vellum, oval, 118 × 98 mm. Painted *c.* 1630. Although an early eighteenth-century
 inscription on the reverse ascribes the miniature to 'old Hoskins', it is now attri-
 buted to Cooper on basis of style.
 By courtesy of the Victoria and Albert Museum (Ham House)

5. Unknown man.
 Vellum, oval, 114 × 89 mm. Painted *c.* 1630. Signed: *S.C.*
 By gracious permission of H.M. the Queen

6. Margaret Lemon (dressed as a young Cavalier).
 Vellum, oval, 120 × 99 mm. Signed: *S.C.* and inscribed with the sitter's name,
 Margaret (in monogram) and *LEMON*. Painted *c.* 1635–40. This important minia-
 ture of Van Dyck's mistress is one of the earliest known examples of Cooper's work.
 By courtesy of the Institut Néerlandais, Paris (Coll. F. Lugt)

7. Elizabeth Cecil, Countess of Devonshire, 1620–1689.
 Vellum, rectangular, 155 × 118 mm. Signed and dated: *Sa: Cooper pinxet A⁰:1642.*
 Second daughter of William Cecil, 2nd Earl of Salisbury, and wife of the 3rd Earl
 of Devonshire whom she married in 1639. Mother of Anne, wife of 5th Earl of
 Exeter, to whom she left this miniature in her will. This miniature is one of
 Cooper's earliest dated works.
 By courtesy of the Marquess of Exeter (Burghley House Collection)

8. Unknown lady.
 Vellum, oval, 70 × 64 mm. Signed: *S.C. fe/1643.*
 By courtesy of Mauritshuis, The Hague

9. Unknown lady.
 Vellum, oval, 73 × 60 mm. Signed: *S.C./1646.*
 By courtesy of the Cleveland Museum of Art, Ohio (Edward B. Greene Collection)

[16]

ILLUSTRATIONS

10. Colonel Robert Lilburne, 1613–1665.
Vellum, oval, 54 × 44 mm. Signed and dated: *SC./1650.*
By courtesy of the Syndics of the Fitzwilliam Museum, Cambridge

11. Unknown man, formerly called Robert Walker, d. 1658.
Vellum, oval, 68 × 51 mm. Signed and dated: *S: Cooper fe: 1645.* The gesso back
of the miniature bears an incised inscription by the artist: *Samuel Cooper fecit feberuaris
1644 ould stile.*
By gracious permission of H.M. the Queen

12. Unknown lady.
Vellum, oval, 74 × 60 mm. Signed and dated: *S.C./1648.*
By courtesy of the Victoria and Albert Museum (Salting Bequest)

13. General George Fleetwood, 1605–1667.
Vellum, oval, 57 × 45 mm. Signed and dated: *SC./1647.*
By courtesy of the National Portrait Gallery

14. Hugh May, 1622–1684 (architect).
Vellum, oval, 67 × 54 mm. Signed and dated: *SC./1653.*
By gracious permission of H.M. the Queen

15. John, 1st Baron Belasyse, 1614–1689, 1st Baron Belasyse of Worlaby.
Vellum, oval, 118 × 102 mm. Signed and dated: *S. Cooper. f. 1646.* The identity of
this sitter as Belasyse has been disputed by Oliver Millar, who considers it in-
correct after comparison with the features of Belasyse on a large portrait.
By courtesy of The Duke of Buccleuch and Queensberry, K.T.

16. (*called*) Abraham Cowley, 1618–1667.
Vellum, oval, 64 × 51 mm. Signed and dated: *SC./1653.* The identification of the
sitter is doubtful. (Cat. No. 59.)
By courtesy of the Duke of Portland, K.G.

17. Robert Dormer, 1629–1694.
Vellum, oval, 65 × 48 mm. Signed and dated: *SC./1650.* By family descent. An MS
at Rousham records that Dormer paid £12 to Mr. Cooper on 8 September 1650.
Robert Dormer was the brother of William Dormer, c. 1631–1683, of whom there

is also a Cooper miniature; he was High Sheriff of Oxfordshire, 1666, and married Annamara, daughter of Edmund Waller, the poet.
By courtesy of T. Cottrell-Dormer, Esq.

18. George Monck, 1st Duke of Albemarle, K.G. 1608-1670.
Vellum, oval, 57 × 48 mm. Signed with monogram: *SC.*
By courtesy of the Duke of Buccleuch and Queensberry, K.T.

19. Sir Justinian Isham, 1611-1675. Son of Sir John Isham.
Vellum, oval, 64 × 51 mm. Signed: *S.C./1653.* The sitter suffered severely for his loyalty to Charles I, and was fined and imprisoned several times. M.P. for North-ampton 1661–1675. By family descent.
By courtesy of Sir Gyles Isham, Bt.

20. Anne Stephens, Lady Pye, d. 1722. Wife of Sir Charles Pye.
Vellum, oval, 70 × 54 mm. Signed: *S.C.* (Cat. No. 61.)
By courtesy of the Duke of Portland, K.G.

21. Oliver Cromwell, 1599–1658.
Vellum, oval, 80 × 64 mm. Unfinished sketch. Painted *c.* 1650. One of Cooper's most important works, from which a number of finished versions were painted. From the collection of Sir Thomas Frankland, great-grandson of Oliver Cromwell, purchased from connections of his descendants by the 5th Duke of Buccleuch.
By courtesy of the Duke of Buccleuch and Queensberry, K.T.

22. Mrs. Oliver Cromwell, née Elizabeth Bourchier, d. 1665. Wife of Oliver Cromwell.
Vellum, oval, 70 × 57 mm. Signed and dated: *S.C./1651.*
By courtesy of the Duke of Buccleuch and Queensberry, K.T.

23. General Henry Ireton, 1611–1651. Regicide; supported Cromwell, whose daughter Bridget he married in 1646.
Vellum, oval, 50 × 40 mm. Signed and dated: *S.C./1649.*
By courtesy of the Syndics of the Fitzwilliam Museum, Cambridge

24. (*called*) Mary Fairfax, Duchess of Buckingham, 1638-1704. Only daughter of Thomas, Lord Fairfax, and wife of George Villiers, 2nd Duke of Buckingham, 1628-1687.
Vellum, oval, 64 × 51 mm. Signed in monogram: *SC.*
By courtesy of the Duke of Buccleuch and Queensberry, K.T.

25. Mrs. John Claypole, née Cromwell, 1629–1658. Wife of John Claypole or Claypoole, d. 1688. Second daughter of Oliver Cromwell.
Vellum, oval, 67 × 57 mm. Signed and dated: *SC./1653.*
By courtesy of the Trustees of the Chatsworth Settlement

26. Unknown lady, formerly called Lucy Percy, Countess of Carlisle, 1599–1660. Ex. Sotheby Heirlooms.
Vellum, oval, 64 × 51 mm. Unsigned.
By courtesy of the Institut Néerlandais, Paris. (Coll. F. Lugt)

27. The Rev. Thomas Staresmore or Stairsmore, d. 1706. Vicar of Edmonton.
Vellum, oval, 62 × 49 mm. Signed with monogram and dated: *SC/1657.*
By courtesy of the Syndics of the Fitzwilliam Museum, Cambridge

28. Unknown lady.
Vellum, oval, 57 × 51 mm. Signed with monogram and dated: *SC./1656.* Ex. Harry Seal Collection.
By courtesy of E. Grosvenor Paine, U.S.A.

29. John Holles, 2nd Earl of Clare, 1595–1666.
Vellum, oval, 65 × 52 mm. Signed with monogram and dated: *SC./1656.* (Cat. No. 58).
By courtesy of the Duke of Portland, K.G.

30. Sir John Carew, d. 1660.
Vellum, oval, 89 × 64 mm. Unsigned.
By courtesy of Col. Sir John Carew Pole, Bt.

(Between pages 56–57)

31. Barbara Villiers, Countess of Castlemaine, and later Duchess of Cleveland, 1641–1709. Wife of Roger Palmer, Earl of Castlemaine.
Vellum, oval, 89 × 70 mm. Signed with monogram and dated: *SC/166-[3?]*, the last numeral being truncated.
By courtesy of the Earl Spencer

32. Anthony Ashley, 2nd Earl of Shaftesbury, 1652–1699.
Vellum, oval, 83 × 67 mm. Unsigned. Painted *c.* 1665. The sitter was at one time wrongly identified as James Scott, Duke of Monmouth, and as such purchased by the late Queen Mary.
By courtesy of the Victoria and Albert Museum

33. Unknown young man.
 Vellum, oval, 65 × 52 mm. Unsigned. (Cat. No. 63.)
 By courtesy of the Duke of Portland, K.G.

34. Lady Smyth, of Ashton Court, Bristol. Wife of Sir Hugh Smyth.
 Vellum, oval, 83 × 67 mm. Signed with monogram: *SC*.
 By courtesy of T. Cottrell-Dormer, Esq.

35. Barbara Villiers, Duchess of Cleveland, 1641–1709. Married Roger Palmer in
 1659; became the mistress of Charles II in 1660; her husband was created Earl of
 Castlemaine in 1661, and in 1670 she was created Duchess of Cleveland.
 Vellum, oval, 80 × 64 mm. Signed with monogram and dated: *SC/1661*. A sketch
 for the head by Cooper is also in the Royal collection.
 By gracious permission of H.M. the Queen

36. Sir Thomas Hanmer, 1612–1678. Page and cup-bearer at the Court of Charles I,
 a man of taste and an eminent horticulturist.
 Vellum, oval, 73 × 57 mm. Unsigned. By family descent.
 By courtesy of Colonel R. G. Hanmer

37. Unknown man.
 Vellum, oval, 72 × 60 mm. Signed with monogram: *SC*. (Cat. No. 57.)
 By courtesy of the Duke of Portland, K.G.

38. Anne Hyde, Duchess of York, 1637–1671. Eldest daughter of Edward Hyde, later
 Earl of Clarendon. Maid of Honour to the Princess of Orange, 1654. Privately
 married to James, Duke of York, 1633–1701, London, 1660.
 Vellum, oval, 57 × 48 mm. Unsigned.
 By courtesy of the Earl Beauchamp

39. John Maitland, 1st Duke of Lauderdale, 1616–1682.
 Vellum, oval, 89 × 70 mm. Signed with monogram and dated: *SC/1664*.
 By courtesy of the National Portrait Gallery

40. Frances Teresa Stuart, Duchess of Richmond, 1647–1702, in male dress. Married
 Charles Stuart, 3rd Duke of Richmond in 1667. Was known as 'La Belle Stuart' and
 is believed to have been the model for the figure of Britannia on the copper coinage.

Vellum, oval, 98 × 73 mm. Signed with monogram and dated: *SC/166-* (the last numeral being trimmed away).
By gracious permission of H.M. the Queen

41. (*called*) John Maitland, 1st Duke of Lauderdale, 1616–1682.
Vellum, oval, 89 × 70 mm. Signed with monogram and dated: *SC./1666.*
By courtesy of the Earl of Jersey

42. Unknown man, in armour.
Vellum, oval, 70 × 57 mm. Unsigned.
By courtesy of T. Cottrell-Dormer, Esq.

43. Unknown lady, formerly called Lady Lucy Percy.
Vellum, oval, 67 × 57 mm. Signed with monogram: *SC.*
By courtesy of the Syndics of the Fitzwilliam Museum, Cambridge

44. Sir Frescheville Holles, 1641–1672.
Vellum, oval, 79 × 65 mm. Signed with monogram and dated: *SC/1669.* (Cat. No. 60.)
By courtesy of the Duke of Portland, K.G.

45. Unknown man, formerly called Henry Jermyn, Lord Dover.
Vellum, oval, 76 × 64 mm. Signed with monogram and dated: *SC/1667.*
By courtesy of the Ashmolean Museum, Oxford (Bentinck Hawkins Bequest)

46. Anthony Ashley Cooper, 1st Earl of Shaftesbury, 1621–1683.
Vellum, rectangular, 210 × 168 mm. Signed with monogram: *SC.* This important miniature is one of the few painted by Cooper showing the sitter's hands. Illustrated by Foster, Vol. I, Pl. XXXVI, but erroneously said to be at the Victoria and Albert Museum. The robes the Earl is wearing are generally considered to be those of the Lord Chancellor, an office not held by Shaftesbury before November 1672. Unless the robes were finished by another hand, it is presumed that they are those of Chancellor of the Exchequer, which office Shaftesbury held from 1661.
By courtesy of the Trustees of the Shaftesbury Estates

(*Between pages 72–73*)

47. (*called*) Lady Hardinge. Possibly Anne, wife of Sir Robert Hardinge, d. 1679
Vellum, oval, 89 × 70 mm. Signed with monogram and dated: *SC/1664.* This miniature is previously unrecorded, and is another rare example of the artist painting hands.
By courtesy of T. Fetherstonhaugh, Esq.

48. Charlotte Paston, Duchess of Yarmouth, *c.* 1650–1684. Illegitimate daughter of Charles II by Elizabeth, Lady Shannon. Married first James Howard d. 1669, and secondly, in 1672, William Paston, Earl of Yarmouth.
Vellum, oval, 83 × 70 mm. Signed with monogram: *SC* and inscribed on the reverse in a seventeenth-century hand: *Lady Paston by Sam: Cooper.*
By courtesy of the Duke of Buccleuch and Queensberry, K.T.

49. Gilbert Sheldon, 1598–1677, Archbishop of Canterbury.
Vellum, rectangular, 114 × 86 mm. In a contemporary silver filigree frame, with mitre and monogram GC on the reverse. Acquired by Edward Harley, 2nd Earl of Oxford, in 1726; in his *Memoranda* the Earl notes: '1726 March- paid 25 Gs for the picture of ABp Sheldon'. (Cat. No. 68.) A replica of this miniature, signed and dated 1667, is in the Walters Art Gallery, Baltimore, Maryland.
By courtesy of the Duke of Portland, K.G.

50. Unknown man, wearing a breastplate.
Vellum, oval, 75 × 59 mm. Unsigned. This miniature was at one time attributed to T. Flatman, but is undoubtedly by Cooper.
By courtesy of the Ashmolean Museum, Oxford

51. Frances Manners, Countess of Exeter, 1630–1669. Daughter of the 8th Earl of Rutland, and first wife of the 4th Earl of Exeter.
Vellum, oval, 80 × 64 mm. Unsigned.
By courtesy of the Marquess of Exeter (Burghley House Collection)

52. Jane Penruddock. b. *c.* 1618.
Vellum, oval, 72 × 59 mm. Unsigned and unfinished. The name of the sitter is scratched on the reverse of the gold locket.
Author's collection

53. Unknown man, formerly called John Wilmot, Earl of Rochester.
Vellum, oval, 83 × 64 mm. Unsigned.
By courtesy of the Ashmolean Museum, Oxford (de la Hey Bequest)

54. Penelope Compton, Lady Nicholas *or* Alice Fanshawe, Lady Bedell.
Vellum, oval, 89 × 70 mm. Signed with monogram: *SC.*
By courtesy of the Duke of Buccleuch and Queensberry, K.T.

55. Thomas Hobbes, 1588–1679. Philosopher; for twenty years tutor and secretary to William Cavendish, later 2nd Earl of Devonshire, and his son; and was mathematical tutor to Charles II.
Vellum, oval, 67 × 57 mm. Unsigned and unfinished.
By courtesy of the Cleveland Museum of Art, Ohio (Edward B. Greene Collection)

56. Lady Elizabeth Percy.
Vellum, oval, 73 × 60 mm. Unsigned. Mentioned in the Countess of Devonshire's will, and on an indenture dated 18 April 1690.
By courtesy of the Marquess of Exeter (Burghley House Collection)

57. Charles II, 1630–1685.
Vellum, oval, 92 × 76 mm. Unsigned and unfinished. A small finished version, signed with monogram: *SC* is in the collection of the Duke of Portland (Cat. No. 56).
By courtesy of D. E. Bower, Esq., Chiddingstone Castle Collection

58. Mrs. Samuel Cooper, née Christiana Turner, 1623?–1693. Daughter of William Turner of York, and sister of Edith Pope, mother of Alexander Pope, the poet. The date of her marriage to Samuel Cooper is unknown.
Vellum, rectangular, 89 × 73 mm. Unsigned and unfinished. The miniature is one of Cooper's outstanding works. Acquired by Edward, Lord Harley, later 2nd Earl of Oxford, for £26 at the sale of the collection of L. Cross(e), the miniaturist, 5.12.1722. (Cat. No. 71.)
By courtesy of the Duke of Portland, K.G.

59. Samuel Cooper, 1609–1672. Self portrait?
Pastel, rectangular, 245 × 194 mm. This portrait is believed to have been in the Royal Collection at Kensington, and according to Walpole, was by Jackson, a relative of Cooper. Basil Long and others have accepted it as a genuine self portrait, and although the matter is still in dispute the work is very much in Cooper's style.
By courtesy of the Victoria and Albert Museum (Dyce Bequest)

(Between pages 88–89)

60. Charles II, 1630–1685.
Red and black chalk on brown paper, rectangular, 175 × 140 mm. This profile drawing of the King is one of two drawings almost identical, drawn by Cooper for his 'Inauguration Medal'. Evelyn in his Diary, 10 January 1662, refers to 'Being

[23]

called into His M's Closet where Mr. Cooper yᵉ rare limner, was crayoning of the King's face and head to make the stamps for the new milled money now contriving . . .'

Collections: Richardson (father and son).

By gracious permission of H.M. the Queen

61. Thomas Alcock.

Black chalk, rectangular, 178 × 114 mm. Probably drawn *c.* 1655. Inscribed on the back-board of the frame: *This Picture was drawne for mee at the Earle of Westmorelands house at Apethorpe . . . by the Greate (tho' little) Limner, The then famous Mr. Cooper of Covent Garden: when I was eighteen years of age Thomas Alcock preceptor.* Bequested to Oxford University by Dr. Rawlinson in 1755 and transferred to the Ashmolean Museum in 1897.

By courtesy of the Ashmolean Museum, Oxford

62. Mrs. Hoskins.

Chalk, rectangular, 280 × 228 mm. Signed: *S C.* on the left of the drawing, and *SC* (monogram) on r. Inscribed on the reverse: *Mrs Hoskins.* The sitter is presumably the wife of John Hoskins, d. 1665, the miniaturist, and aunt of the artist. Collection: Miss Tower, of Weald Hall, Essex, grandmother of the present owner. Another drawing of the sitter, unsigned, is in the same collection.

Private collection

63. John Hoskins, jun.?

This drawing is on the reverse of No. 64. A Dead Child. Part of the man's hat has been cut off. Chalk, rectangular, 178 × 127 mm. Inscribed bottom left: *Dead: Child,* and underneath in another hand: *Mʳ S:C: child done by him.* On the right side bottom, in the same hand as the latter inscription: *N.B. ye son of Old Mʳ Hoskins' son.*

Private collection

64. A Dead Child.

This drawing is on the reverse of No. 63, and is probably the son of John Hoskins, junior.

Chalk, rectangular, 127 × 178 mm.

Private collection

65. Catherine of Braganza, 1638–1705. Daughter of King John IV of Portugal, married Charles II in 1662.

Vellum, oval, 124 × 98 mm. Unfinished sketch.

Mentioned in a list of works by Cooper, belonging to his widow in 1677 and which were being offered to Cosimo III of Tuscany. Possibly bought by Charles II from Mrs. Cooper. In Queen Caroline's collection, St. James's Palace, 1743. One of five important large-scale sketches which Cooper made, and from which repetitions could be executed.

By gracious permission of H.M. the Queen

66. Barbara Villiers, Duchess of Cleveland, 1641–1709.
Vellum, oval, 124 × 98 mm. Unfinished sketch. Collection: as for No. 65.
By gracious permission of H.M. the Queen

67. George Monck, 1st Duke of Albemarle, 1608–1670.
Vellum, oval, 124 × 98 mm. Unfinished sketch. This portrait was one which Cosimo III remembered seeing at the artist's studio, and was anxious to obtain after his death, but which among others, his London agent advised him against purchasing. Collection: as for Nos. 65 and 66.
By gracious permission of H.M. the Queen

68. Frances Teresa Stuart, Duchess of Richmond, 1647–1702.
Vellum, oval, 124 × 98 mm. Unfinished sketch. Presumably the sketch of the Duchess of Richmond, aged 16 or 17, on the list supplied to Cosimo III, giving the date of the portrait as *c.* 1663–64. Collection: as for Nos. 65, 66 and 67.
By gracious permission of H.M. the Queen

69. James Scott, Duke of Monmouth and Buccleuch, K. G., 1649–1685, as a boy. Natural son of Charles II by Lucy Walter. Married Anne Scott, Countess of Buccleuch, and took the surname of Scott, 1663. Executed in the Tower of London, 15 July 1685.
Vellum, oval, 124 × 98 mm. Unfinished sketch. Collection: as for Nos. 65, 66, 67, and 68. A copy of this portrait, thought to be by S. P. Rosse, is in the collection of the Duke of Buccleuch.
By gracious permission of H.M. the Queen

70. Henrietta, Duchess of Orleans, 1644–1670. Sister of Charles II, and fifth daughter of Charles I. Married Philippe duc d'Orleans, 1661.
Vellum, oval, 70 × 57 mm. Signed with monogram and dated: *SC/1670*.

This miniature of 'Minette', is identified as such by comparison with the full-length portrait by Sir Peter Lely, given by Charles II to the City of Exeter in 1672, and now in the Guildhall, Exeter.
By courtesy of Mauritshuis, The Hague

71. Henry Sidney, Earl of Romney, 1641–1704.
Vellum, oval, 83 × 64 mm. Signed with monogram and dated: *SC/1669.*
Acquired by Edward, Lord Harley at the sale of L. Crosse, the limner, 5 December 1722. Bishop Burnet says of him 'he was so set on pleasure, that he was not able to follow business with a due application'. (Cat. No. 62.)
By courtesy of the Duke of Portland, K.G.

72. Lord Clifford of Chudleigh, 1630–1673.
Vellum, oval, 83 × 67 mm. Signed with monogram and dated: *SC*; inscribed on the reverse by the artist: *Sr Thomas Clifford 1672. Æta: 42 Sam: Cooper fecit.* By family descent to the sitter's grand-daughter Anne Clifford to John Gage, 1818. Thomas Clifford became in 1672 1st Lord Clifford of Chudleigh and Lord High Treasurer; he served as a member of the Cabal ministry. The miniature is of great importance, being painted in the last year of the artist's life.
By courtesy of Lord Clifford of Chudleigh

73. Unknown lady.
Vellum, oval, 76 × 64 mm. Signed with monogram and dated: *SC/1671.*
The sitter, whose true identity is still not known, has been called Charlotte de la Tremouille, Countess of Derby, and Margaret Leslie, Lady Balgony.
By courtesy of the Duke of Buccleuch and Queensberry, K.T.

74. Henry Bennet, 1st Earl of Arlington, K.G., 1618–1685.
Vellum, oval, 228 × 178 mm. Unsigned.
This miniature is an interesting example of a portrait by Cooper which has been added to after the artist's death. It is impossible to be sure whether it was left unfinished, but part of the robes, orders and insignia must have been added after 1674, in which year the sitter became Lord Chamberlain. They were probably painted by Susan Penelope Rosse. The miniature is by family descent to the present owner.
By courtesy of Lady Cecilia Howard

Acknowledgements

I should like to express my gratitude to the large number of people who have assisted me with my research, and from whom I have received so much encouragement, without which I could not have embarked on what seemed at first a daunting task. In particular I wish to record my gratitude to the late C. Kingsley Adams, to whom this work is dedicated, for it was his enthusiasm and kindly wisdom which, during a period of over twenty years, encouraged my research and spurred me on to further activities. A special word of thanks is also due to Mr. V. J. Murrell, of the Conservation Department in the Victoria and Albert Museum, for so kindly providing the notes on Samuel Cooper's technique which form appendix VI of this book.

I am particularly grateful to the following people who have helped my research, allowed me access to their notes relating to Cooper, or advised me regarding my manuscript:

Mr. Edward Archibald of the National Maritime Museum, Greenwich; Miss H. Hilton-Simpson; Mr. Robin Hutchison of the Scottish National Portrait Gallery, Edinburgh; Mr. A. J. B. Kiddell of Messrs. Sotheby & Co.; Sir Oliver M. Millar, K.C.V.O., Surveyor of the Queen's Pictures; Mr. V. J. Murrell of the Conservation Department, Victoria and Albert Museum, London; Mr. David Piper, Keeper of the Ashmolean Museum, Oxford; Mr. R. Bayne Powell; Mr. Graham Reynolds, Keeper of Prints and Drawings, Victoria and Albert Museum, London; Dr. Roy Strong, Director of the National Portrait Gallery, London; M. Carlos van Hasselt of the Institut Néerlandais, Paris; and Miss Hermione Waterfield of Messrs Christie, Manson and Woods.

The illustrations have been selected from as wide a number of collections as possible, and I am indebted to the following owners for their generosity in allowing me to reproduce the portraits, and for their unfailing help in allowing me to examine the miniatures

[27]

in their possession. The illustrations will, I have no doubt, show Cooper's mastery of one of the finest arts in the world.

H.M. the Queen; H.M. Queen Juliana of the Netherlands; the Ashmolean Museum, Oxford; the Earl Beauchamp; Mr. D. E. Bower; the Duke of Buccleuch and Queensberry, PC, KT, GCVO; the Trustees of the Chatsworth Settlement; Messrs Christie, Manson & Woods, London; the Cleveland Museum of Art, Ohio, USA (E. B. Greene Collection); Lord Clifford of Chudleigh; the Marquess of Exeter, KCMG; Mr. T. Fetherstonhaugh; the Fitzwilliam Museum, Cambridge; the Earl of Haddington, KT; Col. R. G. Hanmer; Mr. A. H. Harford; Lady Cecilia Howard; Mr. George Howard; the Institut Néerlandais, Paris; Sir Gyles Isham, Bt; the Earl of Jersey; the Koninklijk Kabinet van Schilderijn, Mauritshuis, The Hague; the National Portrait Gallery, London; the Nelson Gallery, Atkins Museum, Kansas City, USA (Starr Collection); Mr. E. Grosvenor Paine, USA; Col. Sir John Carew Pole, Bt; the Duke of Portland, KG; Mrs. L. Schott-Holscheiter, Meilen; the Earl of Shaftesbury; Messrs Sotheby & Co., London; the Earl Spencer; Mr. and Mrs. J. W. Starr, Kansas City, USA; the Victoria and Albert Museum, London, and Mr. R. Williams of the British Museum.

One of the difficulties in obtaining colour reproductions has been, as always, the problem of accessibility for photography and the ever-rising cost of obtaining the transparencies. I am grateful to the owners who have made this possible, and to the staff of Messrs A. C. Cooper, for their unfailing help in carrying out the work.

I should also like to record my thanks to those who have given me invaluable assistance in checking material and proofs and preparing the book for publication. I am particularly grateful to Miss Eileen Brooksbank of Faber and Faber Ltd., Mrs. F. Herrmann, Miss Barbara Priss, Miss D. M. Kleinfeldt and Mrs. Knowles.

Preface

An up-to-date study of the great miniaturist Samuel Cooper has been long overdue, for his importance in the world of art is not confined to Britain alone. Even in his lifetime his reputation had spread throughout the continent of Europe, and he is still considered to be one of the finest, if not the finest portrait painter of his era.

It is now fifty-five years since the late J. J. Foster published his book *Samuel Cooper and the English Miniature Painters of the XVII Century*, in which he gave such fragments of biographical information as were then known, and a list of a large number of miniatures by, or thought to be by, Cooper, and additional information about other artists who were his contemporaries.

Only 150 copies are said to have been issued, and in consequence only a limited number of museums and libraries possess one. This means that the serious collector or student has never had easy access to the work.

B. S. Long in *British Miniaturists*, 1929, gave what was then far the most comprehensive account of Cooper's life and work, which is still invaluable. More recently other important information has come to light. Professor A. M. Crinò, through her study of the life of Cosimo III of Tuscany, has made a major contribution to our knowledge of the relationship between the Court of Cosimo III and Cooper; and Oliver Millar was able to identify the large miniature of Cosimo by Cooper, which had been believed to be lost, and which he discovered in the Uffizi.

In 1960 Graham Reynolds assembled eighty-two miniatures and five drawings by Cooper, which were exhibited at *The Age of Charles II*, held at the Royal Academy, London. This provided a unique opportunity of studying the artist's work throughout the greater part of his working life.

In an article published in the *Connoisseur*, February, 1961, Graham Reynolds dis-

cussed Cooper's work in the light of the exhibition, which he rightly said 'provided an opportunity for a new assessment of his work'. In 1965 I was fortunate enough to be allowed to exhibit twenty-eight miniatures by Cooper at *The British Portrait Miniature Exhibition*, in Edinburgh, sponsored by the Scottish Arts Council. Here again the miniatures came largely from private collections and some of the items had never previously been exhibited. Many of the 6,000 people who visited the exhibition had never had the opportunity of seeing such a comprehensive collection of miniatures, and it was immediately apparent that Cooper's portraits were among those that created the greatest interest.

It is in the light of the knowledge gained from such exhibitions, and from handling Cooper's miniatures over a great number of years that I have ventured to write this biography.

It has been suggested that I should compile a *catalogue raisonné*, but after giving the matter serious consideration I decided that any author embarking on such a project would need to be free to travel extensively in order to verify information and examine collections, and that I would not be able to spare the time and expense involved.

It is to be hoped, however, that such a catalogue will one day be undertaken, for it would prove of immense value, and add greatly to our knowledge of Cooper's contacts. It is not a task to be undertaken lightly, as the total absence of any contemporary list of sitters would make it essential for all the miniatures by, or attributed to Cooper to be examined and compared before any conclusions could be made. The fact that the greater number of Cooper's known miniatures are still in private collections not normally available to the public, makes this task even more difficult.

Because of the desirability of Cooper's portraits it soon became worthwhile for people to add his signature indiscriminately to works executed by his followers, or copyists, and to attribute to him almost any miniature of the period. Many of these attributions or false signatures date back to the end of the seventeenth century or early eighteenth century, and such portraits are still frequently met with in well-known collections where the accuracy of the attributions have never been questioned.

The task of sifting out all the documentation relevant to Cooper's work would be extremely difficult, and in any event one could not hope to make any catalogue complete.

In this present work, I have not attempted to do more than assemble all the available material regarding Cooper's life, family, important patrons and contacts together with an up-to-date appraisal of his achievements. In the course of my research I have examined Cooper's will and that of his wife Christiana, and this has been the means of

publishing certain facts relating to the family which have been previously overlooked.

I have as far as possible examined the majority of works by Cooper in private and public collections in Britain, on the Continent and in the U.S.A., and have compiled a check-list of miniatures which are by, or said to be by, him, and details of the collections in which they were or are contained. This list does not claim to be exhaustive, and in certain cases it has not been possible to trace the portraits, as all too often the collections have changed hands and records have not been kept, or the present owners do not wish their names disclosed.

Unfortunately, the sitters depicted on a large number of Cooper's miniatures are still unidentified, and others are probably inaccurately named. The problem of establishing with certainty their true identity is a difficult one, and constant research and comparison is necessary to bring information up to date. The names given to portraits in early collections and catalogues are frequently based on wishful thinking or on family traditions which have been handed down without question. The fact that so many miniatures are in private collections many of which are not photographed, or, if they are, for obvious reasons are not available to the public, means that only a few students of miniature painting have the time or opportunity to examine them and make comparisons with authenticated portraits, thus making the necessary corrections.

This biography had already been accepted for the press when I received an invitation from Dr. Roy Strong to arrange an exhibition of works by Samuel Cooper at the National Portrait Gallery, London, early in 1974. This exhibition will I hope demonstrate how Cooper's style developed away from that of the Hilliard, Oliver or Hoskins tradition into one which was both freer and more ambitious in its conception, and well able to hold its own against the large portraits of the period painted by Van Dyck, Lely and others.

It is my hope that this biography will prove useful and of interest to all those who appreciate miniature painting, or who are students of seventeenth-century art, and that its publication will serve as a small appreciation of this great artist, the ter-centenary of whose death we commemorated in May 1972.

CHAPTER ONE

From Early Years to Maturity

It is now three hundred years since the great miniaturist Samuel Cooper died, and it seems fitting that the occasion should be marked by a brief survey of his work, and the unique position that he held during a difficult period of British history.

That Cooper's art played a significant part in the history of miniature painting has never been questioned, and the esteem in which he was held by his contemporaries can best be summed up in the words of Charles Beale, who recorded in his diary that on 'Sunday, May 5, 1672, Mr. Samuel Cooper, the most famous limner of the world for a face, died'.

Whether one accepts this assessment or not, there is no doubt at all that Cooper rightly deserves his position as the greatest English-born painter of the seventeenth century, and this irrespective of scale or medium.

From what is known about him, Cooper was obviously a man of culture with varied gifts, was a good linguist, a keen traveller and an accomplished musician. He was evidently found to be good company and had a wide circle of friends both in Britain and on the Continent, where he made important contacts.

Despite the fact that Cooper was undoubtedly a man of some standing and had the *entrée* into both artistic and literary circles, nothing has yet been discovered about his early life, birth or parentage, and any knowledge we have of his personal qualities is derived from brief glimpses of him recorded by a handful of friends and patrons.

The inscription placed on his tombstone provides us with his date of birth as 1609, as it is stated that when he died in 1672 he was in his 63rd year.

Various suggestions have been put forward as to his possible ancestry, but nothing positive has so far come to light. B. S. Long surmised that he might have been a son of

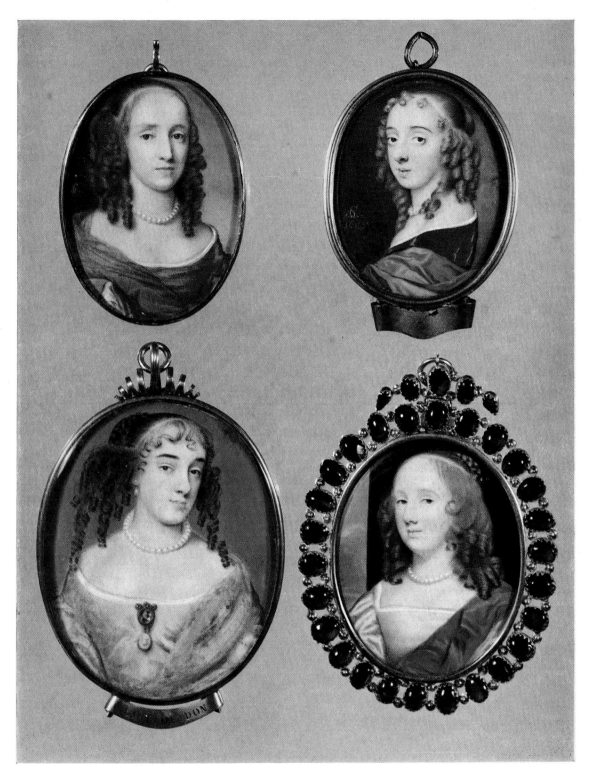

5. Unknown lady formerly called Princess
 Mary, 1631–1660. 70×52 mm.

6. Unknown lady. 57×51 mm.

7. Margaret Brooke, Lady Denham,
 c. 1647–1666. 84×70 mm.

8. Unknown lady. 70×57 mm.

John Cooper or Coperario (1570?–1626/7), a composer and lutenist, basing the suggestion on the fact that Cooper was 'reckon'd one of the best Lutenists . . . in his time'.

Other authorities point out that the name Cooper or Cowper or Kuyper was one commonly met with among the Dutch refugees who were in London at that time, and that Cooper might well have been connected with one of the families of Dutch jewellers who had links with the Continent, and if so this would explain Cooper's fluency in foreign languages and his friendship with people of importance abroad.

One fact about which we can be certain is that Samuel Cooper and his brother Alexander (d. 1660?) were nephews of the miniaturist John Hoskins (d. 1665), and that they were 'bred up' under his care and discipline.

The reason for the boys being made Hoskins' wards is unknown, and it is generally believed that they eventually became his apprentices and received their early training in limning under him. The exact relationship between the Cooper and Hoskins families is uncertain: it has been suggested that Alexander and Samuel Cooper's mother was Hoskins' sister, but it is also possible that Mrs. Hoskins' maiden name might have been Cooper. Biographical information about the Hoskins family is as scanty as that of Cooper's. John Hoskins, by his wife Sarah, had a son John, who almost certainly painted miniatures, or at least assisted his father in his studio, and who, if so, must have worked with his cousins Samuel and Alexander, and was probably about the same age.

It is not known whether there were other Hoskins children, apart from John junior. A fascinating miniature, thought to be a self portrait of Hoskins senior, is in the collection of the Duke of Buccleuch, and has a sketch on the reverse, supposedly of Hoskins and his wife and four children, two of whom may have been Alexander and Samuel Cooper. The sketch is inscribed in ink: *J Hoskins by/himself*, and signed on the front.

For many years there has been controversy over the question as to whether or not Hoskins junior painted miniatures, and attempts have been made to distinguish between the two men on grounds of style and signatures, but without a fully signed miniature by the younger man no final conclusion can be reached. For the present the only portrait which can justifiably be ascribed to the younger Hoskins is the supposed self portrait in the collection of the Duke of Buccleuch, signed and dated: *IH 1656*, and inscribed *Ipse* (= self), which if the date is correct must from the appearance of the sitter represent Hoskins junior. A drawing by Samuel Cooper also thought to be of the younger Hoskins is not unlike the man represented in the Buccleuch collection. For the present, with the exception of this latter portrait, all miniatures attributed to Hoskins are taken to be the work of John Hoskins senior.

Hoskins made his will on 30 December, 1662, at his house 29 Bedford Street, Covent Garden, of which he was the first occupant from 1634 until his death, and where in all probability Samuel Cooper lived for a time. Hoskins left 'unto my welbeloved son John Hoskins . . .' twenty pounds, to buy himself a ring 'or otherwise dispose of the same as he shall think good or fitt'. Everything else that he possessed he left to his wife Sarah, who was his sole executrix.

On 15 February, 1664, Hoskins added a memorandum confirming the disposition of his goods and property to his wife and describes himself as 'John Hoskins living in Bedford Street in or neare the Covent Garden in the County of Middlesex the Elder Limner'. From this wording it rather suggests that John junior was a miniaturist as has been indicated, and that his father was afraid that there might be some confusion over identification.

Nothing has been recorded about Alexander Cooper's early life or the length of time that he spent in Hoskins' home and studio, and one is frustrated by the lack of any significant information about his career. Unlike most artists of the period who came to Britain to practise their art, Alexander went abroad sometime before or in 1631, and appears to have remained on the Continent for the rest of his life. He was already skilled in miniature painting and soon found patronage at the courts of Holland, Denmark and Sweden. He is said to have had some instruction from Peter Oliver (c. 1594–1647), as well as from his uncle, and his fondness for lilac and other subdued backgrounds may well reflect the influence of Oliver rather than that of Hoskins, although the latter artist occasionally used a lilac background in his earlier works.

Only a small number of signed works by Alexander Cooper are known; these are signed with his initials *AC* on the background. He is said to have been skilful in painting landscapes in water-colour, and to have painted in oil. Although he painted miniatures from the life, the fact that he worked for so many years on the Continent probably meant that he was obliged to make miniature copies in oil from large portraits to a greater extent than would have been the case in Britain.

Details of Samuel Cooper's early life are no less obscure than those of Alexander's; the first positive information regarding his time with Hoskins is provided in the de Mayerne MS. No. Sloane 2052, in the British Museum. This describes how, in 1634, Sir Theodore Turquet de Mayerne, Charles I's Swiss physician, visited Hoskins in his studio where he met Cooper, and being interested in the technical aspect of painting got him to write down for him a recipe for preparing lead white. This recipe is preserved with the de Mayerne MS, it is in Samuel Cooper's own hand, and is, apart from signa-

tures on his miniatures, the only known autograph of his in existence.

It has not so far been possible to trace where the Hoskins family lived during Cooper's early years, but as we know, in 1634 John Hoskins became the first occupant of 29 Bedford Street, Covent Garden, for which he held a thirty-one-year lease, and where he lived until his death in 1664/5. It seems probable, therefore, that de Mayerne went to this house to see Hoskins in 1634, when he noted that Cooper was working with his uncle.

In spite of the fact that Hoskins was well patronised by Charles I and his court, Cooper appears to have gained in popularity, and as a result Hoskins became jealous of his nephew and in an effort to recover his own position, took Cooper into partnership with him. This was evidently not a success, and an account of the episode and of Cooper's art is given by B. Buckeridge, appended to *The Art of Painting and the Lives of the Painters*, translated from the French of de Piles, 1706. It reads as follows:

Samuel Cooper Esq;
Was born in London in the Year 1609, and was brought up under his uncle, Mr. Hoskins. He was a performer in miniature, of whom our nation can never sufficiently boast, having far exceeded all that went before him in England in that way, and even equall'd the most famous Italians, insomuch that he was commonly stil'd the Vandyck in little, equalling that master in his beautiful colouring, and agreeable airs of the face, together with that strength, relievo, and noble spirit; that soft and tender liveliness of the flesh, which is inimitable. He had also a particular talent in the loose and gentle management of the hair, which he never fail'd to express well: but tho' his pencil was thus admirable, yet his excellency was chiefly confin'd to the head, for below that part of the body he was not always so successful as cou'd have been wish'd. The high prices his pieces still sell at, tho' far short of their value, and the great esteem they are in even at Rome, Venice, and in France, are abundant arguments of their great worth, and have extended the fame of this master throughout all parts of Europe where art is valu'd. He so far exceeded his master, and uncle, Mr. Hoskins, that he became jealous of him, and finding that the court was better pleas'd with his nephew's performances than with his, he took him in partner with him; but still seeing Mr. Cooper's pictures were more relish'd, he was pleas'd to dismiss the partnership, and so our artist set up for himself, carrying most part of the business of that time before him. He drew king Charles II and his queen, the duchess of Cleveland, the duke of York, and most of the court: but the two pieces of his which were most esteemed, were those of Oliver Cromwell, and of one Swingfield. The former is now in the hands of Richard Graham, Esq.; and by him highly valued. The French King once offered 150 l. for it, yet could not have it. The

[35]

other is in the collection of Colonel Robert Child, who sets a great value upon it. This last picture Mr. Cooper having carried to France, it introduced him into the favour of that court, and was much admir'd there. He likewise did several large limnings in an unusual size, which are yet to be seen in the Queen's closet, and for which his widow received a pension during her life from the crown. That which brought Mr. Cooper to this excellency, was his living in the time of Van-Dyck, many of whose pictures he copied, and which made him imitate his stile. Answerable to his abilities in painting, was his great skill in musick, especially the Lute, wherein he was reckon'd a master. He was many years abroad, and personally acquainted with most of the great men in Holland and France, as well as those of his own country; but he was yet more universal by his works, which were known throughout all parts of Christendom. He died in London in the year 1672, at sixty-three years of age, and lies buried in Pancras church in the fields, where there is a fine marble monument set over him . . .

From the inscription on his tombstone, and from information recorded in biographies by Richard Graham, published in 1695, and that by de Piles, we know that Cooper could speak several languages and that he had travelled a great deal. The date of these travels is not known, nor do we know their full extent, but it has been suggested that the most likely years are those between 1630 and 1642, when the number of known works by him are rather fewer than one would have expected for a man who was by this time of mature age, and already well known in his profession.

There is no record of the date on which Samuel left his uncle, nor do we know where he went to live before 1642.

Although there is not so far any corroborative evidence to support the theory, it was in all probability some time in or before 1642 that Cooper set up on his own, as it is from this year onwards that there is a continuous record of signed and dated miniatures, showing the artist at the height of his powers which did not falter up to his death in 1672. Certainly from 1642 Cooper had his own residence in Covent Garden in the next street to that of his uncle.

According to J. J. Foster, Cooper was 'rated to make up a sum of £250, required by the Vicar and Churchwardens of St. Paul's Covent Garden' in 1642 whilst living in Henrietta Street. *The Survey of London*, Volume XXXVI, 1970, however, records him as paying rates in King Street in 1643, and in Henrietta Street *c.* 1650–1672. Henrietta Street had been laid out in 1631, named after Queen Henrietta Maria, and was described as a 'very broad and pleasant street'. From the names recorded in the *Survey*, the first occupants appear to have been a mixture of titled persons and well-to-do trades-

[36]

men. The numbers of the houses in which Cooper lived are not recorded, but it is interesting to note that his fellow ratepayers included a number of members of the Long Parliament, royalists and members of the medical profession. None of the original seventeenth-century fabric of the street remains, and most of the present buildings date from the nineteenth century, although the street itself has never been widened. A John Cooper, who may possibly have been a relation, lived in 29 King Street, for which he obtained a thirty-one-year lease dated 15 July 1631, for an annual rent of £3.

Evidence that Cooper may have had a sister who survived him is to be found in the *Diary of Robert Hooke, 1672–1680*, edited by H. W. Robinson and W. Adam (London 1935), p. 399:

1678/9
Sat. Feb 14th Guildhall Subpœnas. Water Line. I tended on them all day 10 aa 5. Sam. Cooper's sister. at Jonathans [Coffee House], Sir J. Hoskins and Lodowick.

In this case, the sketch on the reverse of the Buccleuch collection Hoskins self portrait, referred to earlier (see page 33) might of course show one Hoskins child and three Cooper children.

I have not so far been able to trace the date or place of Cooper's marriage to Christiana (or Christina) Turner (1623–1693), daughter of William Turner of York, whose family were landowners in Yorkshire. Christiana was one of seventeen children, of whom Edith (or Editha) (1643–1733), was the mother of Alexander Pope the poet (1688–1744). According to notes in Volume IV of *The Works of Alexander Pope Esq.*, Warburton, 1751, p. 43, Christiana and Edith had at least three brothers, one of whom was killed, another died in the service of King Charles, and the eldest following his fortunes became a 'general officer' in Spain.

In spite of the gap of about twenty years in age, the two sisters evidently were close friends, and Dr. G. C. Williamson states in *The Miniature Collector*, p. 65, that:

According to a document that for a long time was preserved in the Pope family, Mrs. Cooper is said to have handed over to her sister many sketch-books belonging to her husband together with his colour boxes and colours, and some cups 'of precious agate' in which he compounded his pigments, and there is still a tradition in the Pope family that all these treasures have been preserved by some member of that family, and were deposited for greater security at a bank, where it is said they still exist.

Edith's husband was a linen draper, thought to have been a man of means who greatly

[37]

admired Cooper's work, and is said to have erected the monument in Old St. Pancras Church to the memory of Cooper and his wife.

The Pope family were Roman Catholics, and Long mentions that there is reason to think that Mrs. Cooper may also have been a Roman Catholic, but I have been unable to verify this statement.

If the Coopers had any children, they must have died before Cooper made his last will, as no mention is made of them and he appointed his 'deare and loving wife Christiana Cooper my sole executrix'.

Cooper was evidently fourteen years older than his wife, who was only forty-nine years of age when her husband died, and who survived him by twenty-one years.

Fortunately, as with the Hilliards, we know what Cooper and his wife looked like, and his delightfully attractive unfinished miniature of her, now in the collection of the Duke of Portland at Welbeck Abbey, is surely one of his most beautiful works. It shows his ability to portray his sitters with grace and tenderness as well as with convincing honesty. The miniature was acquired by Edward, Lord Harley, for £26 at the sale of the collection of Lawrence Cross(e)'s pictures, limnings, prints, etc., on 5 December 1722. Vertue noted that twelve limnings by Cooper were sold including 'the Lady Grey. dated 1655 Lady Alisbury dated 1648. Coopers wife, not finisht. very good. Lady Sunderland a large head very fine, not finisht'.

The miniature of Christiana Cooper was probably framed by Cross(e) as on the backboard he has written: *Sam^ll Cooper's wife Painted by himself.*

Two portraits of Cooper exist, and both are in the Victoria and Albert Museum. Neither portrait reveals by his expression the side of his character which made Pepys and others describe him as 'good company'.

The miniature self portrait, signed and dated 1657, has no provenance earlier than the Dyce bequest of 1869. The miniature is identified as of Cooper only by an eighteenth-century inscription on the reverse. A small pastel, which is also said to be a self portrait, but about which there has been some doubt for many years, shows him with short curly hair to his shoulders, wearing an unfastened coat over his waistcoat and a short lace cravat tied with a black ribbon. Both these portraits were in the collection of the Rev. Alexander Dyce, who bequeathed them among many other treasures to the Victoria and Albert Museum on his death in 1869. The pastel crayon portrait appears to have passed from the collection of a Mr. Graham to that of Queen Caroline, thence to Mr. Dalton, and then to Horace Walpole at whose sale in 1842 (Lot No. 166) it was purchased by a Mr. Strong for nineteen shillings, and lastly to the Rev. A. Dyce.

[38]

According to Vertue, it was possibly by Jackson, a relative of Cooper's. Samuel Redgrave, when he catalogued the Dyce miniatures, was certain that it was a self portrait, and Basil Long also accepted this attribution as correct. David Piper, however, is convinced both on grounds of quality and a thorough consideration of its pedigree that it is probably the contemporary portrait by Jackson recorded by Vertue. Whilst it is impossible to produce any conclusive evidence, the style and manner of execution of the portrait and the crayons used do not in my opinion rule out the possibility of its being a self portrait, and if so it is in all probability the one mentioned in Mrs. Cooper's will as 'my husbands picture in crayons'.

Two copies by Bernard Lens of the crayon portrait exist. One is in the collection of the Duke of Portland, and inscribed on the reverse of the back-board: *Samuel Cooper a Famous Performer in Miniature, stil'd Van Dyck in little; he Died in London in yᵉ year: 1672: 63 year of Age. Bernard Lens Fecit.* The other version is in the collection of the Marquess of Bristol; on the reverse of this portrait Lens has written that Cooper has: *far exceeded all that went before him in England in that way and been equell the most Famous Italians insomuch that he was stil'd Van Dyck in little.* He adds that it was done from the 'Originall in Creons by himself in yᵉ collection of Mr. Graham'.

Vertue records that when Cooper died there was an oil self portrait in his house. No further evidence of its existence is known.

Additional information regarding Cooper's appearance is provided by an inscription on the reverse of one of his scarce portrait drawings, that of Thomas Alcock, drawn *c.* 1655, which is preserved at the Ashmolean Museum, Oxford. The inscription written by the sitter reads as follows:

This Picture was drawne for mee at the Earl of Westmorelands house at Apethorpe in North-amptonshire by the Greate (tho' little) Limner, The then famous Mr. Cooper of Covent Garden: when I was eighteen years of age. Thomas Alcock, Preceptor.

In his *Catalogue of the Collection of Miniatures, The Property of J. Pierpont Morgan*, Williamson illustrates a supposed self portrait of Cooper, Pl. XLVIII, Volume 1, No. 114, executed in sepia on paper which has been twice folded, and which is said to have at one time had an inscription on the envelope in which it was contained reading: *Given mee by Mrs. Pope.* The present whereabouts of this portrait is unknown, and without seeing it, it is impossible to judge whether or not Cooper painted it.

One of the earliest documentary references to Cooper's art is given by Norgate in his *Miniatura* of *c.* 1650, edited by Martin Hardie, 1919. In it Norgate says:

[39]

SAMUEL COOPER

The very worthy and generous Mr. Samuel Cooper, whose rare pencill, though it equall if not exceed the very best of Europe, yet it is a measuring cast whether in this [i.e. crayon] he doe not exceed himself . . . Those [crayon drawings] made by the Gentile Mr Samuel Cooper with a white and black Chalke upon a Coloured paper are for likenes, neatnes and roundnes *abastanza da fare stupire e marvigliare ogni acutissimo ingegno*. With like felicitie he hath made a picture of a noble Cadet of the first noble family of England, that for likenes cannot be mended with Colours.

Samuel Cooper held a unique position during a difficult period of British history, reared as he was in the reign of Charles I, during which time he had his initial training in art. He succeeded in gaining for himself popularity which soon gave him a position as an outstanding artist, which popularity he retained during the period of the Common-wealth. Considering the great political changes which took place, it was a remarkable achievement that Cooper's reputation as an artist placed him outside the realm of politics, and he was as much in demand during the Restoration as he had been during the Commonwealth.

It seems strange that a man like Cooper, who held such a position of importance, with his wide interests and contacts, should have failed to leave behind him any letters or documents from which a more detailed picture of his life, family, and day-to-day activities could be written up, but all we know has to be sifted out from State papers, works by contemporary authors, and letters from various sitters or acquaintances dis-cussing his merits.

Although it is assumed that Cooper painted members of Charles I's court, he did not as far as is known ever paint a miniature of the King, who was painted more than once by his uncle John Hoskins.

It has been suggested that Cooper visited his brother Alexander in Sweden, and that whilst there he taught Franciszek Smiadecki, who is said to have been of Russian or Polish extraction. If this visit did take place, it could not have been before 1647, the year in which Alexander settled in Stockholm.

It is impossible to say precisely when Cooper began to paint members of Oliver Cromwell's family, but it was certainly in or before 1650. Evidence for this is to be found in the *Calendar of State Papers, 1650*, 1876, p. 420, when Miles Woodshawe writing to Lord Conway says:

I spoke to Mr. Cooper, the painter, who desires you to excuse him one month longer, as he has some work to finish for Lord General Cromwell and his family

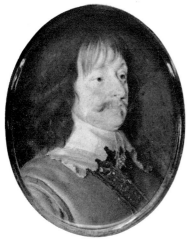

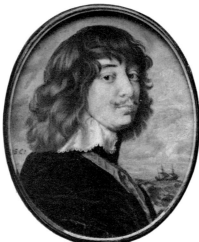

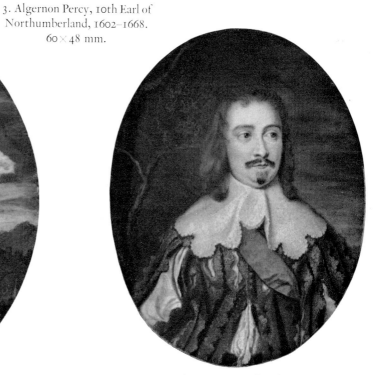

1. Sir John Hamilton, 1605–
1647. 57 × 46 mm. (*attributed*)

2. John, 6th Earl of Rothes,
1600–1641. 52 × 38 mm.
(*attributed*)

3. Algernon Percy, 10th Earl of
Northumberland, 1602–1668.
60 × 48 mm.

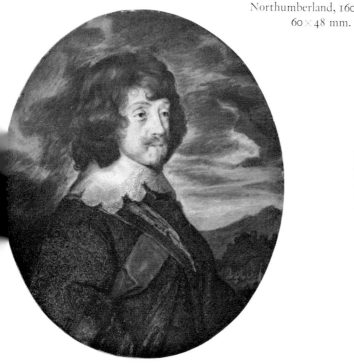

4. Henry Rich, 1st Earl of Holland, 1590–1649.
118 × 98 mm.

5. Unknown man, painted *c*. 1630.
114 × 89 mm.

6. Margaret Lemon, painted *c.* 1635–40. 120 × 99 mm.

7. Elizabeth Cecil, Countess of Devonshire, 1620–1689. 155 × 118 mm.

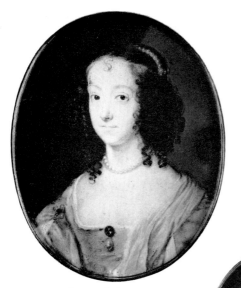

8. Unknown lady. 70 × 64 mm.

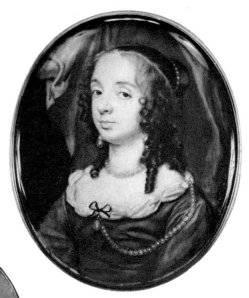

9. Unknown lady. 73 × 60 mm.

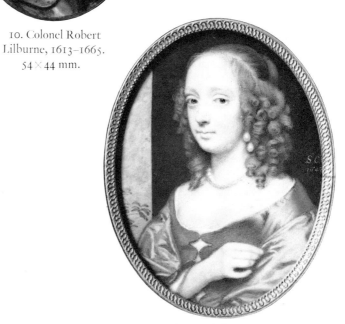

10. Colonel Robert
Lilburne, 1613–1665.
54 × 44 mm.

11. Unknown man formerly
called Robert Walker.
68 × 51 mm.

12. Unknown lady. 74 × 60 mm.

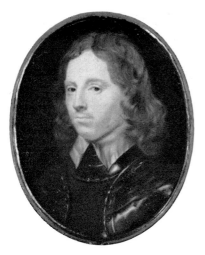

13. General George Fleetwood,
1605–1667. 57 × 45 mm.

14. Hugh May, 1622–1684.
67 × 54 mm.

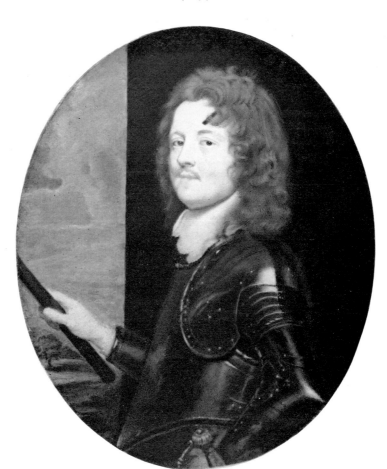

15. John, 1st Baron Belasyse,
1614–1689. 118 × 102 mm.

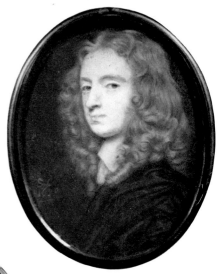

16. (*called*) Abraham Cowley,
1618–1667. 64×51 mm.

17. Robert Dormer,
1629–1694. 65×48 mm.

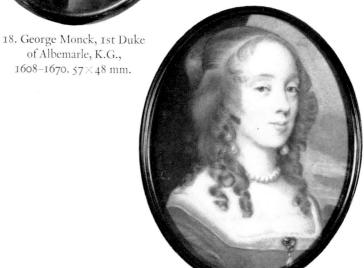

18. George Monck, 1st Duke
of Albemarle, K.G.,
1608–1670. 57×48 mm.

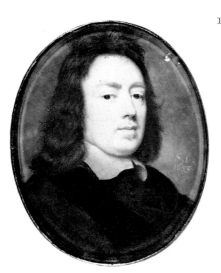

19. Sir Justinian Isham, 1611–1675.
64×51 mm.

20. Anne Stephens, Lady Pye,
d. 1722. 70×54 mm.

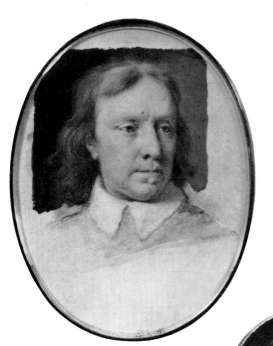

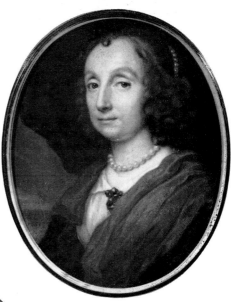

21. Oliver Cromwell, 1599–1658.
80 × 64 mm.

22. Mrs. Oliver Cromwell,
née Elizabeth Bourchier,
d. 1665. 70 × 57 mm.

23. General Henry Ireton,
1611–1651. 50 × 40 mm.

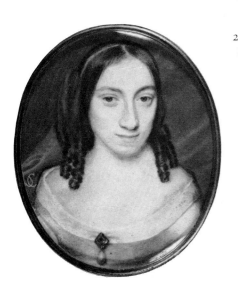

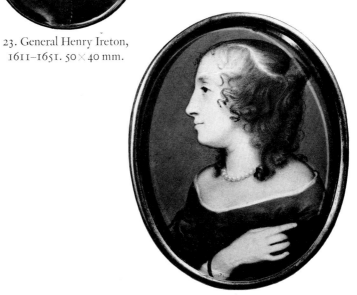

24. (*called*) Mary Fairfax, Duchess
of Buckingham, 1638–1704.
64 × 51 mm.

25. Mrs. John Claypole,
née Elizabeth Cromwell,
1629–1658. 67 × 57 mm.

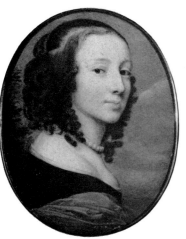

26. Unknown lady. 64 × 51 mm.

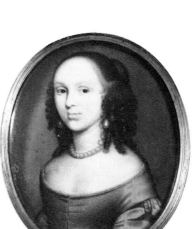

28. Unknown lady.
57 × 51 mm.

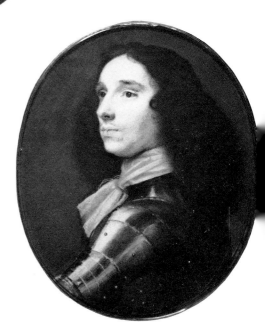

27. The Rev. Thomas Stares-
more or Stairsmore, d. 1706.
62 × 49 mm.

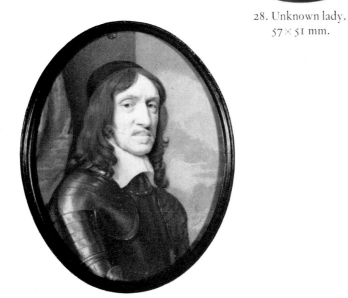

29. John Holles, 2nd Earl of Clare,
1595–1666. 65 × 52 mm.

30. Sir John Carew, d. 1660.
89 × 64 mm.

and again on 28 November 1650:

Mr. Cooper has desired me to appoint for the lady to sit next Tuesday.

Woodshawe wrote to Lord Conway again on 9 October 1651 (*Calendar of State Papers, 1651, 1877, p. 471*):

Mr. Cooper assures me that on the lady's return, he will not fail to do [the picture] for the credit of himself and her. Col. Ashburnham has promised that on her return from the West Country, she shall sit a week together.

Cooper had by this time become so popular that there must have been many who had difficulty in arranging sittings with him. Dorothy Osborne writing to Sir William Temple in letter 27 (assumed date 3 July 1653), E. A. Parry's edition of her letters, published by J. M. Dent & Sons, 1888, says:

For God's sake do not complain so that you do not see me . . . If I had a picture that were fit for you, you should have it. I have but one that's anything like, and that's a great one, but I will send it some time or other to Cooper or Hoskins, and have a little one drawn by it, if I cannot be in town to sit myself.

Writing again on 13 June 1654, Dorothy says:

I shall go out of town this week, and so cannot possibly get a picture drawn for you till I come up again, which will be within these six weeks, but not to make any stay at all. I should be glad to find you here then. I would have one drawn since I came, and consulted my glass every morning when to begin; and to speak freely to you that are my friend, I could never find my face in a condition to admit on't, and when I was not satisfied with it myself, I had no reason to hope that anybody else should. But I am afraid as you say, that time will not mend it, and therefore you shall have it as soon as Mr. Cooper will vouchsafe to take the pains to draw it for you. I have made him twenty courtesys, and promised him £15 to persuade him.

Dorothy Osborne (1627–1695), the daughter of Sir Peter Osborne (1584–1653), married Sir William Temple (1628–1699) statesman and author, in 1655.

In the following year there are references to Cooper regarding a present to the ambassador from Sweden (*Calendar of Treasury Books*). On 1 August 1656, and subsequent

[41]

dates, it was decided to spend a sum of £1500 on this gift, which was to comprise cloth furnished by William Kiffin, a London merchant, a jewel provided by Thomas Simons, graver of the Mint and Seale, and a miniature by Cooper (7 August 1656).

This commission may possibly have led to Cooper visiting Sweden, although there is no documentary evidence to support the theory, and it is generally held that it was some time earlier that Cromwell had sent a miniature of himself by Cooper to Queen Christina of Sweden with the verses by Milton:

Bellipotens Virgo, Septem regina trionum,
Christina, Arctoi lucida stella poli!

Other references exist to Cooper being employed to execute portraits of Cromwell for presentation to Dutch and French diplomats. Sir George Downing, writing from Holland, 4 July, 1658 (*Thurloe State Papers*, Volume VII, pp. 227–230 and 296; also quoted by J. Beresford, *The Godfather of Downing Street*, 1925, p. 95):

The French ambassador hath earnestly desired of me a picture of his highness [i.e. Cromwell]. If you had one from Cooper for Bevering [a Dutch diplomatist], another also might be had for him. Truly it's worth the cost, which is little.

Downing was evidently anxious that these two portraits should be obtained, and in a later letter suggests that if Cromwell cannot sit for both portraits then Cooper, or some other very good hand, might produce a copy.

Sir George Downing (1623?–1684), was a soldier and politician, who throughout the Civil War was a keen follower of Cromwell, and headed the movement wishing to offer Cromwell the Crown. During the time that these letters were written he was resident at The Hague.

Due no doubt to the fact that Cooper was acknowledged to be good company, and a skilled musician, his friends and acquaintances were drawn from a wide circle. Apart from his numerous patrons, his friends included Thomas Hobbes (1588–1679), Samuel Butler (1612–1680), John Aubrey (1626–1697), Samuel Pepys (1633–1703), and John Evelyn (1620–1706), to mention a few.

It is from references to Cooper contained in works by or about these men that we are able to build up a picture of his character and what impact he made on his contemporaries. According to A. A. Wood in his *Athenæ Oxonienses* (third edition, 1817, Volume III), Samuel Butler was:

taken into the service of Elizabeth countess of Kent: in whose family living several years, he did, for a diversion, exercise his parts in painting and music, and at length became so noted for the first, that he was entirely beloved of Sam. Cooper the prince of limners of his age.

The same work refers to a portrait of Thomas Hobbes by Cooper which it is stated hung 'in his Majesty's closet at Whitehall'.

An interesting unfinished sketch of Hobbes by Cooper is in the Edward B. Greene collection, the Cleveland Museum of Art, Ohio. No finished version of this portrait by Cooper has so far come to light, but the sketch gives us a clear insight into the man who was being painted: we can see his kindly good humour with which Aubrey says he was endowed and can well believe his statement that when Hobbes laughed and was merry 'one could scarce see his eyes'.

Aubrey in his *Brief Lives*, p. 338, is probably referring to this portrait when he says:

Amongst other of his [Hobbes's] acquaintances, I must not forget our common friend, Mr. Samuel Cowper, the prince of limners of this last age, who drew his pictures as like as art could afford, and one of the best pieces that ever he did: which his Majesty, at his returne bought of him, and conserves as one of his greatest rarities in his closet at Whitehall. Note. This picture I intended to be borrowed of his majesty for Mr. Loggan [David Loggan] to engrave an accurate piece by, which will sell well both at home and abroad.

With the death of Cromwell on 3 September 1658, political events moved swiftly; his son Richard succeeded him as Protector only to be deposed by the army in May 1659, and by 1660 retired to the Continent, living in Paris under the assumed name of John Clarke.

Charles II returned to London on 29 May 1660, and having already heard of Cooper's artistic ability, lost no time in making his acquaintance and giving him his patronage, details of which are given in the next chapter.

Notes from the notebooks of George Vertue, on artists working in England, published in the *Walpole Society*, 1929/30–1947, contain various references to Cooper. In *Vertue II*, 1931/32, pp. 129–130, there is an account of Cooper's connection with Hoskins, and comments about his work which are very similar to those expressed by de Piles. Vertue mentions two portraits in particular:

two Pieces of his which were most esteem'd were those of Oliver Cromwell. purchased at a considerable Price by Prince Eugene when he was in England. the other in Posses of S^r Rob^t Child. being the Portrait of . . . M^r Swingfield.

Details of two miniatures which were sold at Christie's in the Henry Doetch Collection, 27 June 1895, are mentioned by Long, who suggests the possibility that Cooper may have worked for a time in Germany. The details were as follows:

Lot 207. Portrait of a Burgomaster of Hamburg, by Samuel Cooper, on a silver coin of the old 'Hansa-town'; inscription on the coin, '*Moneta Nova Civit. Hamburgensis, 1636*'—signed 'S.C.'

Lot 208. The Wife of the Burgomaster of Hamburg, by Samuel Cooper, on a Hamburg silver coin of the same kind as the above, but on the reverse. The companion to No. 207. Inscription on the rev. of coin, '*Ferdinand G. Roma Imp. Sem.* Aug. P.F.D.'—signed 'S.C.'

It is tantalising that we do not know how old Cooper was when he and his elder brother went to live with Hoskins, nor where he was educated and in what year he started to paint. We do know that he was only a boy of sixteen when Charles I came to the throne, and that the world in which he grew up was a rapidly changing one.

Gone was the gaudy and ostentatious age of the Elizabethans, with their jewel-bedecked costumes and love of symbols. In art great changes took place, the characteristics of the school of illuminators was forgotten, and artists made serious attempts to portray true likenesses.

Samuel Cooper had the inspiration and ability to paint portraits which reveal the living person in a way that no other artist of the period succeeded in doing, and to preserve for posterity the features of the men and women of his age.

The King's Limner

When Charles II landed at Dover on 25 May 1660, it signified the dawn of a new era. Fifteen years had passed since he had seen England in the spring, and the bells of Canterbury cathedral must have sounded sweetly on his ear as he passed through the narrow streets of the town to spend the first weekend of the Restoration on English soil.

On Tuesday, 29 May, he celebrated his thirtieth birthday amidst the thousands of his subjects who turned out to greet him as he made his way to the Palace of Whitehall, where the Houses of Parliament awaited him.

In the Buckinghamshire village of Maid's Moreton, the rector wrote in the parish register:

This day by the wonderful goodness of God, his Sacred Majesty King Charles II was peacefully restored to his martyred father's throne, the powerful armies of his enemies being amazed spectators and in some sort unwilling assistants to his return.

There were no doubt many who were anxious to renew their acquaintance with the King. John Aubrey was evidently anxious that Thomas Hobbes should be on the spot when the King arrived in London, and sent Hobbes a letter (*Brief Lives*, p. 339):

to advertise him of the Advent of his master the King and desired him by all means to be in London before his arrival; and knowing his majestie was a great lover of good painting I must needs presume he could not but suddenly see Mr. Cowper's curious pieces, of whose fame he had so much heard abroad and seene some of his worke, and likewise that he would sitt to him for his picture, at which place and time he would have the

best convenience of renewing his majestie's graces to him. He returned me thanks for my friendly intimation and came to London in May following.

Aubrey then relates details of the King's visit to Cooper's studio:

It happened about two or three dayes after his majestie's happy returne, that, as he was passing in his coach through the Strand, Mr. Hobbes was standing at Little Salisbury-house gate (where his lord then lived). The King espied him, putt of his hatt very kindly to him, and asked him how he did. About a weeke after he had orall conference with his majesty at Mr. S. Cowper's, where, as he sate for his picture, he was diverted by Mr. Hobbes's pleasant discourse.

There is no evidence that Charles II had ever sat to Cooper before this time, although the two men had possibly met when Cooper was working with his uncle John Hoskins.

The date on which Cooper was appointed King's Limner is not known, but it must have been sometime before 1663, in which year, on 26 May, a warrant was issued for a yearly salary of £200 to Cooper 'in lieu of diet supressed a year ago by the Board of Greencloth, and of board wages', *Domestic State Papers, Charles II*, Volume LXXIV.

On 30 November 1663, Cooper was excused payment of his share of four subsidies (*Calendar of Treasury Books*, 23 December 1663). As was so often the case, Royal patrons were not good payers, and Cooper did not receive his pension regularly, and years later he had only received £600 and had to apply for the balance; an order was then made for him to be paid his arrears and £200 a year.

His position as premier miniaturist lasted for the remaining years of his life, during which time he was kept busily employed painting portraits of his numerous patrons who came from almost all the important families in the country.

Artists not infrequently had flattering verses written about them, and in this Cooper was no exception, for Mrs. Katherine Philips (1631–1664) wrote a poem to him, which reads as follows:

TO MR. SAMUEL COOPER
HAVING TAKEN LUCASIA'S PICTURE, GIVEN 14 DECEMBER, 1662

If noble things can noble thoughts infuse,
Your art might even in me create a Muse,
And what you did inspire you would excuse.

But if it such a miracle could do,
That Muse would not return you half your due,
Since 'twould my thanks, but not the praise persue.

To praise your art is then itself more hard,
Nor would it the endeavour much regard,
Since it and Virtue are thine own reward.

A pencil from an angel newly caught,
And colours in the morning's bosom sought,
Would make no picture if by you not wrought.

But done by you, it does no more admit
Of an encomium from the highest wit,
Than that another hand should equal it.

Yet whilst you with creating power dye,
Command the very spirit of the eye,
And then reward it with eternity;

Whilst you each touch does life to air convey,
Fetch the soul out like overcoming day,
And I my friend repeated here survey;

I by a passive way may do you right,
Wearing in what none ever could indite,
Your panegyrick and my own delight.

Katherine Philips was the daughter of John Fowler, a merchant in the City of London. After her father's death, her mother married Hector Philips of Port Eynon, and in 1647 Katherine married, as his second wife, James Philips of the Priory, Cardigan, who was the eldest son of her stepfather by a previous marriage. She divided her time between her husband's estate and London, where she formed a circle of friends who all adopted various fanciful names, Lucasia's name being Mrs. Anne Owen, she herself being known as 'The Matchless Orinda'. She died of smallpox on 22 June 1664.

There is only one mention of Cooper in John Evelyn's diary, but it is of great significance; on 10 January 1662, he says:

Being call'd into his Majesty's closet when Mr. Cooper, the rare limner, was crayoning of the King's face and head, to make the stamps by for the new mill'd money now con-

triving, I had the honour to hold the candle whilst it was doing, he choosing the night and candle-light for the better finding out the shadows. During this his Majesty discours'd with me on several things relating to painting and graving.

The esteem in which Cooper was held by artists in Holland is illustrated by letters which are mentioned by Graham Reynolds, *English Portrait Miniatures*, p. 55. The letters passed between Constantine Huygens junior, and Christian Huygens, when the latter was in London in 1663. Constantine was a skilled amateur artist, who was at that time experimenting with miniature painting, and sent an example of his work to his brother with a request that he would seek the opinion of Lely and Cooper upon it. Christian evidently succeeded in obtaining the opinions of the two masters, and Constantine in acknowledging their criticisms said, 'Under a master like Cooper one would soon have worked with assurance but here we are in an unlucky country'.

It is traditionally believed that Jean Petitot senior (1607–1691), sent his son over to study under Cooper, and George Vertue records that:

Petito Sen, Enameller. after his return to France sent over his Son, to have some instruction from Cooper the limner to learn limning—which the Junior Petito not much liking or the method of his Instructions. return'd to France without much improvement. *Walpole Society*, Volume XX, p. 69.

There are a number of references to Cooper in the diary of Samuel Pepys, the earliest of which is on 2 January 1661/2, when Pepys expected to be introduced to Cooper and was obviously disappointed when the arrangement came to nothing. He says:

I went forth by appointment to meet with Mr. Grant, who promised to bring me acquainted with Cooper, the great limner in little, but they deceived me.

The next reference is some six years later, when Pepys decided to get Cooper to paint a portrait of Mrs. Pepys.

On 29 March 1668, Pepys had a dinner party and his guests included W. Howe, Mr. Harris and Mr. Banister. The evening was evidently spent in singing and playing musical instruments. Pepys records that:

Harris do so commend my wife's picture of Mr. Hales' that I shall have him draw Harris's head; and he hath also persuaded me to have Cooper draw my wife's, which though it cost £30, yet I will have done.

[48]

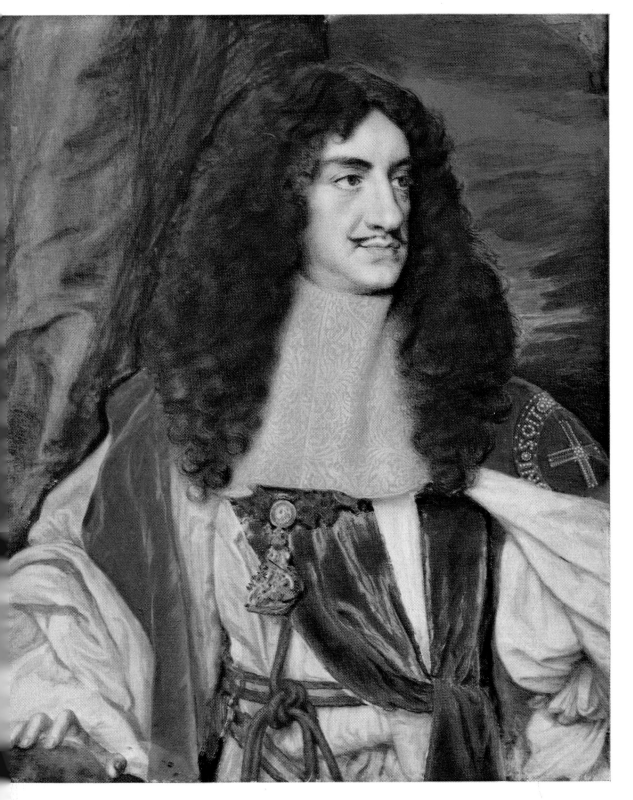

9. Charles II, 1630–1685. 190 × 162 mm.

The only known record of the Hales portrait is an engraving by I. Thomson, 1828, a copy of which is in the National Portrait Gallery, London. The original is reputed to have been destroyed by a prudish Scottish nurse, but which may have been Lot 110 in the Pepys Cockerel sale, 1848, when it was catalogued as 'Portrait of a Lady, Rembrant School'.

On the following day Pepys went by coach to the 'Commongarden [Covent Garden] Coffee-house' where he was to meet Harris and according to his diary:

also Mr. Cooper, the great painter, and Mr. Hales [John Hales or Hayls, d. 1679]: and thence presently to Mr. Cooper's house, to see some of his work, which is all in little, but so excellent as, though I must confess I do think the colouring of the flesh to be a little forced, yet the painting is so extraordinary, as I do never expect to see the like again. Here I did see Mrs. Stewart's picture as when a young maid, and now just done before her having the smallpox: and it would make a man weep to see what she was then, and what she is like to be by people's discourse, now. Here I saw my Lord General's picture, and my Lord Arlington and Ashley's,[1] and several others; but among the rest one Swinfen, that was Secretary to my Lord Manchester, the Lord Chamberlain, with Cooling, done so admirably as I never saw anything: but the misery was this fellow died in debt, and never paid Cooper for his picture: but it being seized on by his creditors, among his other goods, after his death, Cooper himself says that he did buy it, and give £25 out of his purse for it, for what he was to have had but £30. Being infinitely satisfied with this sight, and resolving that my wife shall be drawn by him when she comes out of the country. . . .

There was evidently some delay before a date was arranged with Cooper, and on 1 July Pepys called at several places before visiting Cooper to enquire when his wife should come and sit for her picture. A date was eventually fixed, and on the 6th we read:

Thence to Mr. Cooper's, and there met my wife and W. Hewer and Deb; and there my wife first sat for her picture: but he is a most admirable workman, and good company.

For most of the sittings Mrs. Pepys was accompanied by her companion, Deb Willet, and William Hewer, a close friend of Pepys, whose portrait, by Sir Godfrey Kneller, is in the National Maritime Museum, Greenwich.

[1] Anthony Ashley Cooper, then Lord Ashley, and later 1st Earl of Shaftesbury.

On 8 July, after having dinner, Pepys accompanied his wife to another sitting and remained to watch Cooper painting. He remarked: 'and there saw her sit; and he do extraordinary things indeed'.

On 10 July we find Pepys a little doubtful as to whether or not he is going to like the portrait:

To Cooper's; and there find my wife and W. Hewer and Deb., sitting and painting; and here he do work finely, though I fear it will not be so like as I expected: but now I understand his great skill in musick, his playing and setting to the French lute most excellently; and he speaks French, and indeed is an excellent man.

Three days later on 13 July after purchasing some books and a perspective glass, Pepys again visited Cooper's house to see how the portrait was getting on and after spending the afternoon with them declared: 'it will be an excellent picture'. Mrs. Pepys sat to Cooper again on 16th, and Pepys records:

Thence to Cooper's and saw his advance on my wife's picture which will be indeed very fine.

On Sunday, 19 July 1668, Mr. and Mrs. Pepys had a mid-day dinner party at their house which turned out to be an enjoyable occasion. Pepys describes it as follows:

Come Mr. Cooper, Hales, Harris, Mr. Butler, that wrote Hudibras, and Mr. Cooper's cosen Jacke; and by and by come Mr. Reeves and his wife, whom I never saw before; and there we dined: a good dinner, and company that pleased me mightily, being all eminent men in their way. Spent all afternoon in talk and mirth, and in the evening parted.

Pepys paid two more visits to Cooper's whilst the portrait was being finished, on 25th and 27th of July, and on both occasions thought that the result would be very fine indeed.

Mrs. Pepys had her last sitting on 10 August, and in his diary for that day her husband says:

To Cooper's where I spent all afternoon with my wife and girl, seeing him make an end of her picture, which he did to my great content, though not so great as, I confess, I

had expected, being not satisfied in the greatness of the resemblance, nor in the blue garments: but it is most certainly a most rare piece of work, as to the painting. He hath £30 for his work—and the crystal, and the case, and gold case comes to £8.3s.4d.; and which I sent him this night, that I might be out of his debt.

It is sad that up to the time of writing no trace is to be found of this portrait which was the means of providing posterity with valuable fragments of information about the master who painted it.

In an article on Samuel Cooper published in the *Art Journal*, September, 1850, pp. 293–295, the author lists the miniature of Mrs. Pepys as being in existence, but does not state in whose collection.

One of the few major recent contributions to our knowledge of Cooper from contemporary documents has been provided by Professor A. M. Crinò, who during her research into the records of the Grand Duke Cosimo III of Tuscany, discovered numerous letters relating to Cosimo sitting to Cooper for his portrait in England, and the arrangements for its safe delivery to him on his return, as well as letters between the Grand Duke and his agent Francesco Terriesi, whom he asked to act for him in procuring for his collection certain of Cooper's miniatures which were in the possession of his widow after Cooper's death.

Prince Cosimo de Medici visited England in 1669, and among those who came to pay their respects to him on 18 April was Samuel Cooper, about whom the Prince had already heard. The artist had been recommended to him as one who was skilled in painting from life, and the Prince had been assured that 'No person of quality visits that city without endeavouring to obtain some of his performances to take out of the kingdom'.

Arrangements were evidently made for Cooper to paint the Prince in miniature, and he had his first sitting on 1 June of that year. This was followed by several other sittings at Cooper's house in Henrietta Street, Covent Garden. From the records discovered by Professor Crinò, we get another insight into Cooper's personality: 'a tiny man, all wit and courtesy, as well housed as Lely, with his table covered with velvet'.

The Prince was due to leave London on 11 June, and as Cooper did not like to be rushed, and no doubt had a number of other commissions in hand at the same time, it was unlikely that the portrait could have been finished in time for the Prince to take it with him.

In the following year Cosimo became Grand Duke of Tuscany on the death of his father Ferdinand II, and in a letter written to his London agent Terriesi, who had offered his condolence, we learn that the painting was still incomplete.

[51]

The Grand Duke was obviously anxious to have it, and gave instructions that one of his best friends, Lord Philip Howard, should be given the money to pay for the picture which was to cost £150. This at first sight seems a large sum of money in view of the fact that Cooper normally charged £30, but the significant difference is that this portrait was considerably larger than Cooper's usual format. It is exactly the same size as that of the First Earl of Shaftesbury (210 × 168 mm), and slightly smaller than the superb miniature of Charles II at Goodwood, painted in 1665.

When Professor Crinò wrote her article in the *Burlington Magazine*, 1957, the miniature of Cosimo III was thought to have been lost, and in spite of extensive searches for the portrait nothing more was heard about it until Oliver Millar described its discovery in an article in *Apollo*, January, 1965.

Having regard to the intensive search for the miniature throughout Florence with negative results, it is hardly surprising that Sir Oliver was astonished 'to find it standing on a shelf in the office of the Director of the Gabinetto dei Desegni in the Uffizi'. This portrait is now number 3018 in the Uffizi register of miniatures, and is said to have come from Poggio Imperiale. It has unfortunately suffered from restoration.

Unlike Cooper's usual style, the sitter is viewed slightly from below, leaning against what appears to be the edge of a parapet, and painted against a clear blue sky and cloud background, rather than the more conventional one of a curtain or wall, or the rather drab brownish background which Cooper so often favoured. The miniature is painted in rich colours, the armour being enriched with gold, suffused with the distinctive warm greyish tone which Cooper often used. The painting is free, and the pose one of grandeur, as befitted a Prince of the Medici family. The sitter's hair is modelled with the unmistakable softness of Cooper's mature manner, and the portrait signed with what appears to be an incised monogram SC on the ledge below the Prince's elbow.

On 7 October 1670 Terriesi informed the Grand Duke that Lord Philip Howard was in Flanders, but that he would go to his house in a fortnight's time, and if he had returned by then he would give him the £150.

The transaction was evidently completed during the next two months, and on 5 December 1670, Terriesi wrote to say that the portrait had been taken to Florence by Sir Bernard Gascoign (or Bernardino Guasconi).

Cosimo III, who ruled from 1670 to 1723, was one who showed a real appreciation of English art. During his journey to this country in 1669, he visited the studios of several artists besides Cooper, and made a number of friends. Following in the footsteps of his uncle Cardinal Leopold, who was very historically minded and enjoyed collecting the

portraits of distinguished men both past and present, Cosimo began to add to this collection. He did not confine his interest to painting but acquired a large collection of English watches, clocks and scientific instruments.

His admiration for Cooper's work did not cease with the purchase of his own portrait, and although he did not as far as we know commission Cooper to paint any more miniatures for him during his lifetime, he did after Cooper's death ask Terriesi to try to discover what miniatures by Cooper could be obtained for his collection.

It is from this correspondence, which began in July 1674, and ended in December 1683, that we learn much valuable information about the large number of miniatures which were in the possession of Cooper's widow for several years after his death.

We are indeed indebted to Pepys, Cosimo and other contemporaries, for the few glimpses we have into Cooper's character, from which we can deduce that he was good company, well educated, gifted, much travelled, and clearly at ease in society, and what was more important, able to put his sitters at ease and get them to relax in order that he might draw out their personality and convey it with all the dexterity in his power on to the small portraits which have delighted the world for the past three hundred years.

Although Cosimo remarked on the fact that Cooper was 'well housed', it could not have been ostentatious, or one would have expected Pepys to mention it after at least one of his visits to the painter's house, just as he was moved to indignation at the state in which Sir Anthony Van Dyck lived.

B. S. Long refers to an extract published in *Domestic State Papers, Charles II*, 21 April 1670, which he suggests might allude to relations of Cooper's; it refers to papers respecting a rising of London apprentices in Moorfields, designed for 1 May 1670:

Examination of Rob. Plowman, of Thurgarton-upon-Lee, co Notts, tailor. Came to London 5 weeks since . . . worked for Esquire Cooper, an exciseman, and his lady, living in King Street, Covent Garden, which Cooper is brother to Mr. Cooper, his Majesty's carver. . . . Was advised by Cooper's lady, and Mrs. Baird their housekeeper, to come to London. . . .

This may have been the John Cooper who was living at 29 King Street, from 1631.

There are several references to Cooper's miniatures in *Memoir of John Aubrey, F.R.S.* by J. Britton, 1845. On one occasion Aubrey, speaking of Sir W. Petty, says: 'About 1659 he had his picture drawn, by his friend, and mine Mr. Samuel Cooper, (the prince of limners of his age) one of the likeliest that ever he drew.'

[53]

SAMUEL COOPER

On 22 October 1691, Aubrey writing to John Ray, the naturalist, says:

When I was lately at Oxford I gave several things to the Musæum, which was lately robbed, since I wrote to you. Among others my picture in miniature, by Mr. S. Cowper, (which at an auction yields 20 guineas), and Archbishop Bancroft's, by Hillyard, the famous illuminer in Queen Elizabeth's time.

On 27 October of the same year, Ray replies to Aubrey, and says:

You write that the musæum at Oxford was rob'd but doe not say whether your noble present was any part of the losse. Your picture done in miniature by Mr. Cowper is a thing of great value. I remember so long agoe as I was in Italy, and while he was yet living, any piece of his was highly esteemed there: and for that kind of painting he was esteemed the best artist in Europe.

The years that Ray was abroad were those between 1663 and 1666.

One early collection which contained miniatures by Cooper was that of Sir Andrew Fountaine (1676–1753), who became a close friend of Cosimo III. Fountaine was a distinguished connoisseur, whose advice was frequently sought by English collectors. His own collections contained china, pictures, coins, books, and other objects. Many of his miniatures were lost in a fire at White's Chocolate-house, in St. James's Street, London, where he had hired two rooms to house his collection before removing it to the family house at Narford, Norfolk.

Details of what miniatures were lost are not known, and it is therefore impossible to assess their importance. Fountaine apparently incurred the displeasure of Alexander Pope, Cooper's nephew, who characterised him as the antiquary Annius:

> *But Annius crafty Seer, with ebon wand,*
> *And well-dissembled em'rald on his hand,*
> *False as his gems and cancer'd as his Coins,*
> *Came, cramm'd with capon, from where Pollio dines.*

From these lines we are left wondering what the quality of his miniature collection was, or whether Pope was unfair in his criticism.

Little is known about the latter part of Cooper's life except that up to the last he was kept busily employed with more commissions than he could cope with.

In Part V of the appendix to the Twelfth Report of the Historical MSS Commission,

are quotations from letters belonging to the Duke of Rutland, in which Charles Manners writing to Lord Roos, on 9 April 1672, says:

I haezzen on Mr. Cooper all I can to the finishing of my Lady Exeters picture & he will surely doe it God Willing. . . .

He goes on to say that Cooper is busy with commissions from the King, and the Duke of York.

On 4 May 1672, Charles Manners in another letter tells Lord Roos that it had been impossible for him to send Lady Exeter's picture that Cooper had promised:

with all imaginable respect and kindness to finish it out of hand & actually began it: but then fell dangerously sicke & was confyned to his bed & I very much feare hee cannot possibly outlive 3 days. If hee should live your Lordship shall have it surely exactly compleated: if hee dye I shall redemande that wch was put into his hands & tender it your Lordship. . . .

A facsimile of these two letters is reproduced in the *Catalogue of The Collection of Miniatures The Property of J. Pierpont Morgan,* by Dr. G. C. Williamson, 1906, Pls. LII, LIII.

Charles Manners' prophesy proved only too true, for on the following day Charles Beale recorded in his diary that:

Sunday, May 5, 1672, Mr. Samuel Cooper, the most famous limner of the world for a face, died.

The nature of Cooper's sudden illness is not known, but he must have realised its seriousness when he made his Will only four days before his death and when he described himself as being 'sick and weake in body but of a sound & perfect mind'.

The first mention of Cooper's will appears to be in J. J. Foster's *Samuel Cooper,* when he quotes a few details of the bequests, but does not say where the will was seen. All wills prior to 1858 are now deposited at the Public Record Office, who were unable to trace the actual will, which is said to be mislaid or lost, but of which they had a probate copy from which I obtained a photostat.[1]

[1] See Appendix I

A close scrutiny of this reveals certain important facts that have hitherto been overlooked, and which add valuable information to our knowledge of Cooper's family and friends.

Cooper left bequests of twenty shillings each to buy rings for his cousins John Hoskins junior, his wife Grace, and daughter Mary, as well as to two other cousins Frances and Mary Hoskins, who may possibly have been John Hoskins junior's sisters, although they are not mentioned in the will of John Hoskins senior. Foster gives the spelling of the one as Francis, and it has been assumed that this was John junior's brother, but in the probate copy of the will the name is clearly spelt Frances.

The same sums were left to John, Magdalen and Katherine DeGrange, who were in all probability children of the miniaturist David Des Grange (1611/13—c. 1675), who was a Roman Catholic. Cooper was not as far as we know related to the Des Grange family, who must, however, have been close friends.

The other important fact that emerges from a scrutiny of the will is that Cooper was related to the portrait painter John Hayles or Hales (d. 1679), who was regarded as a rival of Lely and was an imitator and copyist of the works of Van Dyck.

In his will Cooper says 'I give to my cozen John Hayles and to Elizabeth Hayles and Katherine Hayles daughters of the said John Hayles twenty shillings apiece to buy them rings'.

From this it would appear that Pepys had quite a family party at his house on Sunday, 19 July 1668, when he records, 'Come Mr. Cooper, Hales, Harris, Mr. Butler, that wrote Hudibras, and Mr. Cooper's cosen Jacke . . .'.

Although at present no miniatures are known by John Hayles, George Vertue records that:

Samuel Cooper limner, tryd at Oyl Painting. Mr. Hayles seeing that turned to limning & told Cooper that if Quitting limning he would imploy himself that way. for which reason Cooper kept to limning. *Walpole Society*, Volume XVIII, p. 124.

A self portrait in miniature by Hayles is mentioned by Vertue on p. 22, *Walpole Society*, Volume XX:

a head. a limning. in an Oval. the picture of Mr. . . . Hayles painter. done by himself. not well drawn but strongly colour'd . . . this I suppose was one of his essays in Water Colours with intent to oppose. S. Cooper. limner.

[56]

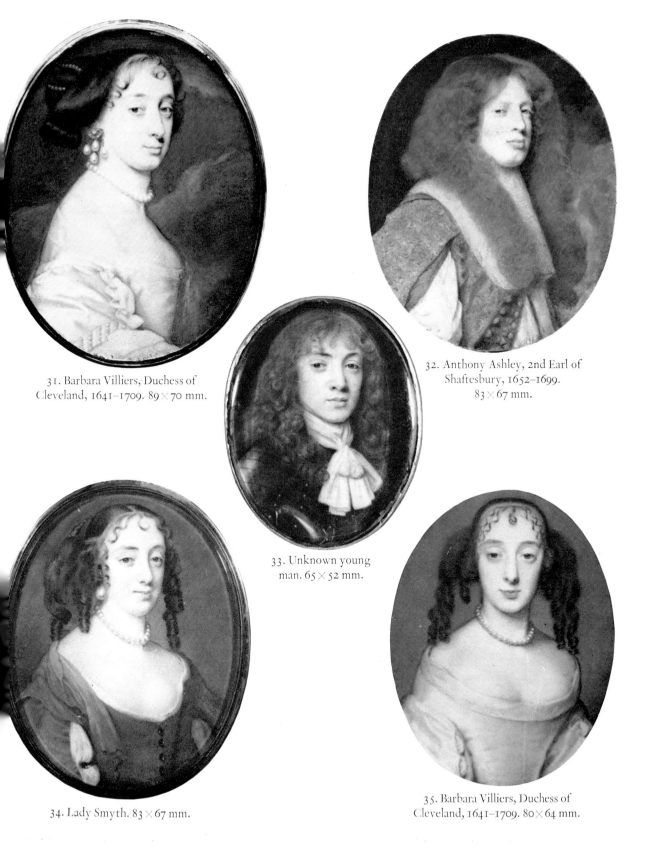

31. Barbara Villiers, Duchess of
Cleveland, 1641–1709. 89 × 70 mm.

32. Anthony Ashley, 2nd Earl of
Shaftesbury, 1652–1699.
83 × 67 mm.

33. Unknown young
man. 65 × 52 mm.

34. Lady Smyth. 83 × 67 mm.

35. Barbara Villiers, Duchess of
Cleveland, 1641–1709. 80 × 64 mm.

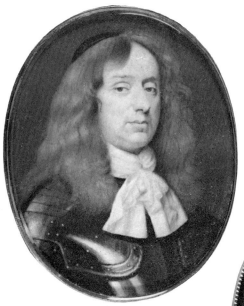

36. Sir Thomas Hanmer,
1612–1678. 73 × 57 mm.

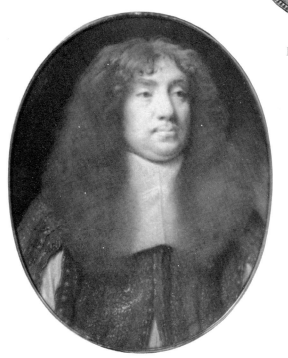

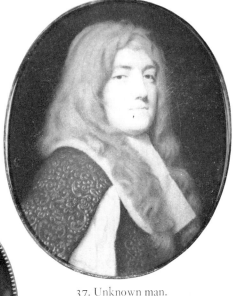

37. Unknown man.
72 × 60 mm.

38. Anne Hyde,
Duchess of York,
1637–1671.
57 × 48 mm.

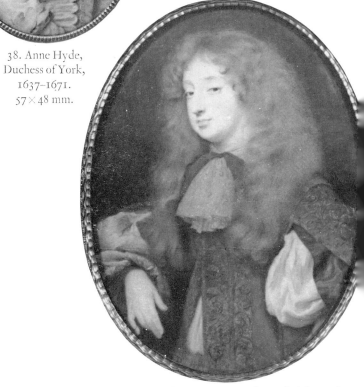

39. John Maitland, 1st Duke of Lauderdale,
1616–1682. 89 × 70 mm.

40. Frances Teresa Stuart, Duchess of Richmond,
1647–1702, in male dress. 98 × 73 mm.

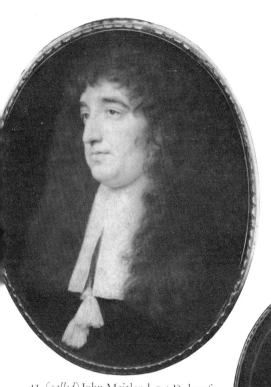

41. (*called*) John Maitland, 1st Duke of
Lauderdale, 1616–1682. 89 × 70 mm.

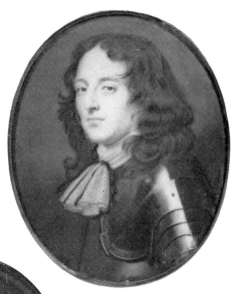

42. Unknown man.
70 × 57 mm.

43. Unknown lady.
67 × 57 mm.

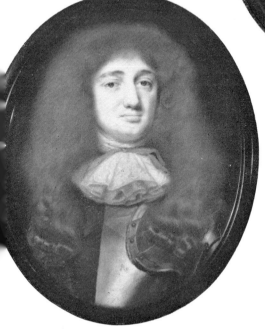

44. Sir Frescheville Holles, 1641–1672.
79 × 65 mm.

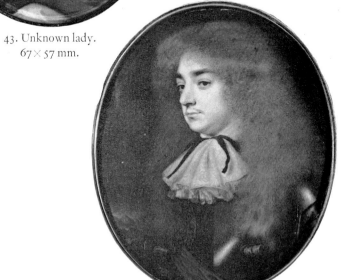

45. Unknown man. 76 × 64 mm.

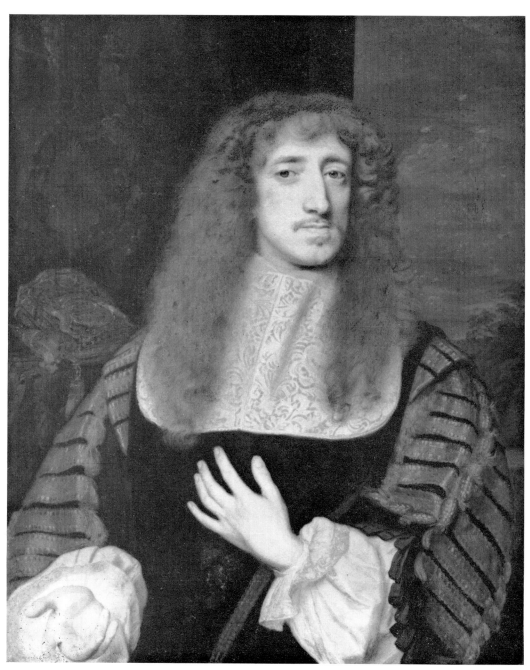

46. Anthony Ashley Cooper, 1st Earl of Shaftesbury, 1621–1683. 210 × 168 mm.

According to Vertue, Hayles lived in Southampton Street, Bloomsbury Square, where he 'dropt down dead in the Garden. being drest in a velvet suit ready to go to a Ld Mayors feast'. A miniature of Hayles by Hoskins is also mentioned by Vertue.

All the remaining part of his estate Cooper left to his wife Christina, or Christiana as she is called in both his will and her own. This included several farms and tenements on the outskirts of Coventry, in the parishes of Exhall and Foleshill, one of which was esti- mated at about thirty acres. How these lands came into Cooper's possession we do not know, nor what contact he had with the area, but as they are not mentioned in Mrs. Cooper's will one can only assume that she parted with them after his death.

Why Cooper expressed a wish to be buried at St. Pancras Church, is difficult to understand, unless he had some connection with the parish at an earlier stage in his life. The parish was quite a distance from Covent Garden, where he had resided for about twenty-nine years, and where his uncle John Hoskins was buried. His widow carried out his wishes, and he was buried in Old St. Pancras Church, which was then situated in the midst of green fields, but which is now in a busy part of London and about half a mile from St. Pancras station. The monument commemorating Cooper and his wife, placed on the east wall of the nave, is said to have been erected by Alexander Pope senior, Mrs. Cooper's brother-in-law, and it has been suggested that the words may have been composed by Thomas Flatman (1635–1688), a follower of Cooper's.

H.S.E.
SAMVEL COWPER Arm:ger
Angliæ Apelles, Sæculi sui et Artis
Decus in quâ excolendâ sicut neminem
quem sequeretur invenit: ita nec qui
eum aſsequatur, est habiturus Supra
Omne Exemplum, simul et Exemplar,
Miniographices artifex summus summis
Europæ principibus notus, et in pretio
habitus cujas porro egregias animi dotes,
Ingenium expolitiſsimum, linguarum
plurimarum peritiam, mores suaviſsimos
ut tam brevis Tabella ritè complecti poſset
ipsius unicè manu delineanda fuit sed
modestior ille, dum per ora, oculosq, omnium

fama volat, cineres hic potius suos optavit
delitescere, ipse in ecclesiæ pace feliciter
Requiescens, una cum chari∫simâ conjuge
Christinâ (et obiit quinto die Maii Anno
MDCLXXII Ætatis suæ 63.)

Quæ Obiit	C A P D	Ætatis Suæ
24. Aug. 93	✠	70

The long Latin inscription can briefly be summarised to mean that: Cooper was the Apelles of England, the glory of his age and of his art, and that he was a consummate artist in miniature, known to and appreciated by the most exalted princes of Europe: to have been unusually gifted, had a most cultured mind, to have been skilled in several languages and to have had charming manners. The date of his death is given as the 5th May, 1672, in the 63rd year of his age.

His will was proved by his widow on 4 July 1672. According to Dr. G. C. Williamson, Alexander and Samuel Cooper were of Jewish extraction, but there appears to be no other evidence for this assumption. Alfred Rubens, in his notes on early Anglo-Jewish artists, *Jewish Historical Society*, Volume XVIII, p. 104, doubts the accuracy of the statement, and Samuel at his own request was buried in a Christian Church.

Mrs. Cooper, who died on 24 August 1693, aged 70, is also commemorated on her husband's monument. At the end of the inscription are the letters 'C.A.P.D.' which Richard Goulding considered could be interpreted to mean 'Curavit Alexander Pope dedicari', which if this is correct would add weight to the suggestion that Pope caused the monument to be erected.

CHAPTER THREE

Christiana Cooper and her Inheritance

When Samuel Cooper died, apart from small bequests to relations and friends, he left all he possessed to his wife, who was his sole executrix. This included property situated on the outskirts of Coventry, and unspecified sums of money which he had lent on mortgage. No mention is made in his will of his limnings or any other paintings which he might have had in his possession, nor did he mention any specific items of household goods and chattles, although we know that he was well housed.

According to Vertue, *Walpole Society* Volume XVIII, p. 118, 'his widow sold all his goods to one Preistman a Wollendrapper corner of Henrietta Street covent Garden'. Whether this was a fact or not we do not know, nor do we know when Mrs. Cooper left the area; certainly she was living in the Parish of St. Giles in the Fields when she made her will twenty-one years later.

Entries relating to Cooper and his wife in *The Calendar of Treasury Books*, Volumes IV–X, are of great interest as they provide the only contemporary evidence that Charles II agreed to give Mrs. Cooper a pension on condition that she let him have 'several pictures or pieces of limning of a very considerable value . . .'

On 17 June 1673, there is an entry which reads as follows:

Money warrant for 118 l. to William Ashburnham, Cofferer of the Household, to be by him paid over to Mrs. Christian Cooper, relect and executrix of Samuel Cooper, His Majesty's limner, being the sum due to him at the time of his death on his annuity, viz. from 1671, Oct. 1, to 1672, May 7: as by the privy seal of 1671, Oct. 25.

Volume IV, p. 173

On the following day June 18, there is another entry:

[59]

Same (Royal Warrant) to the Clerk of the Signet for a Privy Seal for 200 l. per an. to William Ashburnham, Cofferer of the Household, to be by him paid to Miss [sic] Christina Cooper, relect of Samuel Cooper, 'late our limner deceased': there being 'several pictures or pieces of limning of a very considerable value, which are agreed to be delivered into our hands for our own use' by said Christina Cooper, 'whereof we are graciously inclined' to grant her said allowance for life.

Volume IV, p. 180

By 26 February 1675, we find that the pension was already in arrears and that a warrant was issued to William Ashburnham 'to be by him paid to Mrs. Christina Cooper for half a year on her pension in part of two years' arrears thereon to Xmas last'.

It is unfortunate that no detailed list was given of the 'pictures or limnings' which Mrs. Cooper was to have given to the King, and there is no record that these pictures were in fact ever delivered, although it would seem unlikely that any of her pension would have been paid at all if they had not been forthcoming!

With the exception of the sketch of Thomas Hobbes, which was in the collection of James II, and which is now in the Edward B. Greene Collection, the Cleveland Museum of Art, Ohio, miniatures by Cooper were not apparently listed in the Royal collection before Queen Caroline's collection was catalogued by George Vertue in 1743. This list contained the five large sketches which it has always been assumed were the ones given to the King, but in the absence of any documentary evidence we cannot be sure which miniatures were selected by Charles II for his use.

On 24 July 1677, a warrant was issued to Ashburnham for £150 to be paid to Mrs. Cooper for three quarters of her pension of £200 per annum, after which date her affairs are not mentioned until July, 1682.

William Ashburnham had died in 1679 having left a number of persons to whom money was due, and the details of these are given in *The Treasury Books* Volume VII, p. 557, from which it appears that a sum of £1,000 was 'directed to be assigned to Samuell Cooper'.

Charles II died in 1685, and James II succeeded him as King for three unsettled years before he fled to the Continent. On March 19, 1687, we find the last entry relating to Mrs. Cooper:

Same to Board of Greencloth of the petition of Christiana Cooper for payment of the arrears of pension granted to her (late) husband, Samuell Cooper, the late King's Lymner, and after his decease continued to the petitioner; and for payment of said petition to be

settled (upon some reliable fund) for the future.

What arrangements, if any, were then made to pay Mrs. Cooper her pension we do not know, but her name does not appear in the *Treasury Books* again although she lived for another five years.

In 1957 Professor A. Crinò published her discoveries already referred to (see pages 51-2) relating to correspondence between Cosimo III of Tuscany and his London agent, Francesco Terriesi, who was empowered to negotiate with Mrs. Cooper for the purchase of some of her husband's miniatures.

From this correspondence we now know that the artist's widow must have inherited a considerable number of Cooper's miniatures finished and unfinished, many of which are at present untraceable, and most of which appear to have been still for sale as late as 1683. A list was sent to the Grand Duke by Thomas Platt, one time English Consul at Leghorn, with whom Cosimo corresponded for many years. In this list Platt gives a description of nineteen miniatures of great importance which Cooper's widow still had for sale, including among others details of six large sketches, and an even longer list was later made by Terriesi after he had seen the portraits.

The correspondence between Terriesi and Cosimo III regarding the possible purchase of some of these miniatures dates from the latter part of 1670 to 31 December 1683.

The earlier letters relate to the payment for the miniature which Cooper had painted of Cosimo, when he was in London, and which was at last finished. The Grand Duke was anxious to have it as soon as possible, and Terriesi wrote to him on 7 October 1670, telling him that Lord Philip Howard, who was to pay Cooper, was then in Flanders, but that he would go to his house in a fortnight's time, and if by that time he had returned to England he would give him the £150 for the payment. The transaction was evidently duly completed and Terriesi, writing on 5 December 1670, says that the portrait, as has been mentioned before, had been taken to Florence by Sir Bernard Gascoign (or Bernardino Guasconi).

Cosimo had evidently been impressed by what he had seen of Cooper's work, and after the artist's death decided to try to obtain some more examples of his paintings for his collection. He indicated his wishes to Terriesi, and asked him to be on the lookout for good miniatures by Cooper which he could purchase.

On 31 July 1674, Terriesi wrote to tell the Grand Duke that the majority of the miniatures left after Cooper's death were unfinished, but that some of his commissioned works could be bought including one of Lady Cavendish which he could have for £16,

and one of the 'late Duke of Richmond' in a gold box for £40. He did not consider the remaining portraits were very well done, but hoped that in due course he would find some others.

In his reply 4 September 1674, the Grand Duke tells his agent that he is pleased to hear what he has to say about Cooper's works and that he would like him to buy the miniature of Lady Cavendish. He goes on to give details of some of the portraits he remembers seeing in Cooper's studio:

I recall having seen in the house of this painter two rather fine portraits, one of Madame the Duchess of Richmond when she was a young girl, and the other of the old General Monk, father of the present Duke of Albemarle. If these should be for sale you should endeavour to buy them, for I remember that they were well executed with much spirit, and charm, although the first mentioned was not completely finished . . . Please send the small portrait of my Lady Cavendish at once, either in a parcel by Courier through Lyons, or to my Agent in Paris who will send it to me in his diplomatic bag.
As to the portraits of Madame Richmond and General Monk it may help you to notice them that they were in frames of a span and in each case the portrait was to the knee and of the same size as my portrait which you sent me.

Terriesi writing to his master on 18 September 1674, explains that he is not able to send the small portrait of Lady Cavendish straight away as the person who has it is not in town, but that when he returns he will send it as soon as possible. He adds that if he can serve the Grand Duke in the matter of the portrait of the Duchess of Richmond as a girl and that of old General Monck, he will send them by the same channel.

A month later, on 16 October, Terriesi informs Cosimo that the miniature of Lady Cavendish has been sent, and expresses the hope that it has reached him safely. No mention is made of the portrait of the Duchess of Richmond, or that of Monck and no further negotiations seem to have taken place for two years, but the matter was not forgotten, for on 15 February 1676/7[1] the Grand Duke wrote to Terriesi from Pisa telling him that he had heard that Mrs. Cooper had quite a number of unfinished miniatures by her husband that she was hoping to sell and that he would be glad to have that of General Monck, the Duke of Monmouth at the supposed age of 15, the Duchess of Richmond when she was 16 or 17, and the Duchess of Cleveland. Mrs. Cooper was apparently asking £50 each for the first three, and £30 for the last one, which considering

[1] The calendar then in use in Florence made the year begin on 25 March. The Grand Duke's letter, though dated 1676, would be 1677 by our dating.

[62]

their unfinished state he thinks are too expensive. He asked Terriesi to try to buy them at a cheaper rate, especially the one of Monck if the head is well finished, but if only sketched 'it is of no interest to me'. The Grand Duke adds a postscript that if they cannot be bought at a reduced price he will not have them!

The Grand Duke enclosed with his letter a slip of paper on which was a list copied from the original written by Thomas Platt, who it is thought sent it from London, knowing that the contents would be of interest to Cosimo.

The list is of the utmost importance, for it provided detailed information about the identity of many of the portraits left in Cooper's studio on his death. The details are as follows:

Cooper's widow has in her possession these originals of the same size as the picture of His Serenity the Grand Duke but without draperies. They are not finished except for the heads and are priced at £100 each but are in fact being sold for £50.
The Queen
The late Duchess of York
The Duchess of Richmond at 16 or 17 years of age
The Countess of Sunderland
The Duchess of Cleveland
The Duke of Monmouth at the age of 15
General Monck
There are these other portraits that are of a smaller
size and are valued at £30.
The Duke of York
The Duke of Monmouth
Madame the late Duchess d'Orleans
The Duchess of Cleveland
Miss Kirck, now Countess of Oxford
The Duke of Richmond who died in Denmark
Oliver Cromwell
Mr. Hobbes
The Countess of Suffolk
Miss Price, Wife of Mr. Skelton ⎫ formerly maids
 ⎬ of honour
Miss Bointon, Wife of the Earl of Roscommon ⎭ entirely finished
The present Chancellor just begun, and could be bought for less than £20 sterling.

Five of the large unfinished miniatures listed by Platt, representing Queen Catherine of Braganza, the Duchess of Richmond, the Duchess of Cleveland, the Duke of Monmouth, and General Monck, appear to be identical with those now in the collection of H.M. the Queen, and it has always been assumed that they were in all probability the portraits for which Charles II granted Mrs. Cooper a pension. The fact that miniatures answering to the same description were being offered to Cosimo III as late as 1677, and some may even have been in a later list of 1683, leaves the matter in some doubt.

On 26 February 1676 (old style), Terriesi wrote to the Grand Duke and assured him that he would do his best to obtain the portraits he wanted and that he would inform him of the result. This was followed up on 2 March by another letter admitting that he had still not seen the miniatures in question. Furthermore he is disturbed to hear that some of the unfinished portraits were later 'finished by one of his pupils', but hopes to obtain some other miniatures which were not in the widow's possession.

In a letter written on 12 April by the Grand Duke to Terriesi, Cosimo expresses the hope that his agent will be able to purchase some of Cooper's portraits 'from other hands than those of Cooper's widow, because those left to her by her husband were unfinished and had to be finished by a pupil'.

By this time Terriesi is obviously getting discouraged about the whole business and is afraid of being made to pay more than the miniatures are worth, or being cheated by purchasing one that has been finished by another artist, and there the matter seems to have rested for a further two years.

In spite of this lapse of time Cosimo had evidently not forgotten his desire to obtain more of Cooper's works, and on 18 February 1679, his secretary Apollonio Bassetti wrote to Terriesi in London to ask if he could obtain a detailed list of the portraits by Cooper that were in the King's closet giving specific information as to which were the finest.

The agent promised to do his best to comply with this request as soon as possible, but had to write later saying that there would be some delay as the King was at Newmarket and it was not possible to get this information in his absence.

Whether Terriesi was unable to obtain this information, or forgot about it, we do not know, but there is no further mention of the miniatures in the King's collection after that date, and as far as is known no list was ever sent. In December 1681, Terriesi sent the Grand Duke a miniature containing the portraits of King James and the Royal family, which he explains is not by Cooper, but that as he was able to buy it for a moderate price he does not think it will matter if he has made a mistake.

[64]

As late as 1683 Mrs. Cooper had evidently still failed to sell her husband's miniatures, which seems astonishing in view of his great popularity. In what turned out to be a final effort to interest Cosimo in them she sent all the miniatures round to Terriesi's house in the hopes that he would advise his master to buy them. The agent wrote off to the Grand Duke on 24 September 1683, telling him this and informing him that he would make a list giving details of the portraits, and that he was asking Benedetto Gennari (1633–1715) to advise him in the matter. He explains that the faces of some of the miniatures are almost finished and suggests that the busts and accessories could be finished by someone else! presumably in Florence. Cosimo is by this time clearly in no mood to pay more than he has to for the portraits and wrote to Terriesi on 29 October 1683, from Ambrogiana, one of his villas, to say that he was glad to get the report, and would like a detailed description of the portraits together with the lowest price for each.

The list was sent together with a letter from Terriesi on 1/11 October, but little enthusiasm is shown about the possible purchase. Terriesi explains that Mrs. Cooper is asking the same price as Cooper obtained in his lifetime for finished works, and he feels that they are not worth the money, but that she would be willing to reduce the price if Cosimo will take them all. Terriesi adds that he will do what he can to bring her to reason, but that for his part he does not see any special reason why the Grand Duke should want to possess portraits of such people.

The list of portraits as supplied to Cosimo III is as follows:

His Royal Highness The Duke of York, the face finished and beautiful, with a great likeness, the remainder only a sketch.
The Duke of Richmond who died in Denmark, the face finished and the rest in sketch only.
The Duke d'Orleans, only a sketch.
My Lady Fanham, the face finished, the rest little more than a sketch.
Mrs. Price, lady in waiting, face finished and the rest only sketched.
The Queen Mother of Spain when she was a child, sketched only.
Mrs. Boyngton, lady in waiting, almost finished.
The Duke of Monmouth at the age of 15 or 16, almost finished.
The late Lord Chancellor, before he was made Chancellor, little more than a sketch.
Mrs. Roberts, the King's mistress, face almost finished the rest nothing.
The Duke of Monmouth, just begun.
A lady, finished, but not thought to be by Cooper.
Mrs. Cullins, face finished.

[65]

The Duchess of Cleveland, face and head finished and beautiful, but nothing else.
Mother of My lord Rochester, finished but not of much interest.
Roxelaina the comedy actress who was the wife of My lord Oxford, face finished and the rest blank.
An English gentleman, finished and well done.
Mr. Lentul, all finished and well done.
Wife of My lord Anglesea, the face finished and nothing else.
Wife of My lord Anglesey, the face finished, bad ('*cattiva*'), and nothing else.
My lady Sunderland, as a young girl, face finished and nothing else.
All in ovals of about the size of four fingers, like that already mentioned which Cooper painted for your serene Highness.
 Rather more than quarto size
My lady Sunderland, face finished and nothing else.
My lady Shrewsbury, only sketched.
The deceased Duchess of York, face finished and nothing else.
The old Duchess of Richmond, only a sketch.
There are also little sketches of ladies and gentlemen which I do not consider are of any importance.

The Grand Duke received the list, but judging from his reply written from Ambrogiana on 5 November 1683, he was no longer enthusiastic about the whole affair, and does not think that the expense is justified in view of the condition of the portraits. He does however still want to buy the miniature of the Duke of York, and tells Terriesi to negotiate for this one and ignore all the others, but to be careful to see that the sum paid is justified.

Terriesi had in the meantime written to Cosimo to say that he is doing his best to obtain a reduction in price, from Cooper's widow, but that he is doubtful if they are worth having!

On 19/29 November, Terriesi wrote to inform the Grand Duke that he would do his best to bargain for the miniature of the Duke of York, but that Mrs. Cooper is still standing by her demand for £30, the price her husband was paid when he was alive, and that he thinks this price excessive. He adds 'the said woman has now sent to my house the portrait of Cromwell painted by her husband, but it was neither finished nor shaped, being only the head which seems to me well enough painted'. This portrait was not included on the list of those sent previously to Terriesi, but was probably the one on Platt's list. Terriesi says that if he has the approval of Gennari, or some other expert, he

will take the liberty of purchasing both miniatures.

Cosimo replied to this letter from Ambrogiana on Christmas Eve, and appears to accept the fact that both miniatures are to be bought for him. When Terriesi saw the portraits again, however, he came to the conclusion that they were not worth the £25 each which was the lowest price that Mrs. Cooper would consider, and in a letter written to the Grand Duke's secretary Bassetti on Friday, 23 November/3 December 1683, he tells him that he does not after all consider the miniatures worth the money asked, and that he has refused to buy them, and that unless 'his Highness by express command renews the commission' he has arranged to leave them with her. On the following Monday Terriesi wrote to the Grand Duke confirming what he had said and adding that in his opinion the work was so poor that the portraits were not worth more than '5 doppie'.

Cosimo replied on 31 December 1683 to the effect that as Terriesi valued the two miniatures of the 'deceased Cooper' so little he agreed that it was better to leave them where they were rather than spend money pointlessly.

The fact that both Gennari and Terriesi failed to appreciate the artistic merit of these unfinished portraits deprived Florence of what might have been a unique collection of some of Cooper's finest works.

As it is only three miniatures by Cooper are in the Uffizi, namely those of Cosimo III (damaged and now repainted), Frances Teresa Stuart, Duchess of Richmond, and an unknown lady, at one time thought to represent Lady Cavendish. These portraits were exhibited at the *Firenze e L'Inghilterra* exhibition held at the Pitti Palace, Florence, in 1971.

What ultimately became of the miniatures which Mrs. Cooper offered to the Grand Duke we do not know, but in her will, which was not made until 1693, she bequeathed among other things, to her cousin John Hoskins 'all my said husbands pictures in Limning which I shall have by me at the time of my decease'. What became of those that her cousin inherited is a matter for conjecture, nor do we know the number. It may be that they were ultimately sold, and there is a possibility that some of them were purchased by Susan Penelope Rosse, and were among those sold by her husband in 1723. It is significant that a number of the same sitters' names occur in the Rosse sale catalogue, where several miniatures are stated to be by Cooper, and others which may possibly also have been by him, were listed without the artist being identified.

The cataloguing may not have been entirely accurate, and many of the other miniatures listed could have been either by Cooper, or by S. P. Rosse after him.

Mrs. Cooper made her will on 16 May 1693, just three months before her death, when she was living in the parish of St. Giles in the Fields, in the County of Middlesex. She left her nephew Samuel Mawhood, 'cittizen and ffishmonger of London', her sole executor, and apart from numerous bequests to friends and relatives he inherited all her remaining estate. In her will she asked that she should be buried in the Parish Church of St. Pancras, as near to 'my deare husband as may be' and that her funeral expenses and the charge of a monument to be erected over her grave should not exceed fifty pounds.

Samuel Mawhood was presumably the son of her sister Alice Mawhood, to whom she left five pounds; to another sister Elizabeth Turner she left 'one of my broad pieces of gold'. This coin, of which she left eleven to different people, was first issued in 1619 by James I, and was worth at the time twenty shillings, the sum often left to buy mourning rings. Elizabeth also received all Mrs. Cooper's 'bookes pictures meddalls sett in gold and others for the term of her naturall Life'; on her death these articles were to go to Mrs. Cooper's nephew and godson Alexander Pope, to whom she also left 'my painted china dish with a silver foote and a dish to sett it in'. To another sister, Mary Turner, she left ten pounds, and 'to my sister Pope' (Alexander Pope's mother) 'my necklace of pearls and a grinding stone and Muller and my mother's picture in Limning'. Two other sisters are mentioned in the will, 'Mare' to whom she left five pounds, and Jane Smith, to whom she left one hundred pounds, which was to be paid out of a sum of two hundred pounds which was recoverable on the death of Sir Marmaduke Gresham to whom she had apparently lent it. Jane was also to receive Christiana's 'best suite of Damaske conteyning three table clothes and one Dozen of Napkins'. Broad pieces of gold were left to 'my brother Pope'; 'my brother Mare'; 'my brother Calvert'; and 'my brother Smith', and to 'my nephew Samuel Mawhood'. To her nephews William, John, Richard, George, Charles and Thomas Mawhood, Mrs. Cooper left five pounds each, and to her niece 'Ffrances Broughton' five pounds; to her nephew and godson, James Calvert, five pounds, and to her niece Jane Mawhood, daughter of Samuel Mawhood, five pounds. Charles Mare, another nephew, and presumably the son of the sister of that name, also received five pounds. Another nephew 'ffrancis Durant Junior' received five pounds 'to be paid him when he shall attain his age of one and twenty years'. To her cousin Edward Bostock and his wife, and to another cousin Katherine Prior she left five pounds each.

Numerous other bequests of money and possessions were left to friends including five pounds to Dr. Andrew Popham.

[68]

CHRISTIANA COOPER AND HER INHERITANCE

The bequest which is of particular significance is that made to the Hoskins family which was as follows:

to my Cozon Mr. John Hoskins and his wife fifty pounds a piece and to and amongst their children fifty pounds Item I give to my said cozon John Hoskins my husbands picture in crayons with all my said husbands pictures in Limning which I shall have by me at the time of my decease and alsoe Sr Peter Lilly's picture in oyle and to my cozon Hoskins his wife my longe looking glass and dressing box quilted with silk . . .

It is unfortunately impossible to be sure which John Hoskins is the one referred to in the will. If it is Cooper's 'cousin Jack', son of John Hoskins senior, he must have been an old man by 1693 as assuming that the two men were near contemporaries 'cousin Jack' would have been over eighty. The alternative is, of course, that this cousin was the third generation and a grandson of Hoskins senior.

It is tantalising not to know what miniatures this Hoskins inherited and what became of the portrait of Cooper in crayon. The reference to Sir Peter Lely's picture is also ambiguous, and one is left to conjecture whether this was of Lely, a portrait of Cooper by Lely, or just a portrait in oil by Lely of some unknown person.

Mrs. Cooper made ample provision for her maid Ursula Lassells providing that she was still with her at the time of her death. She left her twenty pounds, and all her clothing, table linen, bed linen, bedding, 'two Indian quilts', a fire stove, fender, fire-shovel and tongs, brassware, trunks, items of furniture, and 'my Spanish peece of gold and silver drinking cup and spoone . . .'

The will was signed on the sixteenth of May 1693, and witnessed by Rogor Higginson, Mary Rudd and Joseph Stratton Snr.

Christiana Cooper died three months later on the twenty-fourth of August, and her wishes regarding her burial were carried out and she was laid to rest beside her husband in St. Pancras Church. The monument which was placed on the east wall of the nave on the south section bears an inscription which translated records that he 'reposes in the peace of the church with his wife Christina'.

CHAPTER FOUR

The Artist

In order to assess the true merits of any artist it is necessary to examine as many of his authentic works as possible, covering the whole of his working life, and to take into account the influence that earlier or contemporary artists may have had on him.

In the case of Cooper it is presumed that he had his initial training under his uncle John Hoskins, and it has always been said that in the course of time, due to his ability to catch a likeness, Cooper was employed to paint the faces of Hoskins' sitters, whilst the older man painted the backgrounds. If this statement is true, it adds to the already difficult problem of identifying Cooper's early works.

Cooper was certainly influenced at the outset by his uncle, and there is also no doubt that like many other artists he came under the influence of Van Dyck, whose portraits he is sometimes said to have copied in miniature. If this is a fact, these copies were probably executed early in his career and it seems likely that they were all painted prior to *c.* 1640. A handful of miniatures attributed to Cooper and assigned to the 1630s were discussed by Graham Reynolds in an article, 'Samuel Cooper: some Hallmarks of his Ability', published in the *Connoisseur*, February 1961. The miniatures in question were of Henry Rich, Earl of Holland, at Ham House, and at one time attributed to Hoskins, an 'Unknown Man', signed *S.C.*, and one of a man once said to represent Robert Devereux, 3rd Earl of Essex, both the latter portraits being in the collection of H.M. the Queen.

Another important miniature thought to have been painted before 1640 is that of Margaret Lemon, in male costume, formerly in the Pfungst Collection, and more recently in the collection of M. F. Lugt now housed in the Institut Néerlandais, Paris. The identity of the sitter, who was one of Van Dyck's favourite mistresses, is unquestionable, as her name is inscribed in monogram on the front of the portrait, which is also signed *S.C.* The

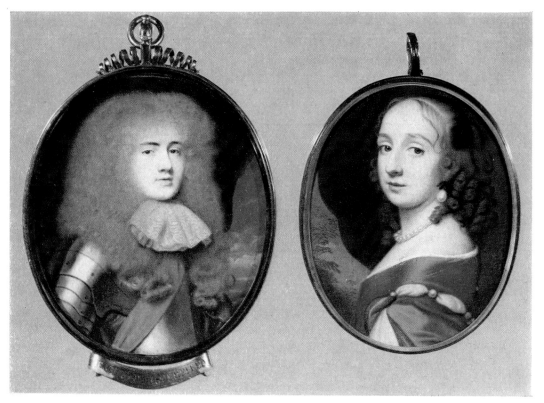

10. James Scott, Duke of Monmouth and Buccleuch, K.G., 1649–1685. 76×64 mm.

11. Mrs. John Claypole, née Elizabeth Cromwell, 1629–1658. 70×57 mm.

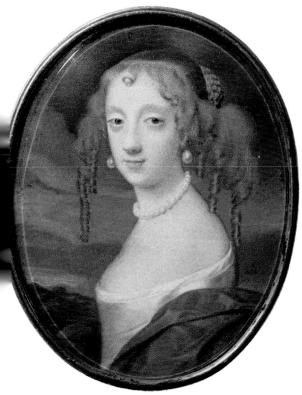

12. (*called*) Barbara Villiers, Duchess of Cleveland, 1641–1709. 86×70 mm.

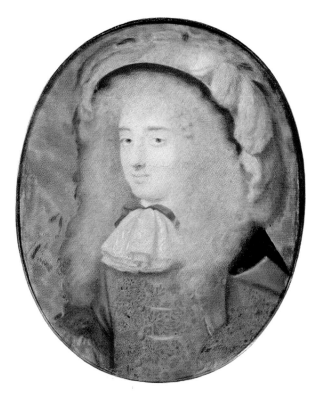

13. Frances Teresa Stuart, Duchess of Richmond, 1647–1702, in male dress. 89×76 mm.

miniature is not a copy of any known portrait of the lady, although Van Dyck painted her several times, and the fact that this is the only accepted portrait of her other than those by Van Dyck suggests that a close friendship may have existed between the two artists. The costume appears to be that of about 1635, and this would accord with the story that the relationship between Van Dyck and his mistress broke up after his marriage in 1639. Margaret Lemon is said to have been so angry at his marriage to Lady Mary Ruthven, that she tried to damage the artist's right hand, and that she subsequently went abroad and married.

The miniature is of outstanding merit, and shows that the artist's style had already reached maturity, and that he had succeeded in adapting Van Dyck's technique in a manner suitable for portraits painted in water-colour on a miniature scale.

It is not possible to give a clear assessment of Cooper's early work due to the fact that, up to the present, no dated works occur before 1642. Many of his miniatures may well be attributed to Hoskins, and date from the period when the two men's work merged so closely together. Two unattributed miniatures in the collection of the Earl of Haddington, representing Sir John Hamilton (1605–1647), and John, 6th Earl of Rothes (1600–1641), may be early examples of Cooper's work. The draughtsmanship of the features is rather tentative, and painted with thin brown lines, but the hair is very much in the manner of Cooper's later style. Certainly neither portrait could be by Hoskins.

His earliest dated portrait is that of Elizabeth Cecil, Countess of Devonshire (1620–1689), signed and dated: *Sa: Cooper pinxet Aº: 1642*. This is in the collection of the Marquess of Exeter, Burghley House. The sitter was the second daughter of William Cecil, 2nd Earl of Salisbury, and grand-daughter of Treasurer Burghley. She became the wife of the 3rd Earl of Devonshire in 1639, and was the mother of Anne, wife of the 5th Earl of Exeter, to whom she left the miniature in her will.

From the excellence of the portrait it is clear that Cooper's art had reached a high standard by this time. The size of the format is $6\frac{1}{8} \times 4\frac{5}{8}$ inches (156 × 117 mm.), considerably larger than usual; it shows the Countess three-quarter length, her hands folded in front of her and standing against a wall draped with a curtain to her right, and a window through which one can see trees to her left.

As with any artist it is necessary to study Cooper's works in depth before one is fully conversant with his style and characteristics. This is not always easy, as by far the greater number of his most important portraits still remain in private collections, which because of their value and fragility are not often on display to the public.

The greatest of these collections are those of H.M. the Queen, the Duke of Portland and the Duke of Buccleuch, whilst others are owned by the Marquess of Exeter, Earl Beauchamp, Viscount Bearsted, the Duke of Devonshire and the Duke of Richmond and Gordon, to mention a few.

Among the miniatures available to the public are those in the Victoria and Albert Museum, the National Portrait Gallery, the National Maritime Museum, the Fitzwilliam Museum, Cambridge, the Ashmolean Museum, Oxford, the Uffizi, Florence, the Mauritshuis, The Hague, the Institut Néerlandais, the Cleveland Museum of Art, Cleveland, Ohio, and the Nelson Gallery-Atkins Museum, Kansas City, Missouri.

One of the early assessments of Cooper's art is given by Horace Walpole in his *Anecdotes of Painting*, Volume III, 3rd edition, pp. 110–116, in which he says:

Samuel Cooper. Owed great part of his merit to the works of Vandyck, and yet may be called an original genius, as he was the first who gave the strength and freedom of oil to miniatures. Oliver's works are touched and re-touched with such careful fidelity that you cannot help perceiving they are nature in abstract; Cooper's are so bold that they seem perfect nature only of a less standard. Magnify the former, they are still diminutively conceived: if a glass could expand Cooper's pictures to the size of Vandyck's they would appear to have been painted for that proportion. If his portrait of Cromwell could be so enlarged, I don't know but Vandyck would appear less great by the comparison.

Later Walpole comments on Cooper's skill as a draughtsman, and whether we agree with his views or not they are worthy of our consideration. He says:

Cooper with so much merit had two defects. His skill was confined to a meer head: his drawing even of the neck and shoulders so incorrect and untoward, that it seems to account for the number of his works unfinished. It looks as if he were sensible how small a way his talent extended. This signal deficience in a painter of portraits—yet how seldom possessed! Bounded as their province is to a few tame attitudes, how grace atones for want of action! Cooper content, like his countrymen, with good sense of truth, neglected to make truth engaging.

Of Cooper's portraits of ladies, Walpole says: Cooper's women like his model Vandyck's are seldom handsome. It is Lely alone that executed the galantries of Charles II.

In spite of these criticisms, Walpole obviously considered Cooper a great artist and

[72]

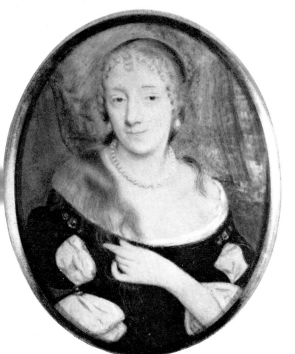

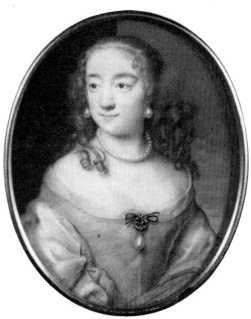

48. Charlotte Paston, Duchess of Yarmouth,
c. 1650–1684. 83 × 70 mm.

47. (*called*) Lady Hardinge.
89 × 70 mm.

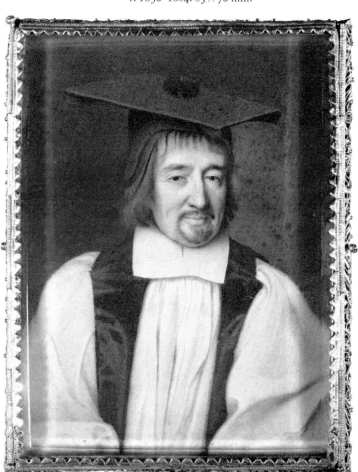

49. Gilbert Sheldon, Archbishop of
Canterbury, 1598–1677. 114 × 86 mm.

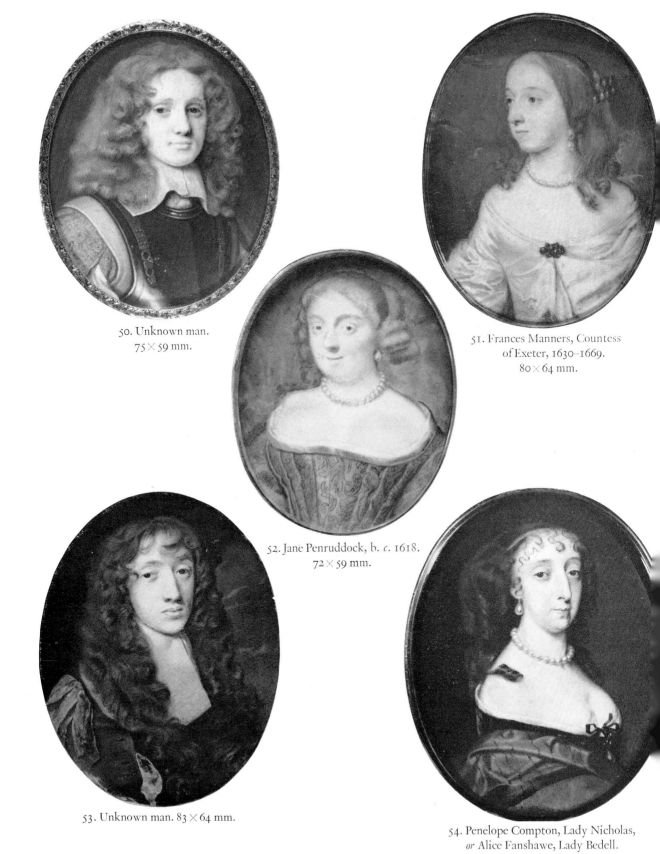

50. Unknown man.
75 × 59 mm.

51. Frances Manners, Countess
of Exeter, 1630–1669.
80 × 64 mm.

52. Jane Penruddock, b. c. 1618.
72 × 59 mm.

53. Unknown man. 83 × 64 mm.

54. Penelope Compton, Lady Nicholas,
or Alice Fanshawe, Lady Bedell.
89 × 70 mm.

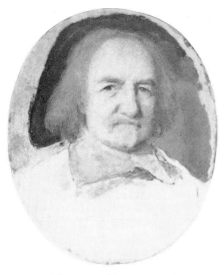

55. Thomas Hobbes, 1588–1679.
67 × 57 mm.

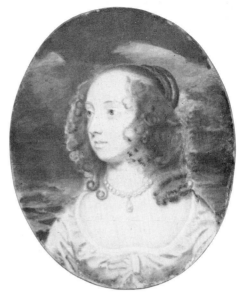

56. Lady Elizabeth Percy. 73 × 60 mm.

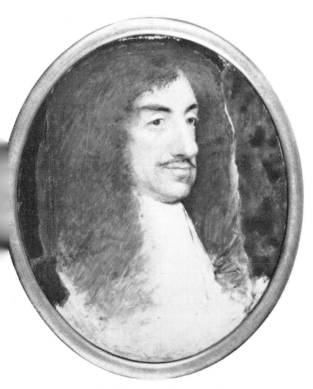

57. Charles II, 1630–1685. 92 × 76 mm.

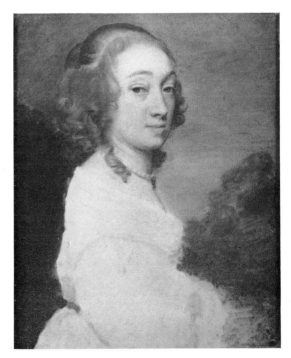

58. Mrs. Samuel Cooper, née Christiana Turner,
1623?–1693. 89 × 73 mm.

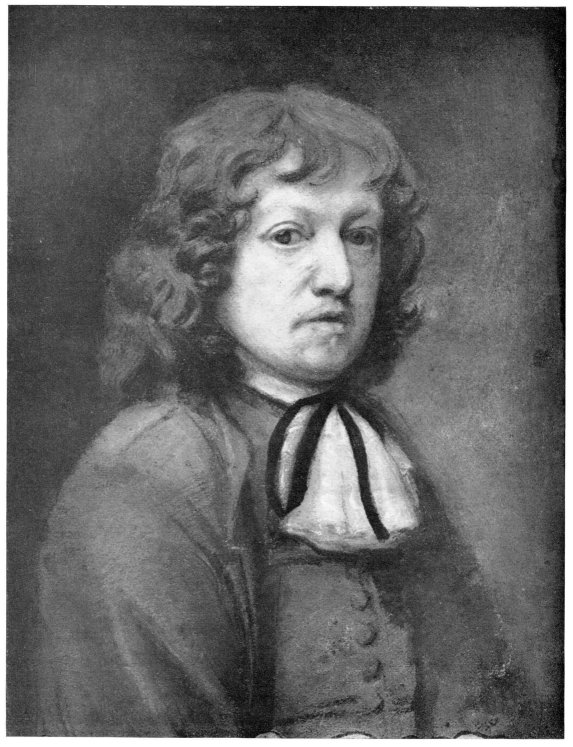

59. Samuel Cooper, 1609–1672. 245 × 194 mm. Self portrait?

remarks: 'The anecdotes of Cooper's life are few; nor does it signify; his works are his history.'

This last comment has proved to be true, for the passage of years has not affected Cooper's reputation in any way, rather the reverse, and it is doubtful if many critics would agree with Walpole. Other tentative suggestions have been put forward to account for the large number of unfinished portraits, and the reason why Cooper concentrated on the face of his sitters to the exclusion of the dress and backgrounds.

'Was Samuel Cooper influenced by Rembrandt?' is a question posed by Graham Reynolds in an article in the *Victoria and Albert Museum Bulletin*, Volume II, No. 3, July 1966. No definite conclusion on this question can be arrived at, and the only justification there is for considering it is the fact that Cooper is known to have visited Holland. The precise date of his visit or visits is still not known, but it is generally assumed that the most likely years are those between 1630 and 1635. His brother Alexander had preceded him, and by 1631 was already well known to the artistic community and would therefore have been in a strong position to introduce Samuel to most, if not all, the artists of note. In this connection it is inconceivable that the two artists should not have met. Rembrandt had by 1632 painted his first major portrait group, *The Anatomy Lesson of Dr. Nicholaes Tulp,* and thus established his success as a portrait painter in Amsterdam, and it seems reasonable to suggest that Cooper would almost certainly have made it his business to see some examples of Rembrandt's portraits which were causing such a stir in Holland. Whether or not he was influenced by the new realm of dramatic lighting which Rembrandt introduced we may never know; what we do know is that in ascribing a miniature to Cooper it is important to note how the highlights fall upon the top and lower lid of the left eye, and are separated by the shaded white of the eye itself. This is one of the surest ways of distinguishing Cooper's work from that of his followers such as Thomas Flatman and Nicholas Dixon, neither of whom succeeded in achieving such a dramatic effect.

Bernard Lens III (1682–1740) was one of those who copied many of Cooper's miniatures, and reiterated what others had said before, that Cooper was styled 'Van Dyck in little', and Graham Reynolds writing in *English Portrait Miniatures*, 1952, p. 49, asserts that:

though a modern critic would certainly agree that he is, irrespective of scale or medium, the greatest Englishborn portrait painter of the seventeenth century, in every way comparable with van Dyck and subtler and more forceful than Lely.

In 1957 David Piper published his fascinating study, *The English Face,* in which he discusses faces of different periods in history as depicted by portrait painters, miniaturists, caricaturists and photographers. He makes several references to Cooper who, he says, is for him one of the greatest British portraitists and that (p. 116):

indeed as a face-painter I would claim that he has no rival in Europe in the seventeenth century . . .

I think it is safe to say that this reputation, having stood the test of three hundred years, will continue to do so in future generations and that the 'Greate tho' little Limner' will live on through his portraits so long as there are those who appreciate art.

It is a well-known fact that a large number of Cooper's miniatures are unfinished, and the reason for this was not necessarily that he had so many commissions that he had not time to finish them (with the exception of those painted just before his death), nor that he left them unfinished because he was only interested in the face. I think it probable that many of them were sketches which he kept by him in order that he might be able to produce replicas at a later date if they were required. This was a practice employed by other artists in different periods, including John Smart in the eighteenth century.

There is no doubt that some of these unfinished portraits are among his finest works. The superb large unfinished miniatures representing the Duke of Monmouth as a boy, General Monck, Queen Catherine of Braganza, the Duchess of Richmond and the Duchess of Cleveland, all in the collection of H.M. the Queen, were in all probability sketches which he would have used for repetitions.

Of all the portraits which Cooper painted, the one which has aroused the greatest feeling is unquestionably that of his unfinished sketch of Oliver Cromwell, in the collection of the Duke of Buccleuch. This portrait, which has been reproduced countless times in books of art and history text books, expresses as Graham Reynolds puts it 'the meeting-place of two contemporary men of genius'.

Legends have been woven round it which even if not true have added to its romance. The Frankland family, who were descendants of Cromwell, from whom the miniature passed to the Duke of Buccleuch's collection, avow that there was a tradition in the family that Cromwell caught the artist in the act of making a copy of the picture, and took it away, thus accounting for its unfinished state.

Vertue, however, records a different story: *Walpole Society,* Volume XVIII, *Vertue I,* p. 31:

THE ARTIST

The Picture of Oliver Cromwell a limning by Samuel Cooper the head only finish't suppos'd to be the best of him it being the very picture Oliver Sate for, the others as Mr. Graham was & others copy'd from this and touch't up by the Life. This picture Cooper kept for himself till Oliver died when his son Richard Protector heard of it Sent a Gentleman for it with twenty pounds to pay for it (that being Mr. Cooper's price), but Cooper knowing its super excellence to the rest & what he coud make by coppies, would not part with it under a hundred pounds which the Protector [i.e. Richard] was Obliged to give him; he gave it to his Sister the Lady Falconbridge [Fauconberg] & she before she died made a Present of it to Sr Thomas Franklin [*sic*] in whose possession it now is. Twas Richard Cromwell that paid Cooper for it after the death of Oliver.

In a further note Vertue says:

Mr. Armstrong has seen both these pictures often on a day. & judges the Oliver of Mr. Graham to be infinitely better. but the other to be older last painted.

One further piece of information by Vertue regarding the miniature of Cromwell, *Walpole Society*, Volume XVIII, p. 118, is of interest:

the original limning of Oliver Cromwell painted by Cooper the face only finisht. (when he died. it was design'd to have been an half length.) but no part of the body was done by him. Cooper kept it by him unfinisht to make coppies for several of Olivers relations one of which was that P. Eugene bought when in Engld. the original of all, was Cutt into an Oval form, by Mr. Cross the limner by order of a Relation of Cromwells it's said that Richard Cromwell paid 100 ll pounds to Cooper. for the very picture as it was.

The date on which the Buccleuch portrait of Cromwell was painted is uncertain. It is known that Cooper was working for the Cromwell family by *c*. 1650, and possibly earlier, and a miniature of Cromwell's wife Elizabeth, signed and dated: *S.C./1651*, is in the collection of the Duke of Buccleuch, and one of his daughter Elizabeth (Mrs. Claypole), signed and dated: *SC/1653*, is in the collection of the Duke of Devonshire, who also possesses a portrait sketch of the Protector in profile, showing him as an older man, and also considered to be by Cooper.

The unfinished portrait, painted *c*. 1650–53, was undoubtedly kept by the artist as a prototype from which to execute finished versions as and when required.

Of these latter finished portraits none have so far come to light dated before 1656,

although portraits of Cromwell were in demand for presentation to foreign diplomats soon after his proclamation as Lord Protector in December 1653.

David Piper in his article in the *Walpole Society*, Volume XXXIV, pp. 27–40, discusses the whole question of contemporary portraits of Cromwell, including the miniatures, and the vexed question as to whether or not there was any connection between the large portraits painted by Robert Walker and Sir Peter Lely, and the Cooper miniatures.

The portrait by Lely and that by Cooper are so close that it seems inconceivable that the one had no connection with the other. A prolonged study of the paintings leaves one with the firm conviction that Cooper has given us the man as he really was, and that we do not have to look any further for the answer as to which was the original portrait.

In *The English Face*, pp. 115–126, Mr. Piper again discusses the Cooper portraits and says:

It is to Cooper's portrait that I return again and again, and it is an image in the light of which all accounts of Cromwell should be read. It enobles Warwick's account of him speaking in Parliament, in a plain ill cut cloth suit:
his linen plain and not very clean . . . a speck or two of blood upon his little band . . . his countenance swollen and reddish, his voice sharp and untunable and his eloquence full of fervour.
It cancels the grudgingness in Clarendon's great assessment, and exposes Evelyn's description as peevish partisanship. . . . It is for me one of the most moving, one of the greatest of British portraits.

One of several versions by Lely of Cooper's portrait is in the City Museum and Art Gallery, Birmingham, and thought to have been painted *c.* 1654.

Needless to say, Cooper's miniature of Cromwell has been copied many times by artists of different periods, notably Bernard Lens III, Christian Richter (1678–1732), Susan Penelope Rosse (1652–1700) and Charles Bancks, a Swede (worked 1738–1792), whose copy, executed in pen and wash, and signed and dated: *CB fecit/1738,* is in my collection. This latter miniature was once in the possession of John Gage (1786–1842), antiquary and barrister.

Cooper seems to have painted a number of miniatures of the Protector's family, including his son Richard, and his daughter Bridget (Mrs. Ireton), wife of Henry Ireton (1611–1651), whom she married in 1646. A miniature of her by Cooper is in the collection of the Duke of Devonshire.

Among Cooper's early dated works is an attractive one of an unknown lady, signed

and dated: *S.C. fe/1643*. This portrait is in the Mauritshuis, The Hague, and is more reminiscent of the style of Hoskins.

In 1644 Cooper executed a portrait of the artist Matthew Snelling (fl. 1644–1670?); this fact is recorded by Vertue, *Walpole Society*, Volume XVIII, p. 116:

> in Mr. Rosse. sale. April 1723
> a limning in chario by S. Cooper of Mr. *Snelling* y^e
> Limner, about 8 inches by 6.
> S.C.
> finely drawn. dated 1644. yet the hands & drapery meanly
> done.

As is to be expected, a number of miniatures by Cooper of his patron Charles II were painted; among those known to exist is the superb large rectangular portrait in the collection of the Duke of Richmond and Gordon. It is signed and dated: *SC/1665*, and shows the King in Garter robes, against a curtain and landscape background. The miniature was given by Charles II to Louise de Keroualle, Duchess of Portsmouth, mother of Charles Lennox, Duke of Richmond.

Another fine miniature of the King by Cooper, also in Garter robes, almost identical to the one at Goodwood and painted in the same year, is in the Mauritshuis, The Hague. This latter miniature is oval in shape.

An interesting unfinished miniature of Charles II is in the collection of D. E. Bower, Chiddingstone Castle. A finished version of this miniature is in the Duke of Portland's collection. A small portrait thought for many years to represent Charles II as a young man, but now identified as of James II, is in the Victoria and Albert Museum.

It is impossible to do more than mention a limited number of Cooper's masterpieces as he was a prolific artist, and fortunately a large number of his portraits have survived.

Among the most important are some in the collection of the Duke of Portland at Welbeck. This collection was formed in the early eighteenth century, by Lord Harley, later 2nd Earl of Oxford, who added to the miniatures of the families of Cavendish and Holles, which were inherited by Lady Henrietta Cavendish Holles whom he married on 31 August 1713. This collection has been added to by succeeding generations up to the present day.

The Portland collection was fully documented by R. W. Goulding, the then Librarian, and the details published in the *Walpole Society*, Volume IV, 1916.

Among the portraits of particular interest in this collection is a fine one of Arch-

bishop Sheldon (1598–1677), wearing his robes, set in a contemporary filigree frame, with a mitre and monogram *GC* on the reverse; this was acquired by Edward Harley, 2nd Earl of Oxford, who in his *Memoranda* records: '1726 March – paid 25 Gs for the picture of ABp Sheldon'. Gilbert Sheldon became Archbishop of Canterbury in 1663. I have seen another version of this portrait set in a gold filigree frame, in the Walters Art Gallery, Baltimore, U.S.A. It is signed and dated: *SC/1667* over the sitter's right shoulder, and : *Æ 69.* over the left shoulder. If one can accept the inscriptions, this is one of the rare occasions that Cooper inscribed the age of the sitter on a portrait.

Other miniatures by Cooper in the Portland collection which are of outstanding merit are as follows:

John Holles, 2nd Earl of Clare, 1595–1666, signed in monogram and dated: *SC./1656*.

Lady Pye, d. 1722, signed: *SC*. The sitter was Anne Stephens, daughter of Richard Stephens of Eastington, Gloucestershire, and wife of Sir Charles Pye.

Henry Sidney, Earl of Romney, 1641–1704, (said to be the handsomest man of his time), signed in monogram and dated: *SC/1669*. Acquired by Edward, Lord Harley at the sale of miniatures owned by L. Cross(e), 5 December 1722.

Sir Frescheville Holles, 1641–1672, signed in monogram and dated: *SC/1669,* purchased for £15 at the same sale as the above.

Richard Butler, Earl of Arran, 1639–1686 (unsigned).

Sir Thomas Tomkyns, d. 1675, signed in monogram and dated: *SC/1661*.

Sir Edward Harley, K.B. 1624–1700, (unfinished).

Mrs. Samuel Cooper, née Christiana Turner, 1623–1693 (unfinished and unsigned).

This latter miniature of the artist's wife is superb. Here we have revealed to us a woman who was gentle and yet had strength of character, her eyes are penetrating and seem to look right through us. There is no doubt that she would have been quite capable of bargaining with the King, when he wished to purchase the large portraits which were in her possession after her husband's death, and for which she was granted a pension. No other miniature of her by Cooper has so far come to light although it is fair to assume that a finished one may well have existed.

Reference has already been made to some of the most important miniatures by Cooper in the collection of H.M. the Queen, but there are other finished portraits in the collection which must be mentioned.

The Royal collection has been formed and re-formed over the years, and much of it was assembled during the nineteenth century. Unfortunately, as far as is known, little or no documentation was made at the time, and it is therefore not possible for us to

[78]

establish exactly when many of the miniatures were acquired.

Apart from the large sketches there is the well-known miniature of Frances Teresa Stuart, Duchess of Richmond (1647–1672), in male attire, signed in monogram and dated: *SC/166–* (the last figure being trimmed away) of which I have seen replicas, and a good copy on enamel. Another miniature of the same sitter dressed in male costume and wearing a hat, is in the Mauritshuis, the Hague. It is signed in monogram and dated: *SC/1666.*

Pepys records in his diary for 15 July 1664 an occasion when he saw her being painted:

Thence with Creed to St. James's; and missing Mr. Coventry, to White Hall; where staying for him in one of the galleries, there comes out of the chayre-rooms Mrs. Stewart, in a most loveley form, with her hair all about her ears, having her picture taking there. There was the King and twenty more, I think, standing by all the while, and a lovely creature she in this dress seemed to be.

Frances Teresa Stuart was remarkable for her beauty; she was maid of honour to Queen Catherine of Braganza, and later became one of the mistresses of Charles II, and was known as 'La Belle Stuart'. She is believed to have been the model for the figure of Britannia on the copper coinage.

In 1667 she eloped from Whitehall with Charles Stuart, 3rd Duke of Richmond, and the couple were secretly married in Kent. In spite of the King's anger at her marriage, she was back at Court within the year.

No one could deny that Cooper's portrayal of two of Charles II's most notable mistresses, Frances Stuart and Barbara Villiers, was remarkably successful and that whatever may be said about his ability as a painter of women, his portraits of these two ladies has given us an insight into their character, and as Graham Reynolds puts it 'we can believe in the vast temperamental difference between the ambitious grasping Cleveland and the frivolous good hearted Richmond'.

Barbara Villiers, Countess of Castlemaine and afterwards Duchess of Cleveland (1641–1709), married Roger Palmer in 1659, and became mistress of Charles II in 1660; her husband was created Earl of Castlemaine in 1661, and in 1670 she was created Duchess of Cleveland.

A number of miniatures of her exist, of which the two most impressive are in the Royal collection. These are the finished version by Cooper, signed in monogram and dated: *SC/1661,* and the large sketch, which as already mentioned, was probably among

the portraits purchased by Charles II from Cooper's widow.

Another fine miniature of Barbara Villiers by Cooper is in the collection of Earl Spencer, and is signed in monogram and dated: *SC/166-*, the last figure being trimmed away.

The Duke of Buccleuch's collection contains yet another portrait said to represent the lady, signed in monogram: *SC*, it depicts the sitter wearing a white dress and mauve wrap, against a cloud and sky background and is very colourful.

The Buccleuch collection owes a great deal to the 5th Duke, Walter Francis (1806–1884), who purchased a large number of miniatures of great importance which were added to the original family collection, numbering some one hundred and fifty, which he had inherited from Elizabeth, Duchess of Buccleuch (d. 1827).

Besides numerous examples of works by great masters, the collection contains interesting miniatures by lesser known and unknown artists.

In addition to the ones already mentioned, there are a number of other important miniatures by Cooper in the Buccleuch collection, including the following:

John, Baron Belasyse of Worlaby, 1614–1689, signed and dated: *S. Cooper f. 1646*. This fine miniature is one of the few signed in full by the artist.

An unknown lady, erroneously called Elizabeth Vernon, Countess of Southampton, signed and dated: *SC/1647*.

Elizabeth Bourchier, Mrs. Cromwell, d. 1665, signed and dated: *S.C./1651*.

Elizabeth Cromwell, Mrs. Claypole, 1629–1658, signed in monogram and dated: *S.C./1653*.

An unknown lady, signed in monogram and dated: *SC/1655*.

James Scott, Duke of Monmouth and Buccleuch, K.G., signed in monogram and dated: *SC/1667*.

An unknown lady, formerly called the Countess of Derby, signed in monogram and dated: *SC/1671*. She was possibly Margaret Leslie, Lady Balgony, d. 1688, afterwards Countess of Buccleuch, and by her third marriage Countess of Wemyss.

A lady *called* Lady Penelope Compton, but possibly Alice Fanshawe, Lady Bedell, signed in monogram *SC*.

Mary Fairfax, Duchess of Buckingham, 1638–1704, signed in monogram: *SC*.

Margaret Brooke, Lady Denham, signed in monogram: *SC*.

General Monck, 1st Duke of Albemarle, K.G. signed in monogram: *SC*.

A list of other miniatures by Cooper in this collection is to be found in *Early English Portrait Miniatures in the Collection of the Duke of Buccleuch*, by C. Holme and H. A. Kennedy, The Studio, 1917.

[80]

Two attractive portraits of ladies are in the collection of the Marquess of Exeter who, it will be remembered, also owns the earliest known dated miniature by Cooper, representing Elizabeth, Countess of Devonshire. These portraits are of:

Frances Manners, Countess of Exeter, 1630–1669, daughter of the 8th Earl of Rutland, and first wife of the 4th Earl of Exeter.

Lady Elizabeth Percy, née Howard, second daughter of the 2nd Earl of Suffolk, unsigned. She married 1 October 1642, Algernon, 10th Earl of Northumberland, whose miniature by Cooper, possibly based on the portrait by Van Dyck, is in the Victoria and Albert Museum. The miniature of his wife is mentioned in the Countess of Devonshire's will, and on an indenture dated 18 April 1690.

Both these miniatures of ladies show Cooper's ability to portray them with sensitivity and charm.

Of the Coopers in the collection of Earl Beauchamp, mention must be made of the following:

Anne Digby, Countess of Sunderland, 1646–1715, signed in monogram and dated: *SC./1660.*

Anne Hyde, Duchess of York, 1637–1671 (unsigned). The sitter was privately married to James, Duke of York in London, 1660.

Elizabeth Slingsby, Viscountess Purbeck, 1619–1645, fully inscribed on the reverse and signed: *S. Cooper.*

Jane Myddleton or Myddelton, 1645–1692, signed in monogram: *SC.* This appealing portrait shows the sitter in an apparently white dress and headpiece, the colour of which is in fact a subtle greyish white with deeper shading. She was the daughter of Sir Robert Needham and a great beauty. She married Charles Myddleton 1660. She attracted many lovers and received a pension from James II.

Some interesting family miniatures are in the collection of T. Cotterell-Dormer, of Rusham House, Steeple Aston. They include:

Lady Smyth, signed: *SC.* (monogram).
Sir Hugh Smyth, signed: *SC.* (monogram).
Robert Dormer, signed and dated: *SC./1650.*
William Dormer, signed and dated: *SC./1653.*
An unknown man in armour, unsigned.

One of the few miniatures which is signed on the front, as well as inscribed on the reverse by the artist, is of Lord Clifford of Chudleigh, owned by the present Lord Clifford

of Chudleigh. It is signed in monogram: *SC*, and inscribed on the reverse: *Sr Thomas Clifford 1672. Æta: 42 Sam:Cooper fecit*. This portrait shows clearly how Cooper's work remained as perfect as ever up to the last year of his life.

Cooper painted a fine miniature of Sir Thomas Hanmer (1612–1678), which has always remained in the Hanmer family, The sitter was page and cup-bearer at the Court of Charles I, and was described as 'a man of taste and an eminent horticulturist'.

The miniature of Sir Thomas was included in the exhibition *The Age of Charles II* at the Royal Academy in 1960, Cat. No. 648, when a fine half-length portrait of him by Van Dyck was also exhibited, painted *c.* 1638. This latter picture was seen by John Evelyn, who recorded in his diary on 24 January, 1685:

I din'd at Lord Newport's, who had some excellent pictures, especially that of Sir Tho. Hanmer, by Van Dycke, one of the best he ever painted; . . .

Sir Thomas and his wife Elizabeth had a daughter called Trevor, later Lady Warner, who was also painted by Cooper and about whom a tragic story is told which relates to her miniature and its ultimate destruction.

Trevor (1636–1670) was taken by her parents to Paris during the Civil War, and the Hanmers found lodgings in the house of a Roman Catholic family, from whom she learnt much about their religion. Her mother, who had been Maid of Honour to Queen Henrietta Maria, died when Trevor was only ten years of age, and the child became obsessed with the idea of becoming a nun. Her father, who had returned to England, married as his second wife Susan, daughter of Sir Thomas Harvey, and Trevor was left abroad in the care of an old Burgher and his wife. After some time her father brought her back to England, and she lived with her grandmother Lady Hanmer at Haughton in Flintshire.

Still wishing to enter a convent, Trevor asked permission to be allowed to go to Paris and join a community there. Her father, who was a staunch Protestant, refused to allow this for fear that he would be thought a Papist, and took his daughter, who was now grown up, to live with him in London. She was considered attractive, was witty, had a good memory and could speak several languages. Her portrait was painted by several artists, including Samuel Cooper.

Cromwell died on 3 September 1658, and was buried with great ceremony in Westminster Abbey on 23 November. Trevor was among those who witnessed the ceremony from a balcony which she shared among others with Sir John Warner and his relations.

This chance meeting was to have far-reaching results, for on 7 June 1659, she and Sir John were married in London, by Dr. John Warner, Bishop of Rochester. Two children were born to them, Catherine, b. 1660, and Susan, b. 1663. After a time, Lady Warner became confused and perplexed about the fundamentals of her faith, and was eventually persuaded by Father Hanmer, a relation, that her only hope of salvation was to become a Roman Catholic.

Trevor then went to see Dr. Buck, Chaplain in Ordinary to Charles II, to whom she explained her problem. Their discussion failed to settle her doubts, and she began to wonder if she had any true beliefs at all. She was finally convinced by Father Travers, of the Society of Jesus, that her only hope of salvation lay in her changing her religion.

When her husband heard of this decision he was very upset, and wishing to convince himself that he fully understood the Protestant faith in which he had been brought up, arranged to discuss the matter with Father Travers. The result of this conversation was that Sir John became distressed at the thought of the separation which, he was assured, death would one day make between him and his wife, and began to consider whether it would not be preferable for them both to enter a Religious order. After further consultation with Dr. Buck, Dr. Sancroft, and Gilbert Sheldon, Archbishop of Canterbury, all of whom did their best to dissuade him from taking this step, particularly when they discovered that children would be involved, Sir John and Lady Warner gave the matter further consideration. They finally rejected the advice, being persuaded that by changing their religion they would save their souls.

Both Lady Warner and her husband were received into the Roman Catholic Church on 6 July 1664, and both decided to join religious orders. After putting her affairs in order, Lady Warner together with her two children, her sister-in-law Mrs. Elizabeth Warner and a relation, Mrs. Frances Skelton, as well as a servant, Mrs. Fausset, who knew the Low Countries, left London for the Continent. Lady Warner placed the children under the care of the Superior of the Ursulins at Liege, and she entered the Order of St. Austen's there, taking the name of Sister Teresa Clare. Sir John, who had remained behind to settle his estates, followed her later and entered the Order of the Society of Jesus in March 1665, taking the name of Brother John Clare. Sister Teresa became anxious about the safety of her children, and wrote to Queen Henrietta Maria asking her to take them under her protection.

The Queen wrote to the Superior in July 1666, telling her of her interest and instructing her not to allow the children to be taken from her without the consent of their parents or guardians, or failing that, of herself.

In 1666, Sister Teresa, wishing to join a stricter Community, transferred to the Order of the Poor Clares of Graveling, where she took the name of Sister Clare of Jesus. Her children's education caused her some anxiety, and she decided to have them moved to Graveling. They arrived on 28 September 1667 accompanied by a servant, 'the Widow Draper', who was to look after them, and as soon as possible their father went to visit them, and after he got to Graveling obtained permission to remain there and make his profession at the same time as Sister Clare in the presence of the children. This service took place on 5 November 1667.

Before leaving England Sir John had arranged to send various items such as his wife's favourite pictures and personal belongings to Graveling, thinking that she would wish to give them to the children; amongst these was a miniature by Cooper. According to the anonymous author 'N.N.' (actually Edward Scarisbrick) of *The Life of the Lady Warner of Parham in Suffolk*, published in 1691, long before either of them had considered joining a community, her husband had 'Procured her picture to be drawn in miniature, by that famous and renowned Artist Mr. Cooper, which being extremely well done and very like her, he caused to be set in Gold, with a Cristal before it'. The portrait must have been painted between 1659 and 1664. Sister Clare asked the Mother Abbess's permission to dispose of the miniature as she liked. Thinking that she was going to give it to one of the girls the Abbess agreed, whereupon Sister Clare immediately opened the case with a pin, and fearing that she would be seen before she could destroy it, scratched the portrait all over and threw it into the fire. When Brother Clare heard what she had done he was very upset and reprimanded her for having deprived the children of 'so comfortable a treasure'. To which she replied that he would not have disapproved had he reflected how fit it was that the picture of what she had taken so much pride in should come to no better end than the original deserved.

Sister Clare was taken ill on the day on which this happened, and after a few weeks' illness died on 26 January, 1670. The Abbess seeing how beautiful she looked in death, sent for Nicholas de Largillière (1656-1746), to paint her portrait, in order to make up for the loss of the miniature. This portrait was engraved by P. Van Schuppen in 1690, and used as the frontispiece to her life. The author comments that 'Yet as great an Artist as he was, his piece, as the Religious testifie, came far short of the Original, and only gave cause of a continual resentment for the loss of that, which Cooper had so admirably drawn to the Life'.

It is interesting to note that both Largillière and Cooper were known to the Warner family, for Vertue records that several of the Warner family were painted by Largillière

when he was in England, and that Sir John Warner senior (d. 1659), was painted by Cooper.

It has never before been possible to discuss the merits of Cooper's drawings as opposed to his miniatures, as until comparatively recently only three were known, namely those of Thomas Alcock, and two profile portraits of Charles II. No doubt others exist, which are at present unrecognised, or attributed to other artists. Those that are now known dispel any doubts that may have existed about his powers of draughtsmanship.

In 1960, some hitherto unknown drawings were shown at the Royal Academy exhibition *The Age of Charles II*. They had been seen and accepted as genuine works by Cooper after examination at the Victoria and Albert Museum in 1957, and were amongst a collection of seventeenth-century drawings owned by Mr. A. H. Harford who has kindly supplied me with information regarding their history. The collection, contained in a portfolio, was left to the present owner by his grandmother Ellen Tower, daughter of the Reverend William Tower, vicar of Braughing, Hertfordshire, and his wife Maria, daughter of Admiral Sir Eliab Harvey, G.C.B., of Rolls Park, Essex. The Tower family can be traced back to Thomas Tower, who died at Tatham, Lancashire in 1659. A Christopher Tower bought Huntsmore Park in 1696, and his son Thomas bought Weald Hall in 1759.

It is not known how the portfolio came into the family, but it has been suggested that there may have been some connection between the Tower family and that of Gibson the dwarf, to whom for many years all the drawings were attributed, and who also knew the Hoskins and Cooper families.

The Gibson family were all artists, Richard (1615–1690), the dwarf (father of Susan Penelope Rosse), William, Edward and D. Gibson. Some of the drawings are still attributed to 'Gibson', and one represents a 'Betsy Rosse', probably a relative of S. P. Rosse, herself a miniaturist.

Ellen Tower married W. H. Harford, D.L., by whom she had a daughter Louise Emily, who married 9 October 1895, the 9th Duke of Beaufort. Louise evidently inherited some miniatures from her mother, which had come from the same source as the drawings and these she left to her son the present Duke of Beaufort. Among this collection are signed works by D. Gibson, and portraits of James II, Mary of Modena, Miss Kirk and Frances Stuart, Duchess of Richmond, all of which were attributed by J. J. Foster to Samuel Cooper, but which are in my opinion probably by S. P. Rosse after Cooper.

From a study of the Michael Rosse sale catalogue of 1723 (see Appendix III) it appears to me that the Harford collection could well have been among the items sold. Several

[85]

portfolios were included in the sale, and the names of some of the sitters correspond to those now in the Beaufort collection.

Five of Cooper's drawings, together with eighty of his miniatures, were exhibited at the Royal Academy in 1960, and provided a unique opportunity to assess the artist's style.

Of the drawings, the most moving is in my opinion that of a dead child, executed in chalk. On the reverse of the paper, is a drawing of a man wearing a hat, part of which is cut away. It is thought to represent John Hoskins junior, and the features are not inconsistent with the supposed self-portrait in the collection of the Duke of Buccleuch, signed and dated 1656.

The drawing supposedly of Hoskins junior by Cooper is inscribed in the bottom left-hand side: *Mr. S:C: child done by him* and in another hand over the S:C: *Dead:child*. In the bottom right hand side is written in the same hand as the first inscription: *NB ye son of old M*^r *Hoskins' son*.

It has been suggested that the child might have been Cooper's child, but from the wording of the inscription under the drawing of the man, it seems to me more likely that it was the child of Hoskins junior, and that who ever put the inscription on the back had access to detailed sources of information regarding the family.

The drawing of the child was compelling and one found oneself drawn back to it time and time again; it is as clear to me now as the day I first saw it. The sketch of the father is forceful and spirited, but is clearly surpassed by one of two drawings of Mrs. Hoskins, presumably Cooper's aunt, and mother of John Hoskins junior.

This drawing is signed in monogram: *SC*, and inscribed *SC*. It depicts a woman past middle age, her head covered with a cap tied under her chin, rounded cheeks and a suggestion of a smile on her face, which is that of a woman of character, and one quite capable of bringing up two young nephews, who for reasons we do not know were left unexpectedly under her care. The sitter's name is inscribed on the reverse in the same hand as that on the drawing of the 'Dead Child'.

The fourth drawing which also represents Mrs. Hoskins, shows her full face in a more serious mood, and is not signed.

A miniature of a hitherto unidentified lady (illustrated Pl. 57b. *English Art,* 1957) by J. Hoskins, in the collection of H.M. the Queen, bears such a striking resemblance to the woman in the drawings, known to represent Mrs. Hoskins, that it seems certain the sitter is the same.

According to Vertue (*Walpole Society,* Volume XVIII p. 107), a profile portrait in

[86]

crayon of John Hoskins by Cooper was in Lawrence Cross(e)'s sale of pictures in 1722.

Prior to these discoveries, the only known drawings by Cooper were those of Thomas Alcock, now at the Ashmolean Museum, on the reverse of which is Alcock's inscription identifying the portrait as being drawn for him by Cooper when the sitter was eighteen years of age, at Apethorpe, Northampton, and two profile drawings in red and brown chalk of Charles II.

These latter drawings are both in the collection of H.M. the Queen, and almost certainly represent the drawing mentioned by John Evelyn on 10 January 1662, when he describes how he was called to 'his Majesties Closet, when Mr. Cooper (ye rare limner) was crayoning of his face & head . . .'. The drawings are almost identical and it is impossible to say which is the original.

The discovery of the hitherto unknown drawings in the Harford collection was therefore of the utmost importance to our knowledge of Cooper's art, and may well be the means of identifying other of his works in due course.

The difficulty in assessing Cooper's artistic development due to lack of signed works at the outset of his career has already been mentioned, and in endeavouring to trace his style and characteristics one is immediately faced with the problem of where to begin.

It is at present accepted that most of Cooper's miniatures painted in or before the 1630s are indistinguishable from those of his uncle John Hoskins. In this connection two miniatures illustrating this point must be mentioned.

The first is the miniature of Henrietta Maria (1609–1669), formerly in the de la Hey collection and now in the collection of H.M. the Queen. In this miniature Henrietta Maria is said to be wearing a dress designed by Inigo Jones, in which she appeared in the Masque 'Tempe Restor'd' on Twelfth Night 1632 (*Walpole Society*, Volume XII, p. 75). Dr Roy Strong has been unable to trace such a design, and considers that the Queen may have been wearing court dress. It was supposedly among the miniatures catalogued by Van Der Doort in Charles I's collection *c.* 1641, when he described it as by Hoskins (*Walpole Society*, Volume XXXVII, p. 106):

. . . the Queenes Picture in limning with a white feather and in a white laced dressing about her breast in a-bleweish purple habitt and Carnacon sleeves-and a part of goulden Tissue Curteine in a-goulden square enamoled wrought Case w^th theis white enamoled Letters MR A Christall the Rock over it.

If indeed this is the miniature referred to, it has been re-framed. The Queen's sleeves are

not carnation in colour, and no reference is made to the alcove in the background, nor is there any mention of the stars on her dress. The portrait is signed in monogram: *SC* in pencil on the prepared gesso back and the late Basil Long considered it to be a genuine work by Cooper. If this attribution could be accepted without question, it would be a key piece. However, a careful examination of the back suggests that the monogram was added after the deep crack had appeared in the gesso surface, and into which the black lead had seeped. This has led Graham Reynolds and others to think that the portrait cannot be used as evidence for Cooper's early style. It is of course possible that the miniature was the combined work of both men.

The other miniature which might well be by Cooper is of Lady Mary Villiers, Duchess of Lennox and Richmond, after Van Dyck, in the collection of the Duke of Portland. The original, which is at Windsor, was probably painted on the eve of her marriage on 3 August 1637, and depicts her as St. Agnes, seated in a rocky cave, her right hand resting on a lamb. Several copies of this portrait exist, with slight variations, including a fine enamel by J. Petitot (1607–1691), signed and dated: *J. Petitot. fec. 1643.*

The miniature in the Portland collection has always been attributed to Cooper, on the basis of family documents. Edward Harley, 2nd Earl of Oxford, saw a painting of her by Van Dyck, when she was the wife of Charles, Lord Herbert, and describes it in a letter to his wife in October, 1738. After reference to her being 'a most Beautifull figure dressed all in white sattin', he continues – 'Her picture you have by Cooper from Vandike in a gilt fillegry Frame'. This attribution was accepted by R. W. Goulding, when he catalogued the collection, but when the portrait was exhibited at *The Age of Charles* II Graham Reynolds re-attributed it to Hoskins, on the basis of style.

Here again we are faced with an unresolved problem, and are forced to the conclusion that for the present Cooper's style can only be traced with certainty from the portrait of Margaret Lemon painted *c.* 1635/40. This miniature is an ambitious piece, and one far removed from the more conservative and less forceful manner of Hoskins and his predecessors. It shows that Cooper had developed characteristics of his own which were to come to maturity in subsequent years.

From 1642 onwards the problem of identification is eased by the fact that there is an almost uninterrupted stream of dated portraits up to his death in 1672. This is not to say that every signed or dated miniature attributed to Cooper can be accepted without question, as all too often spurious signatures have been added either to genuine minia-tures by other artists, or to clever forgeries of Cooper's work which abound. Cooper's portraits were penetrating interpretations of his sitters, painted without resorting to

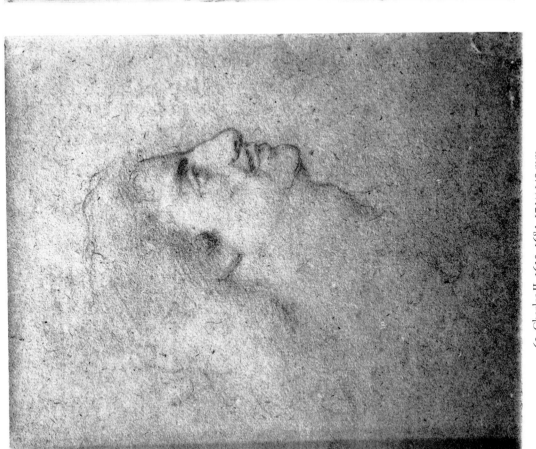

60. Charles II, 1630–1685. 175 × 140 mm.

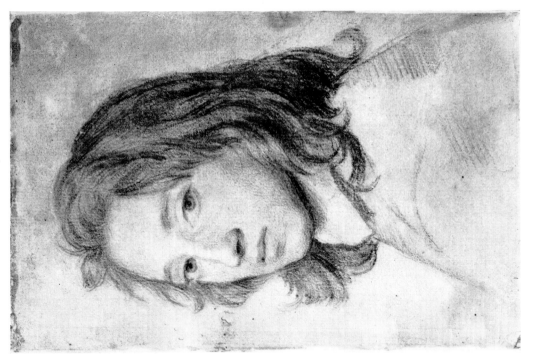

61. Thomas Alcock. 178 × 114 mm.

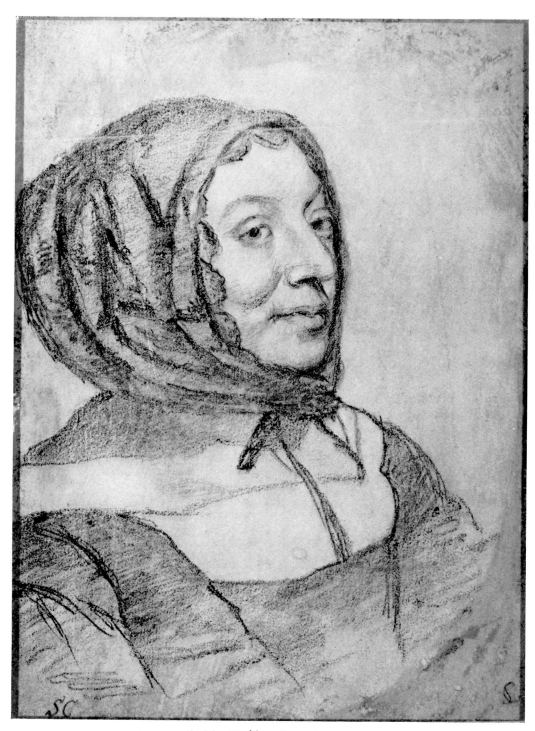

62. Mrs. Hoskins. 280 × 228 mm.

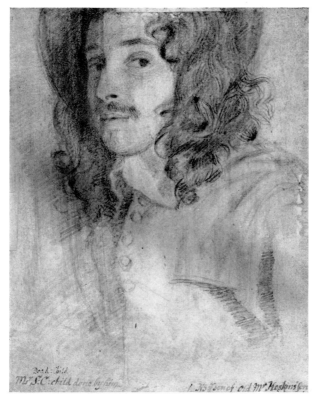

63. John Hoskins, jun.? 178 × 127 mm.

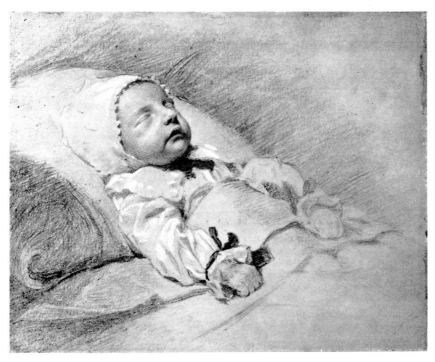

64. A Dead Child. 127 × 178 mm.

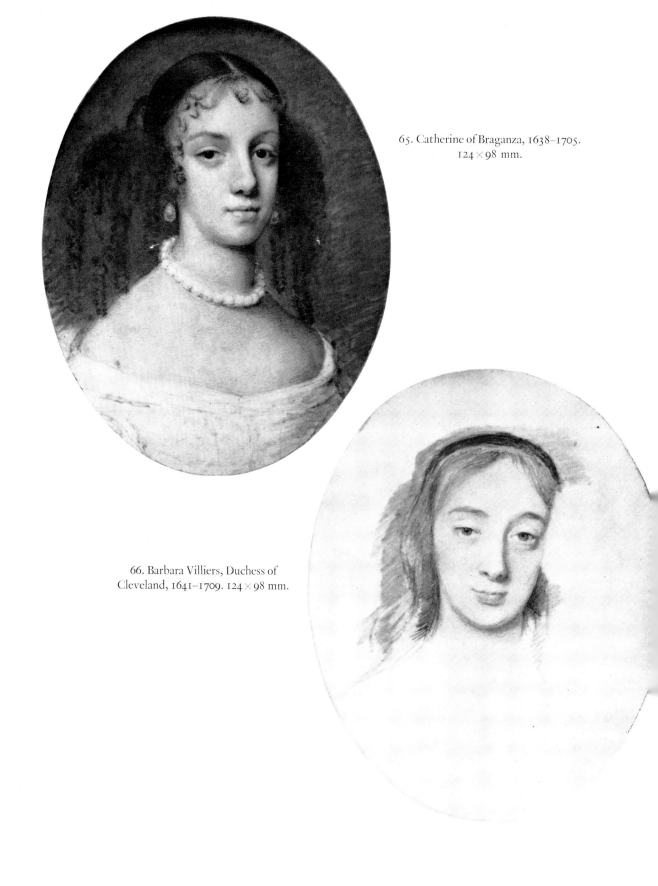

65. Catherine of Braganza, 1638–1705.
124 × 98 mm.

66. Barbara Villiers, Duchess of
Cleveland, 1641–1709. 124 × 98 mm.

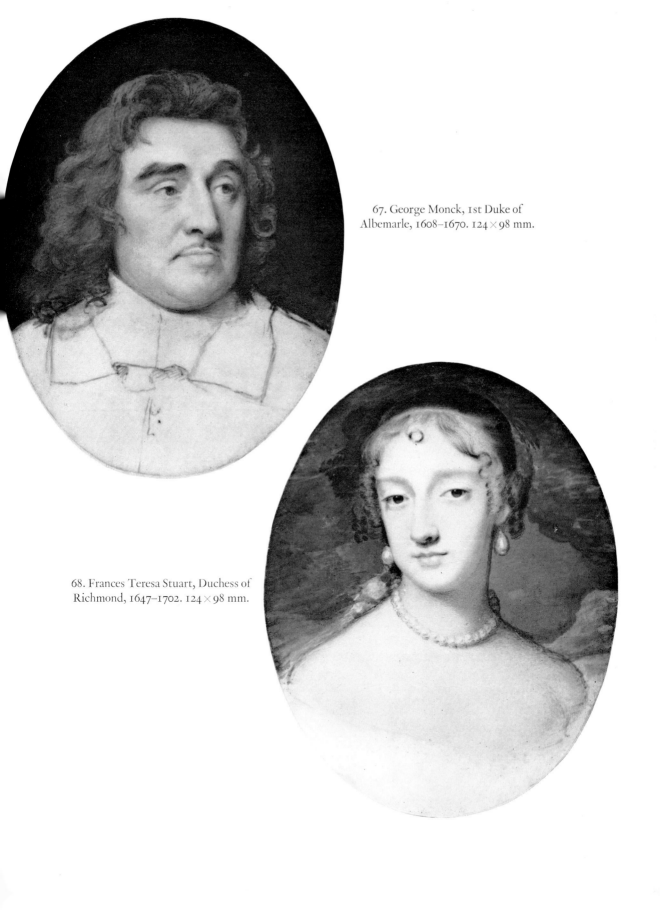

67. George Monck, 1st Duke of
Albemarle, 1608–1670. 124 × 98 mm.

68. Frances Teresa Stuart, Duchess of
Richmond, 1647–1702. 124 × 98 mm.

69. James Scott, Duke of Monmouth and Buccleuch, K.G., 1649–1685.
124 × 98 mm.

70. Henrietta, Duchess of Orleans,
1644–1670. 70 × 57 mm.

71. Henry Sidney, Earl of Romney,
1641–1704. 83 × 64 mm.

72. Lord Clifford of Chudleigh,
1630–1673. 83 × 67 mm.

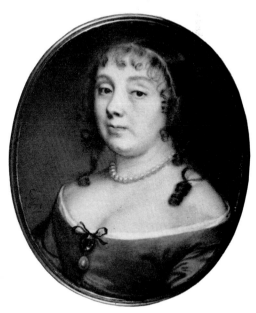

73. Unknown lady. 76 × 64 mm.

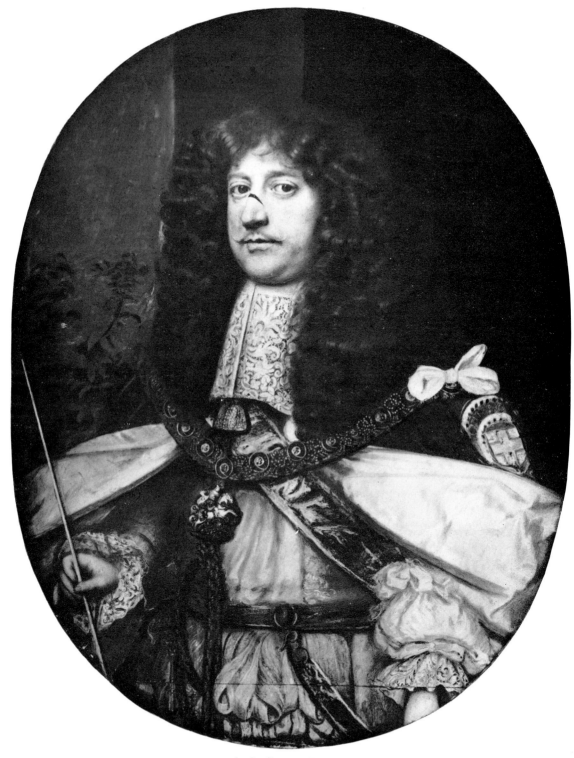

74. Henry Bennet, 1st Earl of Arlington, K.G., 1618–1685. 228 × 178 mm.

mannerisms or conventional poses. They reveal to us the inward character of the men and women who experienced the drab puritanism of the Commonwealth, which lasted from the death of Charles I, 1649, to the return of Charles II, in 1660, and the more relaxed and colourful period of the Restoration.

Of his early dated works, those of Elizabeth Cecil, Countess of Devonshire, dated 1642, and the portrait of an unknown lady, dated 1643, at the Mauritshuis, are both slightly reminiscent of the work of Hoskins, but the portrait on an unknown man once thought to be Robert Walker, d. 1658, in the Royal Collection, signed and dated: *S: Cooper fe: 1645*, is characteristic of the dramatic change in style and lighting that was to be the hallmark of Cooper's work throughout the rest of his life. This latter portrait is particularly interesting as the gesso back of the miniature is incised with the inscription: *Samuel Cooper fecit feberuaris 1644 ould stile*. The sitter is painted against a deep rich brown background which Cooper frequently used; the sitter's face lit from overhead, the shadows falling on the far side of the face, emphasising the contours of the cheeks, nose and mouth. This method of lighting was akin to the 'Tenebrosi', a school of artists founded by Caravaggio, and noted for their bold effects in depicting shadows and light and shade. This method of lighting is the most apparent distinction between the later works of Hoskins in which he painted the shadows evenly illuminated, without any exaggeration, and those of Cooper in which he used a form of dramatic lighting hitherto unknown in miniature painting.

Cooper's miniatures are painted on vellum laid on to card, each base being first prepared with a layer of opaque white, before the portrait was commenced. This in some instances seems to have been rather thicker than others and formed into a gesso substance into which the artist occasionally incised his signature. Cooper broke away from the more meticulous and neat manner of painting which his predecessors had inherited from the school of illuminators, and instead painted his portraits with a broader and freer stroke, more akin to that used in oil painting. Instead of using the pinkish-white flesh colour so familiar to us on the paintings executed by the early miniaturists of the British school, he used a warm reddish-brown which may at the time have been fairly bright, and caused Pepys to think the colouring of the flesh 'a little forced'. This, like the carmines of other miniaturists, has in many cases faded, and today as we examine these portraits we realise that the blending of his colours is so harmonious that his works are endowed with a richness and perfection that was his alone.

He is said to have painted in oil as well as water-colour, but no examples of his work in this medium are at present known. Cooper used a variety of signatures, the most usual

being: *S.C.*, or *S:C:*, either in separate letters or in monogram, often followed by a date either on the same line or below; *S. Cooper, Sa: Cooper pinxet, Samuel Cooper fecit, S: Cooper. fe:*, etc. The lettering is to be found in gold, dark brown or grey, on the background, or in rare cases on some detail of a background such as a pillar. Some miniatures are inscribed by him on the reverse in a manner already discussed.

The size of his format varied. The most usual is oval, 2 inches to $3\frac{1}{2}$ inches (50 to 90 mm.) high. The large unfinished sketches measure $4\frac{7}{8}$ inches (125 mm.), and a few rectangular portraits are $8\frac{1}{4}$ inches (210 mm.) high. One of William Cavendish, Duke of Newcastle, K.G., after Van Dyck, measures $13\frac{5}{8} \times 9\frac{1}{2}$ inches (350 × 240 mm.).

Little is known about the sums Cooper obtained for his work, but from the few instances that are known he appears to have been able to command a fairly high price. In 1650, he was paid £12 for a miniature of Robert Dormer, $2\frac{1}{2} \times 1\frac{7}{8}$ inches (65 × 48 mm), in 1668 Samuel Pepys paid him £30 for his wife's miniature, and Vertue records that a miniature of Sir Peter Lely for which he sat to Cooper seven times and which cost 30 guineas was owned by Lely's son.

In 1670, Cosimo III of Tuscany paid him £150 for a rectangular miniature of about $8\frac{1}{2}$ inches (215 mm.) high. It is interesting to compare these prices with those obtained by Lely, who in *c.* 1671 raised his from £15 to £20 for a head, and £25 to £30 for a half length, so that Cooper was asking twice as much for his portraits.

Although several artists, including Thomas Flatman, were certainly close followers of Cooper and indeed have had their works confused with his, no record has survived to confirm that Cooper ever had any pupils in his studio. Susan Penelope Rosse, 1652–1700, was a great admirer of Cooper's painting, and studied and copied many of his miniatures, a number of these copies being included in her husband's sale in 1723. Vertue mentions the sale in his note books, and says of her:

her first manner she learnt of her Father [R. Gibson]. but being inamour'd with Cooper's limnings. she studied & coppy'd them to perfection—as by these may be seen. nobody ever copy'd him better.

One of her most ambitious attempts at present known is the full scale copy of Cooper's sketch of the young Duke of Monmouth, the original of which, as has already been mentioned, is in the Royal collection. Mrs. Rosse's copy is a faithful replica, but she has not succeeded in emulating Cooper's bold brush-strokes and deep shadows, but drawn the features with thin and rather scratchy lines which show her comparative weakness in

draughtsmanship, and the portrait lacks vitality. This latter miniature is in the collection of the Duke of Buccleuch.

A very important large miniature of Henry Bennet, Earl of Arlington, is in the collection of Lady Cecilia Howard, daughter of the 8th Duke of Grafton. The miniature is by family descent, the 1st Duke of Grafton (d. 1690), having married Isabella Bennet, only daughter and sole heir of Lord Arlington. The miniature is a key piece as it is clearly an original work by Cooper which has been finished off by another hand. The head, background and part of the body all appear to have been executed by Cooper, who may possibly have left it unfinished. The robes, Order of the Garter, Lord Chamberlain's Wand and key, have been added at a later date, sometime after 1674 in which year Lord Arlington was appointed to that office. It seems reasonable to suppose that these additions were made by S. P. Rosse, who is known to have copied a miniature of Lord Arlington by Cooper, and the style of painting is not inconsistent with her work. It will be remembered that Pepys mentioned seeing a limning of Lord Arlington in Cooper's house on 30 March 1668.

A number of miniatures by S. P. Rosse have been and still are attributed to Cooper, and for many years a pocket book containing fourteen miniatures by her of herself, members of her family, and portraits after Cooper were thought to be by him. These portraits are in the Victoria and Albert Museum, where a close examination of inscriptions on the back of the miniatures eventually led to their identification.

A miniature traditionally supposed to represent Nell Gwynn, by S. P. Rosse; was sold for £2,415 at Christie's, 20 February 1973.

The catalogue of miniatures and drawings sold by Michael Rosse in 1723,[1] of which there is a copy in the British Museum, is of the utmost importance, for it contains details of a number of miniatures by Cooper and Richard Gibson, as well as originals and copies by Mrs. Rosse. Of these it is interesting to note that there were, besides the portrait of Monmouth, other copies of 'large heads' after Cooper, the following being listed:

General Monck
The Duchess of Cleveland
The Lord Arlington
Queen Catherine

The fact that S. P. Rosse did not make a practice of signing her works, with the exception of a few after her marriage, makes identification difficult, and I have not so

[1] See Appendix III.

far been able to trace any of the miniatures in the above list with any certainty. Works which can justifiably be attributed to her appear much harsher than any painted by Cooper, not infrequently the lower lip is slightly pouting. The general effect lacks the subtlety of Cooper's colouring.

Thomas Flatman was in fact probably the closest and most successful follower of Cooper, and his earlier works show many of the characteristics of the duller type of Cooper's miniatures but are lacking in the more powerful interpretation which was a hall mark of the older man's work. Points worth noting for comparison are Flatman's use of a rather unpleasing brownish flesh colour, and the prevalence of sky backgrounds, in which he used a rather harsh blue shade not found on Cooper's portraits. Flatman gradually developed a broader freer style and more confidence in the way he presented his sitters. The fact that a number of Flatman's mature works have been mistakenly or intentionally passed off for those of Cooper is in itself an indication of their quality and affinity of style. Unfortunately in some cases Samuel Cooper's signature has been added to miniatures by Flatman in a deliberate effort to deceive, and this has also caused understandable confusion.

A classic example of this was Lot 41, sold at Christie's, 6 July 1965. The miniature was of an unknown gentleman, signed with monogram and dated: *SC/1662*. The miniature was certainly by Flatman, and the inscription added, probably in the late eighteenth or early nineteenth century.

Miniatures painted by members of the Gibson family have in the past also been attributed to Cooper, and although it is still not always possible to assign with absolute certainty works to the individual members of the Gibsons, enough is known to separate them from those by Cooper. A few signed works by R. Gibson and D. Gibson exist and it is on the basis of these that other attributions can often be made.

Nicholas Dixon (fl. 1667–1708), was appointed limner to Charles II in direct succession to Samuel Cooper, but miniatures by him ought not to be confused with those by Cooper as they show nothing of his influence, and are painted in a manner more akin to that of Hoskins.

How then are we to sum up the achievements of a man who is accepted as one of the greatest portrait painters in Europe in the seventeenth century, and probably one of the greatest the world has ever known? David Piper in *The English Face*, says:

One of the reasons why he is so under-rated, or perhaps rather so infrequently rated, is the difficulty of writing about him.

[92]

Perhaps Cooper's greatness is due to the fact that one is never distracted by non-essentials, either in draperies, poses or elaborate backgrounds, but is at once aware of his ability to annihilate himself completely in the portrayal of his sitters as living persons whose characters are revealed to us with a clarity which is unique in this form of portraiture.

It is not easy to find words that fully express our appreciation of this great artist, and what he gave to the world through his painting. John Aubrey probably summed it up best when he said that for him Cooper was—

The Prince of Limners.

For the present we may have to be content to reiterate the words of Walpole when he said:

The anecdotes of his life are few; nor does it signify;

his works are his history.

APPENDIX I

Transcript of Samuel Cooper's Will
Probate 11/339

T^m Samuelis Cooper

In the name of God Amen.

I Samuel Cooper of Saint Paul Covent Garden in the County of Midd^s esquire being sick and weake in body but of a sound & perfect mind and understanding thanks be unto Almighty God for the same And being desirous to settle that estate wherewith it hath pleased God to bless me soe that there may be noe controversie or division amongst any of my friends and relations after my decease for or concerning the same I doe make this my last will and testament in manner and forme following Hereby revokeing and an-nulling and making voyd all former wills and Testaments by me made First I commend my soule into the hands of Almighty god haveing assuredly to receave mercy through the merritts and passion of our Saviour Jesus Christ, And as for my worldly estates I order dispose give and bequeath the same in manner and forme following First if there be any debts of any natiour or kind what soever which I owe or shall be due at the time of my decease my desires are that they shall bee paid and discharged with all expedition by my executrix hereafter named Item I give unto my cozen John Hoskins Twenty shillings to buy him a ring And to his wife Grace Hoskins and his daughter Mary Hos-kins Twenty shillings a piece to buy them rings Item I give unto my cozen Frances Hoskins and Mary Hoskins Twenty shillings a piece to buy them rings Item I make my deare and loving wife Christiana Cooper my sole executrix of this my last will and Testament desiring her to see my body decently buried at Pancrosse Church if she shall think it most convenient Item as for and concerning all the rest and residue of my reall and personall estate in goods and chattells debts credits hous holdstuffs Leases or of what other nature or kinde soever they may be which shalbe lefte and remain after my

funerall expenses debts And Legacies are paid discharged and satisfied I give devise and bequeath the same unto my said loveing wife Christiana Cooper Item I give unto John DeGrange, Magdalene DeGrange and Katherine DeGrange Twenty shillings a piece to buy them rings Item I give to my cozen John Hayles and to Elizabeth Hayles and Katherine Hayles daughters of the said John Hayles Twenty shillings a piece to buy them rings Item as for and concerning all that my messuage Tenement or farme with the appurtenances And all that close or parcell of pasture to the said messuage or Tenement, belonging or with the same lett used or enioyed And which are or sometymes were parcell of the Farme called Wardy Farme heretofore in the tenure or occupation of Joane Smith widow or her assignes and sometyme in the Tenure or occupation of Richard Brookes or his assignes lying and being in the parrish of Exhall in the County of the Citty of Coventry And alsoe all that parcell of ground called Farkley Croft contayning by estimation thirty acres orthereabouts, late in the occupation of Tho: Jud: Edward Hextall and Henry Clayton or some of them lying and being in the said parrish of Exhall in the County of the Citty of Coventry And all that messuage or Tenement or farmhouse with the appurtenances situated and being in in the parish of Folshill alias Foxhill [Foleshill] in the said County of the Citty of Coventrie, And all those severall closes of pasture arrable and woodground hereafter particularly mentioned vizt Highfield, Broomsclose Beechcroft meadowes Burrard close Shippslangley and the wood called the little wood, to the said messuage tenement or farmehouse belonging or appertaining or lett used occupied or enoyed therewithall sett lying and being in the said parish of Foleshill als Foxhill, And are or late were reputed to be parte and parcell of Beechcroft or adwyning thereunto, And alsoe all those several parcells or Arrable Land in the Common field of Folshill aforesaid And a certain close wood called rough close late in the occupation of the Widow Whitehead or her assignee or assignes and now or later were reputed to be parcell of Beechcroft aforesaid And also all those grounds meadows lands Tenements and Hereditaments not herin formerly before particularly mentioned being or reputed to be part & parcell of Beechcroft aforesaid and all and singular outhouses buildings having stables yards gardens orchards backsides ways passages & other appurtenances to any of the premisses belonging or to any part thereof And also all the right Tytle interest clayms and demands whatsoever of mee the said Samuell Cooper both in law or equity of or to any of the aforementioned premisses or any part thereof I give devise and bequeath the same unto my deare and loving wife Christiana Cooper her heires and assigns forever To have and to hold all the afore mentioned devised premises with their and every of their appurtenances unto the said Christiana Cooper her heirs and assigns for ever Item as & for recovering all such summes of money which I have lent unto any person upon mortgage or mortgages And all the said mortgages And all summes of money payable upon any mortgages made either to me or any other person in trust for mee of any

[95]

lands Tenements or hereditaments and all my estate right Tytle and interest both in law and equity to any such lands Tenements and premises which are so mortgaged as aforesaid for any summ or summes of money. And all rentcharges rent seals or other rents which I have anywhere within the realme of England I give devise & bequeath the same to my aforesaid wife Christiana Cooper her heirs executors administrators and assigns forever In witness whereof I have hereunto put my hand and seale the first day of May in the Twenty fourth year of the reign of our Sovereigne Lord Charles the second by the Grace of God, of England, Scotland, France & Ireland King defender of the faith . . . Anno . . . Domini one thousand six hundred and seventy two Samuell Cooper Signed sealed and published as my last will and Testament, these words (of any lands tenements or heriditements) being first interlyned in the presence of William Gaunt [Edwrd] Grey Fuller Thomasen Turner David Pretheroe.

APPENDIX II

Transcript of Mrs. Cooper's Will
Probate 11/415/1793

Died 24 August, 1693

T^m Christiana Cooper

In the name of God Amen.

I Christiana Cooper of the Parish of St. Giles in the Feilds in the County of Middx
Widdow being sick and weake in body but of sound and perfect mind and memory
thankes be to God for the same Doe make and ordaine this my last Will and Testament
hereby revoking all former wills by me at any time heretofore made and first I bequeath
my soule to Almighty God hoping to be saved by the merritts of my blessed Lord and
Saviour Jesus Christ My body to the earth to be decently buried in the Parish Church
of St. Pancras in the said County of Middx as neare my deare husband as may be and
whereas I am possessed of or interested in one messuage or tennement with the appurten-
ances in the Parish of St Leonards in Pouch makers Court in the precinct of St Martins le
Grand in the Citty of London for the remainder of a term of fifty years and of and in four
messuages or tenements situate in or neare Mitcham Green in Mitcham in the County
of Surrey and a parcell of grounds to the said Messuages adjoyning for the remainder of
a term for ninetie nine yeares of and in one other tennement situate in the parish of
St Leonard and precinct of St Martin's le Grand aforesaid adjoyning to the first above
mentioned Messuage or Tennement for the remainder of a term of forty yeares assigned
unto me by Charles Morgan of the parish of St Paul Covent Garden in the County
of Middx grocer by Indenture bearing date the twentieth day of ffebruary in the five and
twentieth year of the raigne of his late Matie King Charles the Second as in and by the
said recited Indenture relation thereunto being had may most fully appeare and whereas
alsoe Edward Gresham of Lymsfeild in the County of Surrey Esq^r and Bertrand Cam-

pion of Newton in the County of Southampton gentlemen by their bond or writing obligatory became bound unto me in the penall sume of four hundred pounds conditioned for the true payment of two hundred and eight pounds with interest within fifteen dayes next after the death of Sir Marmaduke Gresham of Titsey in the said County of Surrey Barronett as by the same obligation or writing obligatorie notation being thereunto alsoe had may more fully appeare and whereas I am likewise possessed of a further personall estate consisting in monies goods and chattles I give and dispose thereof in manner following vizt Inpris I give and bequeath unto my sister Alice Mawhood the sume of five pounds to my sister Elizabeth Turner one of my broad pieces of gold and the use of all my bookes pictures meddalls sett in gold and others for the terme of her naturall Life to my sister Mary Turner ten pounds to my sister Pope my necklace of pearls and a grinding stone and Muller and my mothers picture in Limning to my sister Mare five pounds to my sister Jane Smith one hundred pounds to be paid out of the sume of two hundred pounds before mentioned to be payable within fifteen days next after the death of Sr Marmaduke Gresham in case my said sister shall be living at the time of the decease of the said Sr Marmaduke and the said monies shall be recovered and got in by my Executor Item I gjve unto my said sister Smith my best suite of Damaske conteyning three table clothes and one Dozen of Napkins to my brother Pope a broad peice of Gold to my brother Mare a broad piece of gold to my brother Calvert a broad peice of gold to my brother Smith a broad peice of gold to my Nephew Samuel Mawhood a broad peice of gold to my nephew William Mawhood five pounds to my nephew John Mawhood five pounds to my nephew Richard Mawhood five pounds to my nephew George Mawhood five pounds to my Nephew Charles Mawhood five pounds to my Nephew Thomas Mawhood five pounds to my Neece Ffrances Broughton five pounds to my nephew and godson Alexander Pope my painted china dish with a silver foote and a dish to sett it in and after my sister Elizabeth Turner's decease I give him all my bookes pictures and Meddalls sett in gold or otherwise to my nephew Bartholmew Calvert five pounds to my Nephew and godson James Calvert five pounds to my neece Jane Mawhood daughter of Samuel Mawhood five pounds to my nephew Charles Mare five pounds to my nephew ffrancis Durant Junior five pounds to be paid him when he shall attaine his age of one and twenty yeares to my cozon Mr. Edward Bostock ffuller and his wife five pounds a piece to my Cozon Mr. John Hoskins and his wife five pounds a piece and to and amongst their children fifty pounds Item I give to my said cozon John Hoskins my husbands picture in crayons with all my said husbands pictures in Limning which I shall have by me at the time of my decease and alsoe Sr Peter Lilly's picture in oyle and to my cozon Hoskins his wife my large looking glass and dressing box quilted with silk to Madam Claverham one of my brode pieces of gold to my Lady Ingleby a silver carving spoon and a long

[98]

silver fork to Madam Elliston one of my broade peices of gold and my velvitt hood to Mrs. Higginson one of my broad peices to my godson Richard Higginson a silver cup and spoone to Mrs. Medcalf one of my broad peices to Mrs. Moone one of my broad peices to Madam Hastings a ffrench pistoll and to her daughters my silver box and counters and bras counters my Spanish imbroidered purse and my best green silk carpett and two bookes for the holy weeke to madam Calfe my greate china Bason and bottle to Madam Newport the next large China Bason and two of a less size and a broad china dish and my sett of ffrench ware on the chimney in my chamber being saven peeces to Mr. William Gowen five pounds to Doctor Andrew Popham five pounds and to Mr. Benjamin Aspriee five pounds to Mrs. Elizabeth Grant widdow five pounds to Mrs. Anne Brugis five pounds to Mrs. Lamner three pounds to Mr. Edward Drywell forty shillings to my cozon Katherine Price five pounds Item I give and bequeath unto my servant Ursula Lassells if she shall live with me at the time of my decease twenty pounds in money togeather with all my wearing linnon and clothes and all my table linnon (except the suite of Damaske before given to my sister Smith) and all my hoods scarfes laces tippetts all my sheetes pillows towells my feather bed two bolstors three pillowbers two little one greate four blanketts two Indian quilts a fire stove fender fireshovell fforke and tongs a cane chair with Armes three brass candlesticks one pair of brass snuffers four stone fruit dishes a walnut tree table and three trunkes and my Spanish peece of gold and silver drinking cup and spoone and my walnutt tree chest of drawers and my mind and will is that my Executor herein after named shall pay the respective legacies before mentioned for which noe time is already appointed as soon after my decease as moneys shall arrise and come into his hands out of my estate except only the three several legacies and sumes of fifty pounds given to my Cozen Hoskins and wife and children which I will shall be paid unto them by my Executor when and soe soone as he shall receave the severall debts due to me from Mr. Staley Mr. Crofts and Mr. Arther and not before all the rest residue and remainder of my estate of what kind soever as well the said Messuages as alsoe all other my goods chattles bonds mortgages and readie moneys I wholly give and bequeath unto my Nephew Samuel Mawhood cittizen and ffishmonger of London whom I make constitute and appoint sole Executor of this my last will and testament he paying the legacies above mentioned and I desire that my funerale expenses and the charge of a monument to be erected over my grave may not exceed in the whole the sume of fifty pounds In witness whereof I the said Christiana Cooper have hereunto sett my hand and seale the sixteenth day of May in the year of our Lord Christ one thousand six hundred ninetie and three Chr: Cooper Signed sealed published and declared by the testatrix above mentioned for and as her last will and testament in the presence of us Rogor Higginson Mary Rudd Joseph Stratton Snr.

[99]

APPENDIX III

Extracts from:

A
CATALOGUE
Of the Intire
COLLECTION
of
Mr. MICHAEL ROSSE:
Consisting of
CURIOUS PRINTS AND DRAWINGS:
As also,
LIMNINGS of Mr. COOPER and WERNER, etc.
Statues of Finelli, Antique Seals, Medals,
and other Curiosities.
Which will begin to be Sold by AUCTION on Tuesday
the 2nd of April, 1723, at Eleven a-Clock in the
Morning, and at Six at Night, at Mr. Rosse's
Dwelling House in Cecil-street; and continue
every Day till all are Sold, he intending to
retire into the Country for the Recovery of his
Health.

* * * * *

The sale was in two sections. The first was from 2 April, for six days, and the second from 26 April until the entire collection was sold. A copy of the Sale Catalogue is in the British Museum.

THE MICHAEL ROSSE SALE

FIRST DAY, 2nd APRIL, 1723
LIMNINGS

N.B. No Limnings were included on this day.

* * * * *

SECOND DAY, WEDNESDAY, 3rd APRIL,
LIMNINGS

No.

61.	Two, our Saviour in the Clouds, and a Boy with a pidgeon.	
62.	2, Sir John Germaine and Lady Kingston,	by Mr. Gibson.
63.	2, King William and Queen Mary,	by Mrs. Rosse.
64.	2, Mr. Westenholm and a Lady,	ditto
65.	2, Roger Huet's Mistress and another Lady.	
66.	2, Lady Anderson and another,	by Mr. Gibson.
67.	2, The Lord Kingston and the Duchess of Cleaveland,	ditto
68.	The Countess of Northumberland,	ditto
69.	The Earl of Pembroke in Armour, after Sir Anth. van Dyke.	
70.	Mr. Snelling the Limner,	by Cooper
71.	2, a Gentleman and a Lady.	
72.	2, King Charles and the Duchess of Richmond.	
73.	The Countess of Sunderland,	by Mrs. Rosse after Cooper.
74.	2, the Countess of Sussex and Mrs. Lee.	
75.	King James, by Mr. Richard Gibson. a half length.	
76.	The Morocco Ambassador after Life,	by Mrs. Rosse, ditto.
77.	King Charles I, and the Duchess of York,	Sir Peter Lely.
78.	Lady Chaworth,	Sir Peter Lely
79.	2, Lady Moreland and another.	
80.	2, Sir Henry Slingsby and a Lady.	

DRAWINGS

No.

97.	The Duke of Monmouth,	by Cooper

98. Mr. Wissing and Miss Davis.
99. King Charles and Queen Mary.

FOURTH DAY, FRIDAY, 5th APRIL
LIMNINGS

No.

181.	Roxelana, Countess of Oxford.	
182.	Sir J. Fortescue's Daughter by the Life,	by Mrs. Rosse.
183.	Queen Mother, after Van Dyke.	
184.	Mr. Roberts, Son to Lord Radnor,	by Cooper.
185.	The Countess of Carnarvan,	by Mr. Gibson.
186.	The Prince of Orange.	
187.	Lady Radnor,	by Cooper.
188.	The Duchess of Cleaveland.	
189.	The Earl of Pembroke, after Van Dyke.	
190.	The Duchess of York,	by Mr. Gibson.
211.	Salmacis and Hermaphroditus,	by Werner.
212.	A Lady, finely painted in black and white,	by Cooper.
213.	Mertillo and Amarillis,	by Werner.
214.	Corisca and Satyr,	by ditto
215.	The Countess of Suffolk, highly finished,	by Cooper.
216.	Two, the Duke and Duchess of York.	
217.	Venus, Cupid and Mercury, after Coregio,	by Mrs. Rosse.
218.	A Woman's Head, finely painted	by Cooper.
219.	A naked Nymph and a Boy,	by Werner.
220.	Jason and a Dragon,	by ditto

DRAWINGS

No.

241.	The Countess of Oxford,	by Cooper.
242.	A Gentleman in Armour,	ditto

FOURTH NIGHT, FRIDAY, 5th APRIL

DRAWINGS

211.	[271?] A Locket Picture, a Lady,	by Mr. Cooper.
272.	The King of France,	by Petito.
273.	Lord Chancellor Hyde's Lady, enamelled.	

* * * * *

SECOND SALE, 26th APRIL, 1723

THIRD DAY

LIMNINGS

No.

166.	King Charles, after Van Dyke,	by Sir Peter Lely.
167.	The Duchess of York,	by ditto
168.	The Lady Chaworth, a crayon,	ditto
169.	2, A Woman, by Hilliard, and Mr. Geltrop.	
170.	2, Our Saviour's Head and a Ship at Sea.	
171.	A Lady in Blue.	by Mr. Richard Gibson.
172.	The Lady Kingston,	ditto
173.	The Lady Anderson,	ditto
174.	Sir John Germain,	ditto
175.	The Lord Kingston,	ditto
176.	The Duchess of Cleaveland,	ditto
177.	A Boy in the Clouds, with a Cross,	ditto
178.	A Boy with a Pidgeon,	ditto
179.	Captain Ashton,	by Mrs. Rosse.
180.	Mr. Westenholm,	ditto
181.	A Lady in Blue,	ditto
182.	Mr. Roger Hewitt's Mistress,	ditto
183.	A Lady in Blue,	ditto
184.	The Lady Moreland,	ditto
185.	A Woman's Head,	by ditto

SAMUEL COOPER

No.

186.	A Man's Head,	by Mrs. Rosse.
187.	A Lady's Head,	ditto
188.	Sir Henry Slingsby,	ditto
189.	Mr. Wissing,	ditto
190.	The Countess of Sussex,	ditto
191.	The Duchess of Richmond, after Cooper.	
192.	Mrs. Davis, after Cooper.	
193.	King Charles, after Mr. Reyly	
194.	The Duke of York, after Cooper.	
195.	The Duchess of York.	
196.	King Charles, after Sir Peter Lely.	
197.	Queen Mary, after Sir Godfrey,	by Mrs. Rosse.
198.	King William,	ditto.
199.	Queen Mary,	ditto.
200.	Mrs. Whorwood,	ditto.
201.	The Prince of Orange,	ditto.
202.	The Dutchess of Cleveland in a Night-dress.	
203.	Roxelana, the Comedian, Countess of Oxford.	
204.	The Queen Mother after Van Dyke.	
205.	The Countess of Carnarvan,	by Mr. R. Gibson.

No.

246.	Two, King Charles and the Prince of Orange	
247.	King James and his Queen,	by Mrs. Rosse.
248.	2, King William and Queen Mary,	ditto
249.	2, King James and a Gentleman	
250.	2, The Duke of Bolton and Lady Kingston.	
251.	2, The Prince of Orange and Sir Charles Hedges.	
252.	2, The Duchess of Cleaveland and Mazarine, Mr. Cross.	

253. 2, The Duchess of Portsmouth and Lord Chancellor
 Hyde's Lady.
254. The King of France enamelled, by Petito.
255. The Lady Bellasis and Colonel Panton.
256. King James and his Queen.
257. A Man in Armour, by Mr. Sam Cooper.
258. A Lady, by ditto
259. 3 Round drawings in Frames by Hans Holbein.
260. 3 ditto
261. 2, Drawings in Frames by Isaac Oliver.
262. 2, ditto
263. A very fine double Drawing upon Box in a Frame.
264. 1, The Countess of Sandwich.
265. Our Saviour in the Garden.
266. The Flight into Egypt, very fine.
267. A Lady drest with Roses.

LIMNINGS, ETC.

No.
268. Fifteen very curious Drawings on a black Tablet.
269. A small Madona in Oil on Copper.
270. A Crucifix, after Van Dyke, by Mr. Richard Gibson.
271. The Duke of Monmouth, by Samuel Cooper.
272. The Earl of Pembroke in Armour, after Van Dyke, by Mrs. Rosse.
273. The Countess of Sunderland, after Cooper, ditto
274. The Morocco Ambassador by the Life, ditto
275. Mr. Snelling the Limner, by Mr. Samuel Cooper.
276. The Duchess of Cleaveland, whole length after Sir
 Peter Lely.
277. General Monk, after Cooper, large Head.
278. Queen Catherine, ditto by Mrs. Rosse.
279. The Duke of Monmouth, ditto
280. The Duchess of Cleaveland, ditto
281. The Lord Arlington, ditto

SAMUEL COOPER

LIMNINGS

No.

350.	A dead Christ, after Palma,	by Mrs. Rosse.
351.	A Madona, after Van Dyke,	ditto
352.	A Madona, after old Palma,	ditto
353.	The Earl of Pembroke, after Van Dyke,	ditto
354.	An Ecco Homo, after Leonardo,	ditto
355.	The Countess of Oxford,	by Cooper.
356.	The Duchess of York.	by Mr. Richard Gibson.
357.	Mr. Roberts, son to Lord Radnor,	by Cooper.
358.	The Lady Radnor,	ditto
359.	Jason and the Dragon,	by Mr. Werner.
360.	A naked nymph, and a Boy,	ditto
361.	A Lady finely painted in Black and White, etc.	by Cooper.
362.	The Countess of Suffolk, highly finished,	ditto
363.	Corisca and a Satyr,	by Werner.
364.	Mertillo and Amarillis,	ditto
365.	Salmacis and Hermaphroditus,	ditto
366.	Venus, Mercury etc. after Corregio,	Mrs. Rosse.

These lists are the result of intensive research but cannot, even so, be considered fully comprehensive.

★	= Indication that the author has not examined the miniature.
called	= The identification of the sitter is uncertain.
c.	= *circa*, about the period indicated.
'On Mrs. Samuel Cooper's list'	= refers to the list sent to Cosimo III *c.* 1676–1683 (see pages 63–66).
Pierpont Morgan Coll.	= J. Pierpont Morgan, Esq., whose collection was sold at Christie's, 24–27 June 1935.
de la Hey Coll.	= Major R. M. O. de la Hey, whose collection, which was by family descent, was sold at Sotheby's, 27 May and 4 November 1968.
R. W. Goulding	= *The Welbeck Abbey Miniatures, Walpole Society*, Vol. IV, 1916.
Portland Collection	= Where catalogue numbers are given they refer to those given by R. W. Goulding.
Sotheby Heirlooms	= The collection belonging to Major-General Frederick Edward Sotheby, Ecton Hall, Northampton. Sold at Sotheby's, 11 October 1955.
/	= Indicates a fresh line between the signature and the date.

APPENDIX IV

Dated Works by or Attributed to Samuel Cooper
in Private and Public Collections

	SITTER	PAST OR PRESENT OWNER
1642	Arundel, Henry Frederick, Earl of, 1608–1652.	Brussels Exhibition, 1912 (Cat. No. 56).
	Devonshire, Lady Elizabeth Cecil, Countess of, 1620–1689. Signed and dated: *Sa:Cooper pinxet Aº: 1642.*	The Marquess of Exeter.
1643	An unknown lady. Signed and dated: *SC fe./1643.*	Mauritshuis, The Hague (Cat. No. 991).
	An unknown lady. Signed: *S.C/1643.*	Sold Christie's 3.12.1963. Present location unknown.
1644	★Snelling, Matthew (fl. 1644–1670?).	Michael Rosse sale, 1723.
1645	★Cooper, Samuel, 1609–1672. Signed and dated: *S. Cooper f 1645.*	Vertue IV, p. 68. Walpole Society, XXIV, 1935–6.
	Unknown man, formerly *called* Walker, Robert, d. 1658. Signed and dated: *S:Cooper fe: 1645.* An incised inscription by the artist on the reverse of the miniature reads: *Samuel Cooper fecit feberuaris 1644 ould stile.*	H.M. the Queen.

DATED WORKS

1646 Belasyse, John, 1st Baron, of Worlaby, 1614–1689. Signed and dated: *S. Cooper. f.1646.* — The Duke of Buccleuch and Queensberry, K.T.

Belasyse, John, 1st Baron, 1614–1689. Signed and dated: *SC/1646.* This is a smaller version of the Buccleuch miniature, the arm holding the baton being omitted. In spite of the signature, the work is weaker than one would expect from Cooper, and the miniature may be a copy by another hand. — Fitzwilliam Museum, Cambridge (Museum No. 3786).

*Cave, a gentleman of the Cave family. — Stanford Hall (1916).

Cranborne, Charles, Viscount, d. 1659. Signed and dated: *SC/ 1646.* Restored. — The Marquess of Salisbury.

An unknown lady. Signed and dated: *S.C./1646.* — E. B. Greene Coll., Cleveland Museum of Art, Ohio.

An unknown lady. Signed and dated: *S.C. 1646.* — Institut Néerlandais, Paris. (Coll. F. Lugt.)

1647 Cromwell, Oliver, 1599–1658. Signed and dated: *SC/1647,* possibly in a later hand. — The Marquess of Exeter.

Cromwell, Richard, 1626–1712, *called.* Signed and dated: *SC/1647.* — Victoria and Albert Museum, London.

Fanshawe, Miss Alice, later Mrs. Fanshawe, 1627–1662 (possibly). Signed and dated: *S.C./1647.* — Ex Pierpont Morgan Coll. Starr Collection, Kansas City.

Fleetwood, General George, 1605–1667. Signed and dated: *SC./1647.* — National Portrait Gallery, London.

Foote, Sarah, wife of Sir John Lewis, *called.* Signed and dated: *S.C./1647.* — Viscount Bearsted.

Rochester, Anne St. John, Countess of, 1614–1696. Signed and dated: *S.C. 1647.* Inscribed on the reverse: *The Lady Rochester don by S. Cooper in London.* — The Earl Spencer.

SITTER	PAST OR PRESENT OWNER
Sandwich, Jemima, Countess of, wife of 1st Earl. Signed and dated: *S.C./1647* in gold.	Ex Pfungst Coll. Fitzwilliam Museum, Cambridge (Museum No. 3829).
An unknown lady. Signed and dated: *SC/1647*.	Viscount Bearsted.
An unknown lady, formerly *called* Princess Mary, 1631–1660. Signed and dated: *S.C./1647*.	The Duke of Buccleuch and Queensbury, K.T.
An unknown lady. Signed and dated: *SC/1647*. The sitter is the same as the lady called Alice Fanshawe, ex Pierpont Morgan Coll., now Starr Collection, Kansas City.	The Duke of Buccleuch and Queensberry, K.T.

1648	*Ailesbury, Countess of, née Diana Grey, wife of Robert, 1st Earl, d. 1685.	L. Cross(e) sale, 5.12.1722.
	Claypole, Mrs. née Elizabeth, Cromwell, 1629–1658, *called*. Signed and dated: *SC/1648*.	H.M. the Queen.
	Ley, Lady Margaret. Signed and dated: *S.C./1648*.	Fitzwilliam Museum, Cambridge (Museum No. 3787).
	Rochester, Anne St. John, Countess of, 1614–1696. Signed and dated: *SC./1648*.	Mrs. Holscheiter, Zurich.
	Unknown lady. Signed and dated: *S.C./1648*.	Salting Bequest, Victoria and Albert Museum, London.

| 1649 | Cromwell, Henry, 1628–1674 (possibly). | Sold Sotheby's, lot 12, 1.6.1970. |
| | *Fairfax, General Thomas, 3rd Baron, 1612–1671. | Ex Pierpont Morgan Coll. Sold Christie's, lot 32, 24.6.1935. Present location unknown. |

DATED WORKS

SITTER	PAST OR PRESENT OWNER
Ireton, General Henry, 1611–1651. Signed and dated: *S.C./1649*.	Fitzwilliam Museum, Cambridge (Museum No. 3828).
Lilburne, Colonel Robert, 1613–1665. Signed and dated: *SC/1649*.	Sold Christie's, lot 40, 6.7.1965.
Lindsey, Montague Bertie, Earl of, 1608?–1666. Signed and dated: *SC·/1649*.	Fitzwilliam Museum, Cambridge (Museum No. 3824).
Monmouth, Henry Carey, 2nd Earl of. Signed and dated: *S.C./1649*. (1596–1661).	Metropolitan Museum, New York.
Huntley, George Gordon, 2nd Marquess of, d. 1649. Signed and dated: *S:C/164–* (the numerals are indistinct). After Van Dyck.	Mauritshuis, The Hague.

1650	Buckingham, Mary Fairfax, Duchess of, 1638–1704. Signed and dated: *SC./1650*.	The Duke of Buccleuch and Queensberry, K.T.
	Dormer, Robert, 1629–1694. Signed and dated: *SC./1650*.	T. Cotterell-Dormer, Esq.
	*Graham, Sir Richard, Bt., of Esk and Netherby.	Brussels Exhibition, 1912 (Cat. No. 43). Mrs. J. Abercrombie.
	*Leigh, Elizabeth.	Nationalmuseum, Stockholm.
	Lilburne, Colonel Robert, 1613–1665. Signed and dated: *SC./1650*.	Fitzwilliam Museum, Cambridge (Museum No. 3830).
	Manners, Grace Pierpont, Lady. Signed and dated *SC* (monogram)/*1650*.	The Duke of Rutland.
	*Northumberland, Algernon Percy, 10th Earl of, 1602–1668, *called*.	The Marquess of Anglesey.
	Rivers, Sir Thomas, Earl of Southampton, d. 1657. Signed and dated: *S.C. 1650*.	Sold Sotheby's, lot 27, 9.2.1961.
	Scrope, Sir Adrian, d. 1667. Signed and dated: *S.C./1650*.	The Duke of Buccleuch and Queensberry, K.T.

SAMUEL COOPER

SITTER	PAST OR PRESENT OWNER
Unknown man in armour, *called* General George Fleetwood. Signed and dated: *SC. 1650.*	Ex de la Hey Coll. Sold Sotheby's, lot 52, 27.5.1968.
Unknown man in armour. Signed and dated: *SC./1650.*	Salting Bequest, Victoria and Albert Museum, London.
Unknown lady, possibly Mrs. Fairfax. Signed and dated: *SC/1650.*	Victoria and Albert Museum, London.

1651

Cromwell, Mrs, née Elizabeth Bourchier, d. 1665. Signed and dated: *S.C./1651.*	The Duke of Buccleuch and Queensberry, K.T.
Fleetwood, General Charles, d. 1692. Signed and dated: *S.C./1651.*	Ex Pfungst Coll. Present location unknown.
Unknown man. Signed and dated: *SC/1651.*	The Duke of Buccleuch and Queensberry, K.T.
Unknown man in armour, *called* Richard Cromwell. Signed and dated: *S.C. 1651.*	Sold Sotheby's, lot 4, 25.5.1964.

1652

Cromwell, Bridget (Mrs. Ireton), 1624–1681. Signed and dated: *SC/1652.*	The Duke of Devonshire.
Cromwell, Elizabeth (Mrs. Claypole), 1629–1658. Signed and dated: *SC./1652.*	The Duke of Buccleuch and Queensberry, K.T.
Lenthall, William, 1591–1662. Signed and dated: *SC./1652*	National Portrait Gallery, London.
Lilburne, Colonel Robert, 1613–1665, *called.* Signed and dated: *SC/1652.*	George Howard, Esq.
Townshend, Sir Horatio, later Viscount, 1630–1687, *called.* Signed and dated: *SC/1652* (restored).	The Duke of Buccleuch and Queensberry, K.T.
Townshend, Lady Mary, 1st wife of Sir Horatio, Townshend. Signed and dated: *S.C./1652.*	Ex Pierpont Morgan Coll. Sold Christie's, lot 26, 24.6.1935. Present location unknown.

1653

Claypole, Elizabeth, 1629–1658, *called.* Signed and dated: *S.C./1653.*	The Duke of Buccleuch and Queensberry, K.T.
Claypole, Elizabeth. Signed and dated: *SC./1653.*	The Duke of Devonshire.

DATED WORKS

SITTER	PAST OR PRESENT OWNER
Gainsborough, Countess of (Elizabeth Wriothesley?). Signed and dated: *SC* (monogram)·/*1655*.	Ex Pierpont Morgan Coll. Sold Christie's, lot 28, 24.6.1935. Present location unknown.
★Grey, Lady.	L. Cross(e) sale, 5.12.1722.
Richmond and Lennox, Charles Stuart, Duke of 1638–1672, *called*. Signed and dated: *SC*/*1655*.	The Duke of Buccleuch and Queensberry, K.T.
Unknown lady. Signed and dated: *S.C.*/*1655*.	The Duke of Buccleuch and Queensberry, K.T.
1656 ★Bedingfield, Sir Henry, 1633–1687. Dated: *1656*.	Ex Pierpont Morgan Coll. Sold Christie's, lot 34, 24.6.1935. Present location unknown.
Clare, John Holles, 2nd Earl of, 1595–1666. Signed and dated: *SC.* (monogram)/*1656*.	The Duke of Portland, K.G. (Cat. No. 58).
Cromwell, Oliver, 1599–1658 Signed and dated: *SC*/*1656*.	National Portrait Gallery, London.
Monck, General George, Duke of Albemarle, K.G., 1608–1670, *called*. Signed and dated: *SC.*/*1656*.	Private Collection.
Rutland, John Manners, 8th Earl of, 1604–1679. Signed and dated: *S.C.*/*1656*.	The Duke of Rutland.
Unknown lady. Signed and dated: *SC.* (monogram)/*1656*.	Ex Harry Seal Coll. Sold Christie's, lot 91, 16.2.1949. E. Grosvenor Paine, U.S.A.
1657 Campden, Edward Noel, Viscount, later 1st Earl of Gainsborough, d. 1689. Signed and dated: *S.C.*/*1657*.	Ex Pierpont Morgan Coll. Sold Christie's, lot 22, 24.6.1935. Fitzwilliam Museum, Cambridge (Museum No. 3832).

DATED WORKS

SITTER	PAST OR PRESENT OWNER
Cooper, Samuel, 1609–1672. Self portrait. Signed and dated: *SC* (monogram)/*1657*.	Victoria and Albert Museum, London.
Cromwell, Oliver, 1599–1658. Signed and dated: *SC.*/*1657*.	London Museum.
*Cromwell, Oliver, 1599–1658. Signed and dated: *SC*/*1657*.	Viscount Harcourt.
Fanshawe, John, of Parsloes, 1619–1689. Signed and dated: *SC.* (monogram)/*1657*.	Ex Pierpont Morgan Coll. Sold Christie's, lot 31, 24.6.1935. Present location unknown.
Fiennes, Colonel Nathaniel, 1608–1669. Signed and dated: *SC.* (monogram)/*1657*.	The Earl Beauchamp.
Lindsey, Montague Bertie, 2nd Earl of 1608?–1666. Signed and dated: *SC.*/*1657*.	Fitzwilliam Museum, Cambridge (Museum No. 3788).
Palmer, Sir William, 1605–1682. Signed and dated: *SC* (monogram)/*1657* and inscribed: *Æt. 52*.	Victoria and Albert Museum, London.
Staresmore (or Stairsmore), The Rev. Thomas, d. 1706. Signed and dated: *SC* (monogram)/*1657*.	Fitzwilliam Museum, Cambridge (Museum No. 3928).

	SITTER	PAST OR PRESENT OWNER
1658	Cromwell, Richard, 1626–1712. Signed and dated: *S.C.*/*1658*.	Ex Pierpont Morgan Coll. Present location unknown.
1659	Henley, Sir R. (possibly), formerly *called* 1st Earl of Sandwich. Signed and dated: *SC.* (monogram)/*1659*.	Victoria and Albert Museum, London.
166–	Richmond, Frances Teresa Stuart, Duchess of, 1647–1702 in male dress. Signed and dated: *SC.* (monogram)/ *166–*, the last figure cut away.	H.M. the Queen.
166–(3?)	Cleveland, Barbara Villiers, Duchess of, 1641–1709. Signed and dated: *SC* (monogram)/*166–(3?)*, the last figure truncated.	The Earl Spencer.

[115]

	SITTER	PAST OR PRESENT OWNER
1660	Harvey, Sir Daniel, d. 1674. Signed and dated: *SC.* (monogram)/*1660.*	Mrs. T. R. C. Blofeld.
	*Owen, Mrs. Anne (Lucasia).	Vertue IV, p. 9, *Walpole Society*, Vol. XXIV.
	Penn, Admiral Sir William, 1621–1670 (possibly). Signed and dated: *SC.* (monogram) *1660.*	Mrs. Holscheiter, Zurich.
	Sunderland, Anne Digby, Countess of, 1646–1715. Signed and dated: *SC.* (monogram)/*1660.*	The Earl Beauchamp.
	Vernon, George, 1635–1702. Signed and dated: *SC* (monogram)/*1660.*	Lord Vernon.
	Wiseman, Richard, 1622?–1676. Signed and dated: *SC* (monogram)/*1660.*	The Duke of Rutland.
	Unknown man in armour. Signed and dated: *SC./1660.*	The Duke of Buccleuch and Queensberry, K.T.
1661	Cleveland, Barbara Villiers, Duchess of, 1641–1709. Signed and dated: *SC* (monogram)/*1661.*	H.M. the Queen.
	Southampton, Thomas Wriothesley, 4th Earl of, 1607–1667, *called.* Signed and dated: *SC.* (monogram)/*1661.*	The Duke of Bedford.
	Tomkyns, Sir Thomas, d. 1675. Signed and dated: *SC* (monogram)/*1661.*	The Duke of Portland, K.G. (Cat. No. 55).
	York, James, Duke of, later James II, 1633–1701. Signed and dated: *SC* (monogram)/*1661.*	Ex Sotheby Heirlooms. Victoria and Albert Museum, London.
1662	Unknown man, *called* Lord John Cutts. Inscribed on the reverse of the frame: *Lord John Cutts/Signed/S. Cooper/1662.*	Mrs. E. H. Heckett, U.S.A.
1663	*Fauconburg, Mary Cromwell, Countess of, 1636/7–1712/3.	Ex E. M. Hodgkinson Coll. Present location unknown.
	*Lindsey, The Countess of. (Noted by R. W. Goulding, 1914.)	The Earl of Ancaster.

DATED WORKS

[117]

SITTER	PAST OR PRESENT OWNER
Sheldon, Gilbert, Archbishop of Canterbury, 1598–1677. Signed and dated: *SC* (monogram)/*1667*/*Æ 69*.	Walters Art Gallery, Baltimore, U.S.A.
*Verney, Mr.	Vertue IV, p. 143, *Walpole Society*, Vol. XXIV.

	SITTER	PAST OR PRESENT OWNER
1668	*Gwynn, Nell, 1650–1687, *called*.	Brussels Exhibition, 1912 (Cat. No. 62).
	*Pepys, Mrs. Samuel, 1640–1669.	Present location unknown.
1669	Holles, Sir Frescheville, 1641–1672. Signed and dated: *SC* (monogram)/*1669*.	The Duke of Portland, K.G. (Cat. No. 60).
	Richmond, Frances Teresa Stuart, Duchess of, 1647–1702. Signed and dated: *SC* [–]*69*.	Uffizi Gallery, Florence.
	Romney, Henry Sidney, Earl of, 1641–1704. Signed and dated: *SC* (monogram)/*1669*.	The Duke of Portland, K.G. (Cat. No. 62).
	Sandwich, Edward Montagu, 1st Earl of, 1625–1672. Signed and dated: *SC.* (monogram)/*1669*.	Dyce Bequest, Victoria and Albert Museum, London.
	Unknown lady, *called* Lady Cavendish. Signed and dated: *SC* (monogram)/*1669*.	Uffizi Gallery, Florence.
167–	James II, 1633–1701. Signed and dated: *SC.*/*167–*.	Ex Buccleuch Coll. National Maritime Museum, Greenwich.
1670	Charles II, 1630–1685. Signed and dated: *SC.*/*1670*.	Rosenborg Castle, Copenhagen.
	*Cosimo III of Tuscany, 1642–1723. Signed: *SC* (monogram) and painted *c.* 1670.	Uffizi Gallery, Florence.
	Orleans, Henrietta, Duchess of, 1644–1670. Signed and dated: *SC.* (monogram)/*1670*.	Mauritshuis, The Hague.
	Shaftesbury, Anthony Ashley Cooper, 1st Earl of, 1621–1683. Signed and dated: *SC*/*1670*.	Philadelphia Museum of Art, U.S.A.

DATED WORKS

	SITTER	PAST OR PRESENT OWNER
1671	Unknown lady, possibly Margaret Leslie, Lady Balgony, d. 1688 (afterwards Countess of Buccleuch and, by a third marriage, Countess of Wemyss). Signed and dated: *SC* (monogram)/*1671*.	The Duke of Buccleuch and Queensberry, K.T.
1672	Clifford of Chudleigh, Lord, 1630–1673. Signed and dated: *SC* (monogram) and inscribed on the reverse by the artist: *Sr Thomas Clifford 1672. Æta: 42 Sam: Cooper fecit.*	Lord Clifford of Chudleigh.

APPENDIX V

Undated Miniatures by or Attributed to Samuel Cooper

—◦◦◦◦◦—

Albemarle, George Monck, 1st Duke of, 1608–1670 (unfinished sketch). — H.M. the Queen.

Albemarle, George Monck, 1st Duke of, 1608–1670. Signed: *SC* (monogram). — The Duke of Buccleuch and Queensberry, K.T.

Alcock, Thomas. Unsigned and unfinished. Drawn *c.* 1655 when the sitter was eighteen years of age. Inscribed on the reverse of the frame. — Ashmolean Museum, Oxford.

★Anglesea [Anglesey], Lord. (? 1st Earl, 1614–1686). — On Mrs. Samuel Cooper's list.

★Anglesea [Anglesey], Lady. — On Mrs. Samuel Cooper's list.

★Arlington, K.G., Henry Bennet, 1st Earl of, 1618–1685. — Seen by Pepys, 30 March 1668.

Arlington, K.G., Henry Bennet, 1st Earl of, 1618–1685.
The above miniature by Cooper was possibly left unfinished, the robes and Orders having been added after 1674, in which year he became Lord Chamberlain. They were probably painted by S. P. Rosse. — Lady Cecilia Howard.

Arran, Richard Butler, Earl of, 1639–1686. Unsigned. — The Duke of Portland, K.G. (Cat. No. 69).

[120]

UNDATED MINIATURES

SITTER	PAST OR PRESENT OWNER
Arundel, Henry Frederick, Earl of, 1608–1652. Signed: *S.C.*	Starr Collection, Kansas City, U.S.A.
*Aubrey, John.	Present location unknown.
*Bagot, Sir W.	Sir W. Windham Wynn.
Bolton, Duchess of (possibly wife of Charles, 1st Duke). Signed: *SC* (monogram).	E. Grosvenor Paine, U.S.A.
*Boynton, Mrs. (later Duchess of Tyrconnel).	On Mrs. Samuel Cooper's list
*Boy's head, after Van Dyck.	Vertue IV, p. 17, *Walpole Society*, Vol. XXIV. 1935/36.
*Bristol, Digby George, 2nd Earl of, 1612–1677, *called*.	Northcote sale, July, 1934.
Brooke, Robert Greville, 2nd Baron, 1607–1643 (possibly). Unsigned.	Victoria and Albert Museum, London.
Buckingham, Mary Fairfax, Duchess of, 1638–1704, *called*. Signed: *SC* (monogram).	The Duke of Buccleuch and Queensberry, K.T.
Carew, Lady. Unsigned.	Sir J. Carew Pole.
Carew, Sir John, d. 1660. Unsigned.	Sir J. Carew Pole.
*Carlisle, James Hay, Earl of, d. 1636.	Present location unknown.
Catherine of Braganza, 1638–1705 (unfinished sketch).	H.M. the Queen.
Charles II, 1630–1685 (profile in chalk).	H.M. the Queen.
Charles II (profile in chalk).	H.M. the Queen.
Charles II (unfinished and unsigned).	D. E. Bower, Esq.
Charles II.	Fitzwilliam Museum, Cambridge (Museum No. 3909).
Charles II. Signed: *SC* (monogram).	The Duke of Portland, K.G. (Cat. No. 56).
Charlton, Sir Job, 1614–1697. Unsigned.	The Earl Beauchamp.
*Chichester, Countess of. Painted *c.* 1640/9.	Present location unknown.
Clarke, Lady, d. 1695.	Sold Christie's, lot 131, 2.5.1961.
	The Art Institute, Chicago.

SAMUEL COOPER

SITTER	PAST OR PRESENT OWNER
Clarke, Sir William, 1623?–1666.	Sold Christie's, lot 130, 2.5.1961. The Art Institute, Chicago.
Claypole, Mrs. John, 1629–1658. Inscribed in ink on the reverse: *S. Cooper/p*[inxi]*t*.	Chequers, Bucks.
Cleveland, Barbara Villiers, Duchess of, 1641–1709, *called*. Signed: *SC* (monogram).	The Duke of Buccleuch and Queensberry, K.T.
Cleveland, Barbara Villiers, Duchess of, 1641–1709 (unsigned sketch).	H.M. the Queen.
Cooper, Lady Anthony Ashley, née Cecil, d. 1649. Unsigned.	Private Collection.
Cooper Mrs. Samuel, 1623?–1693 (unfinished and unsigned).	The Duke of Portland, K.G. (Cat. No. 71).
Cooper, Samuel, 1609–1672 (attributed) (crayon).	Victoria and Albert Museum, London.
Cromwell, Henry, 1628–1674, *called*. Unsigned.	The Duke of Buccleuch and Queensberry, K.T.
Cromwell, Oliver, 1599–1658 (unfinished sketch).	The Duke of Buccleuch and Queensberry, K.T.
Cromwell, Oliver, 1599–1658 (sketch in profile).	The Duke of Devonshire.
Cromwell, Richard, 1626–1712, *called*. Signed *S.C.*.	Starr Collection, Kansas City.
Cromwell, Richard, 1626–1712, *called*.	George Howard, Esq.
*Cullens, Mrs.	On Mrs. Samuel Cooper's list.
*Cumberland, Countess of.	Mrs. Wyndham Cook.
*Davis, Mrs. (Mary), actress, fl. 1663–1669.	Present location unknown. (A copy after Cooper was in the Rosse sale, 1723.)
Dead Child, probably J. Hoskins jun.'s child (chalk drawing).	Private collection.
Denham, Margaret Brooke, Lady, c. 1647–1666/7. Signed: *SC* (monogram).	The Duke of Buccleuch and Queensberry, K.T.

SITTER	PAST OR PRESENT OWNER
Denmark, Princess Ivardie of, *called.* Signed: *SC* (monogram).	The Earl Beauchamp.
Elizabeth, Princess, 1635–1650, *called.* Unsigned.	The Earl Beauchamp.
Essex, Robert Devereux, 3rd Earl of, 1591–1646, *called.* Painted *c.* 1630–35, unsigned.	H.M. the Queen.
Exeter, Frances Manners, Countess of, 1630–1669. Unsigned.	The Marquess of Exeter.
Exeter, John Cecil, 4th Earl of. Painted *c.* 1672.	Ex Pierpont Morgan Coll. Sold Christie's, lot 33, 24.6.1935. Present location unknown.
*Fairfax, Lady, wife of Thomas, 3rd Baron.	Present location unknown.
Fairfax, Thomas, 3rd Baron, 1612–1671.	Fitzwilliam Museum, Cambridge (Museum No. 3825).
Fairfax, Sir William, 1609–1644. Painted *c.* 1630/5. Signed: *SC* (monogram)	Sold Sotheby's, 15.3.1971. The Hon. Mrs. E. J. Johnston.
*Fanham, Lady.	On Mrs. Samuel Cooper's list.
Fauconberg, a gentleman of the family. Signed: *SC* (monogram).	E. B. Greene Coll., Cleveland, Ohio.
Graham, Mrs.	R. Bayne Powell, Esq.
*Hamilton, James, 3rd Marquess and 1st Duke of, 1606–1649.	Vertue V, p. 41, *Walpole Society*, Vol. XXVI.
Hamilton, Sir John, 1605–1647, 3rd son of 1st Earl of Haddington (attributed).	The Earl of Haddington, K.T.
Hampden, John, 1594–1643, *called.*	The Earl Spencer.
Hanmer, Sir Thomas, 1612–1678. Unsigned.	Col. R. G. Hanmer.
Harley, Sir Edward, K.B., 1624–1700 (unfinished and unsigned).	The Duke of Portland, K.G. (Cat. No. 67).
Hobbes, Thomas, 1588–1679 (unsigned sketch).	E. B. Greene Coll., Cleveland, Ohio.
Holland, Henry Rich, Earl of, 1590–1649. Painted *c.* 1630, unsigned.	Victoria and Albert Museum, Ham House.

SITTER	PAST OR PRESENT OWNER
*Hoskins, John, sen., d. 1665 (chalk).	L. Cross(e) sale, 5.12.1722.
Hoskins, John, jun.? (drawing). (Inscribed in later hand?).	Private collection.
Hoskins, Mrs. (chalk). Signed: *S.C.*	Private collection.
Hoskins, Mrs. Unsigned.	Private collection.
James II when Duke of York, 1633–1701. Signed: *SC* (monogram).	Viscount Bearsted.
James II (small), formerly identified as Charles II.	Victoria and Albert Museum, London.
*Johnson, Cornelius, 1593–1664.	Once in the possession of L. Crosse's sister. Recorded by Vertue, I. p. 146, *Walpole Society*, Vol. XVIII.
Jones, Inigo, 1573–1652, *called.*	Fitzwilliam Museum, Cambridge (Museum No. PD-1955).
Jones, Inigo, 1573–1652, *called.* Unsigned.	R. Bayne Powell, Esq.
Juxon, Bishop William, 1582–1663, *called.* Unsigned (attribution uncertain).	Institut Néerlandais, Paris.
*Kircke, Miss (Countess of Oxford). Diana, 2nd wife of Aubrey de Vere, 20th Earl of Oxford, 1626–1703.	On Mrs. Samuel Cooper's list.
*Lely, Sir Peter, 1618–1680.	Noted by Vertue, I, p. 7, *Walpole Society*, 1929/30. Coll. 'Mr. Lely jun.'.
Lemon, Margaret. Painted *c.* 1635.	Institut Néerlandais, Paris.
Lennox and Richmond, Lady Mary Villiers, Duchess of, 1622–1685. After Van Dyck, traditionally said to be by Cooper, but attributed to J. Hoskins by Graham Reynolds, *The Age of Charles II*, 1960/61.	The Duke of Portland, K.G. (Cat. No. 72).
Lenthall, William, 1591–1662, *called.* Unsigned.	Geoffrey Manning, Esq.
Lewis, Sir John Bt., *c.* 1615–1671. Unsigned.	Viscount Bearsted.

SITTER	PAST OR PRESENT OWNER
Loudoun, John Campbell, Earl of, d. 1662.	Ex Pierpont Morgan Coll. Sold Christie's, lot 30, 24.6.1935. Present location unknown.
*Lyttelton, Anne Temple, Lady, 1649–1718.	Viscount Cobham.
*Lyttelton, Anne Temple, Lady (unfinished).	Viscount Cobham.
*Lyttelton, Constantine, 1638–1662.	Viscount Cobham.
Man in a brown doublet. Unsigned.	H.M. the Queen of the Netherlands.
Mary, Princess of Orange, 1631–1660, *called*.	H.M. the Queen.
*May, Baptist, 1629–1698	Lord De Saumarez.
Maynard, Sir John, 1602–1690, *called*. (N.B. The above miniature is attributed to Cooper but may be by T. Flatman.)	The Duke of Buccleuch and Queensberry, K.T.
Milton, John, 1608–1674, *called*. Signed: *SC* (restored).	The Duke of Buccleuch and Queensberry, K.T.
Monmouth and Buccleuch, K.G., James Scott, Duke of, 1649–1685, as a boy, unfinished sketch, *c.* 1664.	H.M. the Queen.
Monmouth and Buccleuch, K.G., James Scott, Duke of.	H.M. the Queen.
Montrose, James Graham, Marquess of, 1612–1650, *called*. Unsigned.	The Duke of Buccleuch and Queensberry, K.T.
Morland, Sir Samuel, Bt., 1625–1695. Unsigned.	Victoria and Albert Museum, London.
Morton, Anne, Countess of, d. 1654. Signed: *S* in a later hand.	Ex de la Hey Coll. E. Grosvenor Paine, U.S.A.
Muggleton, Lodowicke, 1609–1698. Unsigned. The above miniature has always been attributed to Cooper, but is in my opinion by a follower, after Cooper.	Ex Pierpont Morgan and Hickson Colls. Private Collection.
Myddleton, Jane, 1645–1692. Signed: *SC* (monogram).	The Earl Beauchamp.

SAMUEL COOPER

SITTER	PAST OR PRESENT OWNER
Newcastle, William Cavendish, Duke of, 1592–1676. Unsigned. After Van Dyck.	The Duke of Buccleuch and Queensberry, K.T.
Newport, Francis, Lord, later 1st Earl of Bradford, 1619–1708, (*possibly*).	Victoria and Albert Museum, London.
Nicholas, Penelope Compton, Lady, or Alice Fanshawe, Lady Bedell. Signed: *SC* (monogram)	The Duke of Buccleuch and Queensberry, K.T.
Northampton, James Compton, 3rd Earl of, 1623–1681.	Sold Christie's, 29.2.1972.
Northumberland, Algernon Percy, 10th Earl of, 1602–1668. Signed: *S.C.*	Victoria and Albert Museum, London.
Orleans, Henrietta, Duchess of, 1644–1670. Signed: *SC* (monogram).	Victoria and Albert Museum, London.
*Orleans, Philip, Duke of, 1640–1701.	On Mrs. Samuel Cooper's list.
*Osborne, Dorothy (Lady Temple), 1627–1696. Painted *c.* 1654.	Present location unknown.
*Oxford, Countess of (Roxelana), née Davenport.	Michael Rosse sale, 1723.
Penruddock, Jane, b. *c.* 1618 (unfinished and unsigned). The sitter's name scratched on the reverse of the locket.	Mrs. D. Foskett.
Percy, Lady Elizabeth. Unsigned.	The Marquess of Exeter.
*Price, Miss (Mrs. Skelton).	On Mrs. Samuel Cooper's list.
Purbeck, Elizabeth Slingsby, Viscountess, 1619–1645. Signed: *S. Cooper*. Inscribed with the sitter's name and title on the reverse.	The Earl Beauchamp.
Pye, Anne Stephens, Lady, d. 1722. Signed: *S.C.*	The Duke of Portland, K.G. (Cat. No. 61).
Pym, John, 1594–1643. Signed: *SC*.	Chequers, Kent.
*Radnor, Lady, wife of John, 1st Earl.	Michael Rosse sale, 1723.
Radnor, John Robartes, 1st Earl of, 1606–1685 (by or after Cooper). Signed: *SC*.	T. Fetherstonhaugh, Esq.

[126]

SITTER	PAST OR PRESENT OWNER
Richmond, Frances Teresa Stuart, Duchess of, 1647–1702. Painted *c.* 1663, unfinished sketch.	H.M. the Queen.
*Roberts or Robartes, Mr. (son of 1st Earl of Radnor).	On Mrs. Samuel Cooper's list.
*Roberts, Mrs.	On Mrs. Samuel Cooper's list.
*Robinson, Sir John (copied by Col. Seymour).	Vertue IV, p. 120, *Walpole Society*, Vol. XXIV.
Rothes, John, 6th Earl of, 1600–1641 (attributed).	The Earl of Haddington, K.T.
Rupert, Prince, 1619–1682.	National Maritime Museum, Greenwich.
Selden, John, 1584–1654, *called*.	Ex Sotheby Heirlooms. Sold Sotheby's, lot 30, 11.10.1955. Present location unknown.
Shaftesbury, Anthony Ashley Cooper, 1st Earl of, 1621–1683. Signed: *SC* (monogram).	Shaftesbury Estates.
Shaftesbury, Anthony Ashley, 2nd Earl of, 1652–1699. Painted *c.* 1665/70.	Formerly in the Coll. of the late Queen Mary, 1867–1953. Victoria and Albert Museum, London.
*Shaftesbury, Dorothy Manners, Countess of.	Ex Pierpont Morgan Coll. Sold Christie's, part of lot 39, 24.6.1935. Present location unknown.
Sheldon, Gilbert, Archbishop of Canterbury, 1598–1677. Unsigned.	The Duke of Portland, K.G. (Cat. No. 68).
*Shrewsbury, Lady.	On Mrs. Samuel Cooper's list.
*Simson (musician). Probably Christopher Simson, d. 1669.	Lawrence Crosse sale, 5.12.1722.
Smyth, Lady. Signed: *SC* (monogram).	T. Cotterell-Dormer, Esq.
Smyth, Sir Hugh. Signed: *SC* (monogram).	T. Cotterell-Dormer, Esq.

SITTER	PAST OR PRESENT OWNER
*Spain, Mariana, The Queen Mother of (as a child).	On Mrs. Samuel Cooper's list.
*Stirling, Earl of.	Lord Sandys.
Suffolk, Barbara Villiers, Countess of, 1632–1681. Inscribed in pencil on the reverse: *C. Suffolk*.	The Duke of Portland, K.G. (Cat. No. 70).
*Sunderland, Countess of.	On Mrs. Samuel Cooper's list.
Sunderland, Lady Dorothy Sidney, 1617–1684, *called*. Signed: *SC* (monogram).	The Duke of Buccleuch and Queensberry, K.T.
Sunderland, Lady Dorothy Sidney, 1617–1684, *called*.	Ex de la Hey Coll. Sold Sotheby's, lot 194, 4.11.1968.
*Swinfen or Swynfen, John, b. 1612.	Samuel Pepys *Diary*, Nov. 1662.
*Swinfield, Mr.	Sir Robert Child Coll. Vertue II, p. 130, *Walpole Society* Vol. XX.
*Sydney, Colonel.	L. Crosse sale, 5.12.1722.
Thanet, Nicholas Tufton, Earl of, 1631–1679. (attributed). Unsigned and possibly after Cooper.	The Duke of Buccleuch and Queensberry, K.T.
*Thurloe, John, 1616–1668.	Present location unknown.
Tyrconnel, Frances Jennings, Duchess of, 1647/9–1731.	Lord Talbot de Malahide.
Unknown man. Painted *c.* 1630–40. Signed: *S.C.*	H.M. the Queen.
Unknown lady, *called* The Duchess of Richmond (attributed).	H.M. the Queen.
Unknown man.	H.M. the Queen of the Netherlands.
Unknown man in armour.	Ashmolean Museum, Oxford.
Unknown man, formerly *called* John Wilmot, Earl of Rochester.	Ashmolean Museum, Oxford.
Unknown divine.	The Earl Beauchamp.

SITTER	PAST OR PRESENT OWNER
Unknown man in armour (attributed).	The Earl Beauchamp.
Unknown lady, formerly *called* Princess Mary, 1631–1660. Signed *SC* (monogram).	The Duke of Buccleuch and Queensbury, K.T.
Unknown man in armour. Unsigned.	T. Cotterell-Dormer, Esq.
Unknown man.	Fitzwilliam Museum, Cambridge (Museum No. 3827).
Unknown man. Painted *c.* 1660–1665.	Fitzwilliam Museum, Cambridge (Museum No. 3831).
Unknown man.	Fitzwilliam Museum, Cambridge (Museum No. PD. 957–1963).
Unknown lady, formerly *called* Lady Lucy Percy. Signed: *SC.*	Fitzwilliam Museum, Cambridge (Museum No. 3826).
Unknown man, *called* John Thurloe, 1616–1668.	Fitzwilliam Museum, Cambridge (Museum No. 194–1961).
Unidentified lady of the Pinfold family.	Fitzwilliam Museum, Cambridge (Museum No. PD 58–1948).
Unknown man, *called* General Fleetwood.	Ex de la Hey Coll. Sold Sotheby's, lot 52, 27.5.1968.
Unknown man. Unsigned.	Mrs. D. Foskett.
Unknown lady.	Victoria and Albert Museum, Ham House, Middlesex.
Unknown man in armour. Unsigned.	Mrs. Holscheiter, Zurich.
Unknown lady. Painted *c.* 1643.	Mauritshuis, The Hague.
Unknown lady.	Philadelphia Museum of Art, U.S.A.
Unknown man. Signed: *SC* (monogram).	The Duke of Portland, K.G. (Cat. No. 53).

SITTER	PAST OR PRESENT OWNER
Unknown man. Signed: *SC.*	The Duke of Portland, K.G. (Cat. No. 54).
Unknown man. Signed: *SC* (monogram).	The Duke of Portland, K.G. (Cat. No. 57).
Unknown young man. Unsigned	The Duke of Portland, K.G. (Cat. No. 63).
Unknown lady, formerly *called* Lady Carlisle.	Ex Sotheby Heirlooms. Sold Sotheby's, lot 39, 11.10.1955. Institut Néerlandais, Paris.
Vane, Sir Henry, the younger, 1612–1662. Inscribed on the reverse with the sitter's name.	The Duke of Portland, K.G. (Cat. No. 64).
Vane, Sir Henry, jun., 1612–1662.	Mrs. E. H. Heckett, U.S.A.
*Verney, Mr., 1667?	Vertue IV, p. 143, *Walpole Society*, Vol. XXIV.
*Warner, Sir John, d. *c.* 1659.	Vertue IV, p. 120, *Walpole Society*, Vol. XXIV.
*Warner, Lady Trevor, née Hanmer, d. 1670.	Destroyed (see pages 82–4).
Witherington, Sir William. Painted *c.* 1670 (attributed).	Fitzwilliam Museum, Cambridge (Museum No. 3751).
Wriothesley, Thomas, 4th Earl of Southampton, 1607–1667. Unsigned.	Sold Sotheby's, 9.2.1961; and again 19.6.1967.
Yarmouth, Charlotte Paston, Duchess of, *c.* 1650–1684. Signed: *SC* (monogram).	The Duke of Buccleuch and Queensberry, K.T.
York, James Duke of, 1633–1701, *called.*	Mrs. Holscheiter, Zurich.
York, Anne Hyde, Duchess of, 1637–1671. Unsigned	The Earl Beauchamp.

APPENDIX VI

Some Notes on the Painting Materials and Methods used by Samuel Cooper

by V. J. MURRELL

Department of Conservation, Victoria and Albert Museum

It would be foolish to claim that we know everything that there is to know about Cooper's materials and methods, but there is much that becomes evident on a careful study of his miniatures, especially in comparison with those of his contemporaries about whose methods we know a great deal. It is unfortunate that it was not until very recently that non-destructive methods of pigment and media analysis were developed and that they have not, as yet, been directed towards the special problems of the analysis of miniatures. However, there is much general information on the methods of the period contained in the treatises of Norgate, Sanderson and Alexander Browne.[1] There is only one direct documented reference to Cooper's materials and procedures, but this is an important one; the general lack of comment is, in itself, revealing.

It is important to remember that Cooper lived in an age when the artist was intimately concerned with the choice and preparation of his own materials. True, most of the pigments could be bought prepared, but the artist had to be able to judge their quality when making his purchases, and they still had to be ground finely and mixed

[1] Edward Norgate, *Miniature or the Art of Limning*, edited by Martin Hardie, from a manuscript of circa 1650, Oxford, 1919.

William Sanderson, *Graphice; the use of the Pen and Pencil, or the most excellent Art of Painting*, London, 1658.

Alexander Browne, *Ars Pictoria; or an Academy Treating of Drawing, Painting, Limning, Etching*, London, 1669.

with a binder; there were some colours which artists preferred to make up themselves. The artist would also prepare the support on which he painted and sometimes make his own brushes, or pencils as they were then called, although the London brushmakers had a reputation for making very fine pencils for miniature painting. These may seem very mundane activities, by modern standards, but at the time artists were well aware that their choice of materials and the care with which they prepared them would be reflected in the excellence and durability of their works.

The techniques of portrait miniature painting were derived from the methods of the manuscript illuminators and were developed during the sixteenth century by artists such as Holbein, Hilliard and Oliver into a very refined watercolour method, which was well adapted to the exacting task of painting very small portraits. It was not a water colour technique as we know it today; neither was it true gouache, although by Cooper's time so much white was being added to the colours that the end results are indistinguishable. In modern terms a watercolour is a transparent painting carried out in a water-soluble medium, whereas a gouache is a painting in a water-soluble medium which is completely opaque; those colours which are not naturally opaque being rendered so by the addition of white. The Elizabethan miniaturists painted with fairly thick layers of pigment mixed with just enough binder to hold the colour together. However, the features were carried out in transparent colours on a prepared ground and the method should properly be described as a mixed gouache and watercolour technique.

There is a common myth that early miniatures were frequently painted directly on pieces of card. It is true that one very occasionally comes across an early miniature painted in this way, but they are extremely rare and, in my experience, even more rarely attributable to a particular artist. Dr. G. C. Williamson, in his book *The Art of the Miniature Painter*[2] and in his contribution on 'Miniature Painting' in the *Encyclopaedia Britannica*,[3] has grossly exaggerated the incidence and has thus helped to perpetuate the myth. In the *Britannica* he says that miniatures were 'painted mainly on the backs of playing cards, very occasionally upon thin skin, usually chicken skin, stretched across such card'. The illuminators had painted on vellum, but once it had been removed from its traditional place in the book, with the support and protection of a binding, it was necessary to provide it with additional support and so the vellum was usually stuck, with starch paste, to a piece of card, generally a playing card with the cypher showing at the reverse. The vellum used was very thin and fine grained and, because of the thickness

[2] Dr. G. C. Williamson, *The Art of the Miniature Painter*, London, 1905.

[3] Williamson's contribution to the earlier editions of the *Encyclopaedia Britannica* has now been replaced by a reliable article, written by Mr. Graham Reynolds, Keeper of Paintings at the Victoria and Albert Museum. This article has appeared in the 1968 and subsequent editions of the *Encyclopaedia*.

[132]

of the pigment on it, its presence can often only be detected by inspecting the edge of the support under powerful magnification. As Hilliard says in his treatise on limning, 'Knowe also that parchment is the only good and best thinge to limme one, but it must be virgine parchment, such as neuer bore haire, but younge things found in the dames bellye; some calle it vellum, some abertive (deriued frome the word abhortiue for vntimly birthe).[4] Although, as Daniel V. Thompson points out in his *Materials of Medieval Painting*,[5] it is certain that few of the fine skins sold under the names 'virgin' or 'abortive' parchment were from still-born calves, it is evident from the treatises that artists took great care over the selection of prepared skins and there is absolutely no evidence to support Williamson's bold assertion that miniatures were painted on chicken skin. Edward Norgate gives a detailed description of the method of preparing vellum for miniature painting: 'Take an ordinary Card, and scrape the back side to make it even and cleane; then take a peece of abortive parchment of the same bignes, and past it on with fine starch which you may prepare by beating it with a knife or some such flat thing in the palme of your hand to break the knots in the starch, which laid on smooth with a great pencill, instantly paste the parchment, and let it rest till it be halfe dry. Then take it and lay the pasted side on the cleane and a smooth grinding stone, and holding it fast, polish the back side of the Card with a tooth, and make it as smooth and even as possibly may be. This polishing the back side will make the other side, where on you are to worke, as smooth as glasse.' Because of the increase in the size of miniatures, which in Cooper's time were generally upwards of three inches in height, this method was modified by coating the back of the card with a thin layer of glue/chalk gesso, to counter the pull of the vellum at the front and so prevent the card from buckling. It was not done in every case, but many of Cooper's vellums were prepared in this way.

The preparation of artists' pigments is too complex a subject to explore in detail here, but generally colours were divided into two categories: those which had to be ground to a fine powder, and those which were prepared by washing because grinding would have destroyed their hue. The pigments were first crushed in a mortar and then those colours which were to be ground were mixed with water and ground with a muller on a slab of porphyry or some such material. They were then washed over several times to remove any impurities. Colours which could not be ground were crushed and then shaken up with water. After a few minutes the water was decanted, taking with it the finest particles of pigment, which were recovered by allowing the water to stand for a long

[4] Nicholas Hilliard, *A Treatise concerning the Arte of Limning*, Annual Volume of the Walpole Society, 1911–12, from a manuscript of *circa* 1600.

[5] Daniel V. Thompson, *The Materials of Medieval Painting*, London, 1936.

[133]

time so that they settled on the bottom of the vessel before decanting again. Sometimes several grades of pigment were made by repeated decanting. Miniaturists were very careful in their choice of pigments and although many used lakes which faded when exposed to light, they avoided pigments which they thought could cause disastrous chemical reactions, such as orpiment, verdigris and the artificial copper blues and greens. A typical palette of the period is that suggested by Sir William Sanderson in his *Graphice*:

WHITES	*REDS*	*YELLOWS*
Ceruse	Indian lake	Massicot
White lead	Red lead	English ochre

GREENS	*BLUES*
Sap green	Indigo
Pink	Ultramarine (lapis lazuli)
Green bice (malachite)	Bice (azurite)
Cedar green (crysocolla)	Smalt

BROWNS	*BLACKS*
Umber	Cherrystone black
Spanish brown	Ivory black
Cologne earth (Vandyck brown)	Lamp black

Note: Pink was, in fact, a yellow to brown colour made from the dysetuff of certain berries, and had to be mixed with a blue to make green.

Powdered gold and silver, which had figured so prominently in the palettes of the Elizabethans, were not used in Cooper's time to anything like the same degree. The early miniaturists had delighted in the use of metallic pigments, which they burnished to a high polish to represent armour and jewellery. They also used gold powder for their elaborate inscriptions. Cooper sometimes used gold for his signatures and occasionally for representing gilt buttons, but armour and other metallic objects he generally rendered in ordinary pigments. In his miniature of a gentlemen, possibly Sir R. Henley, at the Victoria and Albert Museum, can be seen a rare use of powdered gold for rendering the unusual quality of the highlights in satin.

It is evident from the relative lack of fading in Cooper's miniatures that he largely eschewed the impermanent colours such as sap green, pink and the lakes, and used a fairly limited palette of earth and mineral colours. In the seventeenth century it was difficult to avoid using white lead because there were few acceptable substitutes. This colour has the serious disadvantage that in the presence of atmospheric hydrogen sulphide it turns black, and the frequent occurence of this phenomenon in Cooper's miniatures points to the fact that he used it extensively. The only authenticated piece

of writing in Cooper's hand is a note written for Sir Théodore Turquet de Mayerne, the physician, about the preparation of colours. Williamson mentions this in *The Art of the Miniature Painter*, but summarises it inaccurately and omits one of the colours mentioned. He says that it is a recipe for colours to be used *with* white lead, whereas it is, in fact, a general directive for the preparation of white lead, bice, massicot, red lead and vermilion. Although the note was written while Cooper was working in his uncle's studio, there is no reason to doubt that he continued to use these colours in his mature works. The complete palette would, of course, have included several more colours. Williamson repeatedly states that Cooper used sepia. That colour, although known in antiquity, was not rediscovered in modern times until the late eighteenth century.

When the pigments had been ground or washed to a fine consistency they had to be mixed with a binder.[6] The binder normally used for miniature painting was gum arabic or, more correctly, gum senegal, which is the clearest and the most easily soluble of the acacia family of gums. The gum would be dissolved in water to make a weak solution and then mixed with small quantities of colour to make a thickish paste. A test patch of colour was then painted out to ensure that the paint had the correct amount of binder. If the colour was shiny when it dried, it had too much binder; if it rubbed off on the finger, then it had too little. The necessary adjustment was then made by either adding more pigment and water, or more gum solution. This was a very essential procedure because some pigments have the ability to absorb more binder than others and the proportion can also vary according to how finely the colour has been ground. When the colour was judged to be correctly bound it was smeared around the sides of a mussel shell or a small turned ivory box, and was allowed to dry there. When the painter wished to use the colour he would wet it with a brush in the same way as one would with modern watercolours in pans. Some colours, such as the lakes, tend to crack if bound with gum alone, so it was a common practice to add a plasticiser to them, such as sugar candy or honey. We do not know with absolute certainty that these were Cooper's methods, but they were the methods of the artists preceding and following him, and there is no evidence to the contrary. However, when an original genius presents itself on the artistic scene there is usually a controversy, after a safe interval of a century or so, over the composition of a 'secret' medium which would account for such unparalleled virtuosity. This has happened to many great painters, and Cooper is no exception. At various times it has been suggested that he painted with honey, with starch, or with

[6] The terms used in describing the constituents of paint are as follows: The *binder* is the substance which holds the pigment particles together and attaches them to the support.

The *diluent* is the liquid which, being a solvent for the binder, enables one to take up the pigment in the brush and manipulate it on the support. A mixture of binder and diluent is described as the *medium*.

a kind of dextrine made from sugar, while one journal which frequently reproduced his works described them as being painted in oil on vellum! Williamson advances his own view that laevulose was used, and adds that it has often been used, like sugar candy and glycerine, as a plasticiser. He does not make it clear whether he means that the laevulose was used as a binder or as a plasticiser. If, as seems probable, he means that laevulose was used by Cooper as a plasticiser, I would agree that this is possible, with the reservation that Cooper would have used honey rather than pure laevulose. The continued use of honey as a plasticiser for watercolour until the middle of the nineteenth century, when it was superceded by glycerine, makes it highly unlikely that the separation of laevulose from honey with alcohol was understood in Cooper's time. Indeed the earliest mention of the use of laevulose for this purpose that I have seen is in Sir Arthur Church's *Chemistry of Paints and Painting*,[7] which was written in the late nineteenth century and which also gives directions for using glycerine for the same purpose. If Cooper did use honey it would not have been unusual for, as we have seen, it was the common practice of many of the miniaturists of his time. Of the other theories put forward the only one which bears serious consideration is the possible use of starch. It has frequently been used as a binder, but anyone conversant with its properties would realise that it could but increase the problems of fine miniature painting, being more suited to the execution of large cartoons and scene painting. Again, however, it could have been used in small quantities with gum arabic to serve as a plasticiser. It is often recommended for that purpose in later treatises. If Cooper used either honey or starch as a plasticiser for gum, the quantities which would have been necessary would have made no difference to the working properties or to the final appearance of his paint. A comparison under magnification of the surface quality of Cooper's paint with that of Hoskins and other contemporaries reveals nothing which suggests the use of a different medium, but it does reveal a remarkable facility with the brush. It is interesting that Norgate, who was extremely inquisitive in technical matters, praises Cooper's work without making any reference to his methods. Finally we have the note which Cooper wrote for de Mayerne, where he clearly states that the colours mentioned are to be mixed with gum and sugar candy.

It is not unlikely that Cooper's working methods were the same as Hoskins', whose equipment is described in some detail in the de Mayerne manuscript.[8] The bound colours were kept in small, turned ivory dishes. A turned ivory palette was used, about four inches in diameter, which was slightly concave. Small amounts of wetted colour

[7] Sir Arthur Herbert Church, *The Chemistry of Paints and Painting*, London, 1890.

[8] Sir Théodore Turquet de Mayerne, British Museum Manuscript, Sloane 2052, folios 29, 77, 149 verso.

were transferred from the ivory dishes to the edge of the palette, and were then mixed in the centre. White and blue, which were used in fairly large quantities, Hoskins kept separately in ivory pots. Some artists preferred to mix their colours on a large piece of mother-of-pearl.

The brushes or pencils used were most probably made from squirrel hair, taken from the tip of the tail and bound together in small bundles, with the hairs curving in to form the tip. These bundles were then set in goose quills which were subsequently mounted on sticks. Contrary to a popular notion, brushes were not exceedingly finely pointed. The legendary 'brush with one hair' would be literally impossible to use. It is difficult to work in any medium with a brush which does not have a full body of hair, because it will not carry sufficient colour. Miniature painting brushes usually have a full body of hair tapering to a slightly rounded tip. If the brush is too finely pointed the results tend to have a scratchy appearance. Cooper appears to have painted with rather larger brushes than his contemporaries.

In England it was customary to paint the flesh on a ground, rather than directly on the vellum. It was a highly esteemed method of painting and Norgate says that '. . . the English, as they are incomparably the best Lymners in Europe, soe is their way more excellent, and Masterlike Painting upon solid and substanciall body of Colour much more worthy Imitation than the other slight and washing way'. Imitated it was, for we hear that Louis Hans van der Brughen 'couchoit du blanc sur son velin, et cherchoit à imiter la manière d'Olivier et de Coupre qui travailloient avec estime en Angleterre'.[9] The method was to sweep over the area that the head would occupy on the vellum with a large brush loaded with somewhat liquid colour. This colour was basically white, with small amounts of red, yellow and brown, and occasionally blue, according to the complexion of the sitter. The tone was kept very light so that this ground layer could serve as the highlight of the modelling. This flesh ground was called the 'carnation' by the early limners and the method persisted in England from the time of Holbein until the eighteenth century when vellum was superceded by ivory as a painting surface. The outline of the features was sketched in lightly over the carnation with a pale brown or red colour. Any excess ground which extended beyond the contours of the features was taken off with a damp brush, so that it would not 'pick up' when other colours were painted on those areas. At this period miniaturists painted in a strictly observed procedure. Once the outline of the face had been drawn, usually with a pale mixture of lake and white, the 'dead-colouring' was done. This was effected by lightly hatching on the carnation the various tones of the face; red in the cheeks and lips, blue tones around the

[9] Jean François Félibien, *Entretiens sur les vies et sur les ouvrages des plus excellens peintres anciens et modernes*, Paris, 1672–88.

eyes, and so on. Then the shadows which formed the modelling of the features were gradually hatched in. The idea was to tone down the carnation to form the modelling and shadows of the face, leaving islands of bare carnation to stand for the highlights. Once the dead-colouring was done, the middle tone of the hair was washed in, and the basic tone of the background established. Although the effect relied on the colours being semi-transparent, white was added to most of the flesh tones in small quantities to give them body and make them blend well. Norgate says of painting the features '. . . in alle or most of the shadowes white is ever a dayly guest, and seldome absent but in the deepest shadowes'. The dead-colouring and laying-in of the tones of the hair and background would be accomplished in one sitting. In later sittings the modelling of the features would be deepened and 'sweetened' by working over with finer brush strokes, blending the shadows and giving subtlety to the blunt statement of the dead-colouring. The shadows and folds of the drapery would be hatched with darker colour on the middle tone already laid, while the highlights would be added with opaque light tones. The hair and background would be worked over in the same way. For a clear demonstration of the stages in painting a miniature at this period the reader is urged to study the series of unfinished miniatures by Susan Penelope Rosse in the Victoria and Albert Museum.

In his brushwork Cooper was an innovator and although many of his miniatures conform to the procedures set out above, most of his best works are painted in a very free manner. In some of his miniatures the carnation is not visible, because he has worked over and over the flesh with free, broad strokes, so that the highlights have an impasto quality. Williamson asserts that Cooper used a green underpainting. There is absolutely no evidence to support this. In all the Cooper miniatures which I have examined where the carnation is visible, it is of a very pale, cream colour, and the dead-colouring of the shadows over it is in a rich red-brown. As mentioned earlier, he occasionally used gold for rendering metallic objects or for highlighting costume, but as often as not he painted armour and gilt objects using colours in an illusionistic technique; and his backgrounds occasionally depict a landscape or a stormy sky, carried out in an improvised mixture of transparent and opaque wash and stipple.

Selected Bibliography

ART JOURNAL, London, September 1850, pp. 293–5.

AUBREY, J., *Brief Lives* (1669–96), Edited by A. Clark, 2 vols., Oxford 1898.

BAKER, C. H. COLLINS, *Lely and the Stuart Portrait Painters*, 3 vols., London 1912.

BECKETT, R. B., *Lely*, London 1951.

BERESFORD, J., *The Godfather of Downing Street*, London 1925.

CLEVELAND MUSEUM OF ART, *Portrait Miniatures* (the Edward B. Greene Collection), Ohio 1951.

CRINÒ, PROFESSOR ANNA MARIA, *Burlington Magazine*, Vol. 99, London 1957.

— *Rivista d'Arte*, Vol. 29, 1954.

de MAYERNE, SIR THÉODORE TURQUET, MS. BRITISH MUSEUM, Sloane 2052, folios 29, 77, 149, verso.

DE PILES, R., *The Art of Painting*, 1st edition, London 1706. (I have used the second edition of 1744.)

DICTIONARY OF NATIONAL BIOGRAPHY. London.

EVELYN, JOHN, *Memoirs illustrative of the Life and Writing of John Evelyn comprising his Diary from the year 1641 to 1705; and a selection of his familiar letters.* 2 vols., London 1818.

FOSKETT, DAPHNE, *British Portrait Miniature Exhibition Catalogue*, Scottish Arts Council, Edinburgh 1965.

— *Dictionary of British Miniature Painters*, London 1972.

FOSTER, J. J., *Samuel Cooper and the English Miniature Painters of the XVIIth Century*, 2 vols, London 1914–1916.

GOULDING, R. W., *The Welbeck Abbey Miniatures*, Walpole Society, Vol. IV, 1916.

HOLMES, C. and KENNEDY, H. A., *Early English Portrait Miniatures in the Collection of the Duke of Buccleuch*, The Studio, London 1917.

HOOKE, DR. ROBERT, *Diary*, edited by H. W. Robinson and W. Adam, London 1935 and 1968.

L'Exposition de la Miniature a Bruxelles en 1912, published 1913, Brussels and Paris.

LONG, B. S., *British Miniaturists,* London 1929.

MAURITSHUIS, *Beknopte Catalogus,* Amsterdam 1968.

MCKAY, ANDREW, *Catalogue of the Miniatures in Montagu House,* London 1899.

MILLAR, OLIVER, *Abraham Van Der Doort's Catalogue of the Collections of Charles I,* Walpole Society, Vol. XXXVII, Oxford 1958–60.

— 'Notes on British Art', *Apollo,* London January, 1965.

— *Tudor, Stuart and Early Georgian Pictures in the Royal Collection,* London 1963.

— *The Age of Charles I,* The Tate Gallery, 1972.

Miniatures in Water Colour at Madresfield Court, privately printed, 1928.

'N. N.' [Edward Scarisbrick] *The Life of the Lady Warner, of Parham in Suffolk,* London 1691.

NORGATE, EDWARD, *Miniatura,* c. 1650, edited by Martin Hardie, Oxford 1919.

OSBORNE, DOROTHY, *Letters,* edited by E. A. Parry, London 1888.

PEPYS, SAMUEL, *Diary,* edited by H. B. Wheatley, 8 vols. in 3, London 1952.

PIPER, DAVID, *The English Face,* London 1957.

PITTI PALACE, FLORENCE, *Firenze e L'Inghilterra,* Florence September, 1971.

REYNOLDS, GRAHAM, *English Portrait Miniatures,* London 1952.

— 'Samuel Cooper: Some Hallmarks of his Ability', *Connoisseur,* London 1961.

— 'A Miniature Self-Portrait by Thomas Flatman', *Burlington Magazine,* London March, 1947.

ROYAL ACADEMY OF ARTS, LONDON. *British Art, Commemorative Catalogue,* 1935.

— *17th Century Art in Europe,* Winter Exhibition, 1938.

— *British Portraits,* Winter Exhibition, 1956–57.

— *The Age of Charles II,* Winter Exhibition, 1960–61.

RUBENS, ALFRED, Further Notes on Anglo Jewish Artists, *The Jewish Historical Society of England,* Vol. XVIII, p. 104, London 1958.

Sale Catalogue, Michael Rosse, 1723, copy in British Museum.

Survey of London, Vol. XXXVI, 1970.

THE QUEEN'S GALLERY, *Van Dycke, Wenceslaus Hollar and The Miniature Painters at the Court of the Early Stuarts,* 1968.

VERTUE, GEORGE, Notebooks of. *Walpole Society,* 1930–1947 (see Walpole, below).

VICTORIA AND ALBERT MUSEUM, Publications

 Henry J. Pfungst Collection, 1914–1915.

 Portrait Miniatures, 1948, reprint 1959.

 William and Mary, 1950.

 Bulletin, vol. II No. 3. July, 1966.

WALPOLE, HORACE, *Anecdotes of Painting in England,* 1st Edition 1762–71, 5 vols. and subsequent edition. London.

SELECTED BIBLIOGRAPHY

Walpole Society, Vertue Notebooks. I. Vol. XVIII, 1930; 2. Vol. XX, 1932; 3. Vol. XXII, 1934; 4. Vol. XXIV, 1936; 5. Vol. XXVI, 1938; Index. Vol. XXIX, 1947.

— *Contemporary Portraits of Oliver Cromwell*, by David Piper, Vol. XXXIV, Oxford 1952–1954.

— *Abraham Van Der Doort's Catalogue of the Collection of Charles I*, edited by Oliver Millar, Vol. XXXVII, Oxford 1958–60.

— *The Inventories and Valuations of The King's Goods, 1649–1651*, edited by Oliver Millar, Vol. XLIII, Oxford 1970–1972.

WARBURTON, WILLIAM, *The Works of Alexander Pope, Esq.*, 9 vols., London 1751.

WHINNEY, MARGARET and MILLAR, OLIVER, *English Art, 1625–1714*, Oxford 1957.

WILLIAMSON, DR. G. C., *The History of Portrait Miniatures*, 2 vols. London 1904.

— *Catalogue of the Collection, the Property of J. Pierpont Morgan*, 4 vols. London 1906–7.

— *The Miniature Collector*, London 1921.

Index

INDEX

INDEX

INDEX

Victoria and Albert Museum, 38, 72, 77, 81, 85, 91

Villiers, Barbara, *see* Cleveland

Walker, Robert (d. 1658), 76, 89

Walpole, Horace, 4th Earl of Orford (1717–1797), 38, 72, 73, 93

Walpole Society: Vol. IV, 77; Vol. XII, 87; Vol. XVIII, 56, 59, 74, 75, 77, 86; Vol. XX, 48, 56; Vol. XXIV, 76; Vol. XXXVII, 87

Walters Art Gallery, Baltimore, 78

Warner, Catherine (b. 1660), 83

Warner, Mrs. Elizabeth, 83

Warner, Sir John, 82, 83

Warner, Sir John, sen. (d. 1659), 85

Warner, Susan (b. 1663), 83

Warner, Lady, *née* Trevor Hanmer (d. 1670), 82, 83

Warwick, Sir Philip (1609–1683), 76

Weald Hall, 85

Welbeck Abbey, 38

Wemyss, Countess of, *see* Balgony

Westminster Abbey, 82

Whitehall, the Palace of, 43, 45, 79

White's Chocolate House, St. James's, London, 54

Willett, Deb, 49, 50

Williamson, Dr. G. C., 37, 39, 55, 57

Windsor, Royal Collection, 88

Wood, Anthony A. (1632–1695), 42

Woodshawe, Miles, 40, 41

Works of Alexander Pope, Esq., The, edited by Warburton, 37

York, Anne Hyde, Duchess of (1637–1671), 63, 66, 81

York, the Duke of, *see* James II